To

LAURA

A CERTAIN ALCHEMY

Thank you for your help & I
enjoyed looking at your Greenhouse pictures.

2010

There is an element of magic in precious metals—a certain camera almost like a magic words and you can

photography—light, chemistry, alchemy. You can wield a wand. Murmur the right conjure up proof of a dream.

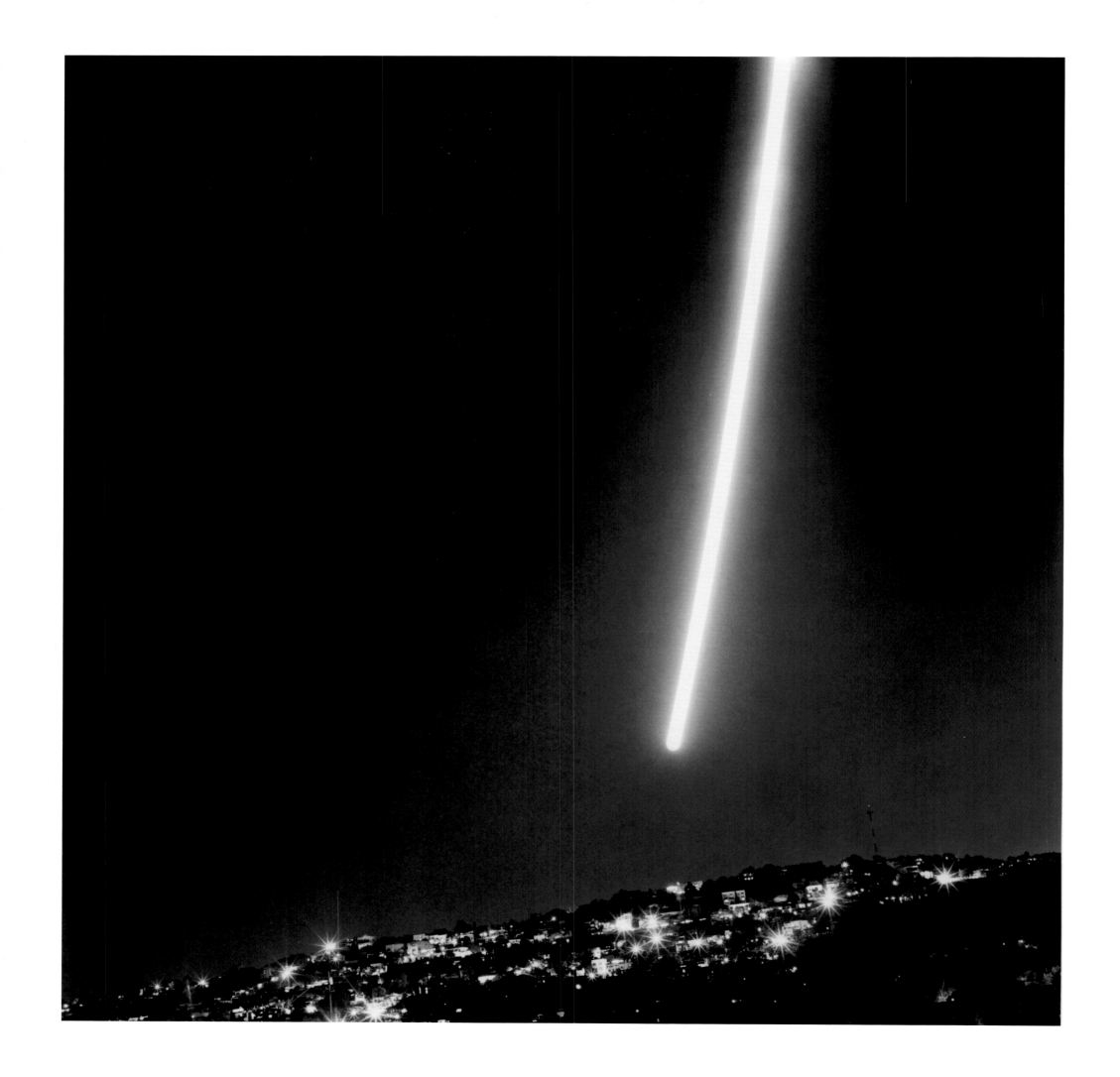

1 **ASCENSION** 2001 | 2 **SKYWARD** 2001

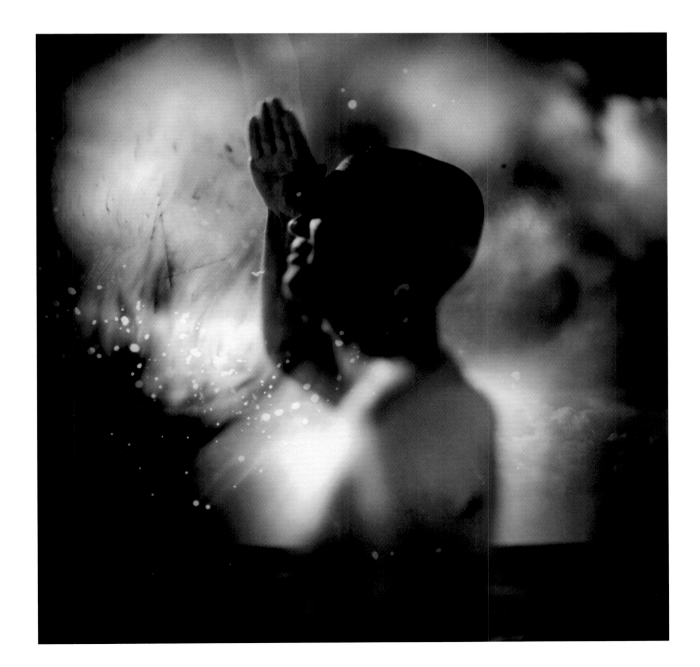

a certain

INTRODUCTION BY **BILL WITTLIFF**

alchemy

AFTERWORD BY **PATRICIA CARTER**

keith carter

UNIVERSITY OF TEXAS PRESS ❧ AUSTIN, TEXAS

A slightly different version of the Introduction first appeared in
Natural Histories—Keith Carter,
The Art Museum of the Southeast Texas, Beaumont, 2000.

Requests for permission to reproduce material
from this work should be sent to:
Permissions
University of Texas Press
P.O. Box 7819, Austin, TX 78713-7819
www.utexas.edu/utpress/about/bpermission.html

∞ The paper used in this book meets the minimum requirements
of ANSI/NISO Z39.48-1992 (R1997) (Permanence of Paper).

Library of Congress Cataloging-in-Publication Data

Carter, Keith, 1948–
A certain alchemy / Keith Carter ; introduction by Bill Wittliff ;
afterword by Patricia Carter. — 1st ed.
p. cm. — (Southwestern & Mexican photography series.
The Wittliff collections at Texas State University in San Marcos)

ISBN 978-0-292-71908-8 (cl. : alk. paper)
1. Photography, Artistic.
2. Carter, Keith, 1948 – I. Title.
TR655.C37 2008
779.092—dc22

2008011501

Book and jacket design by Bill Wittliff, DJ Stout, and Julie Savasky.

TO PC

Silver apples of the moon,
Golden apples of the sun.

ACKNOWLEDGMENTS

All artists I know need the work of others. More importantly perhaps,
we all need the friendship of others. I've been making photographs now for over
three decades. Occasionally the road traveled was paved with gold. Other times the
Angel of Mud grinned and mired my wheels. But it would have been a rutted and
rocky journey indeed without the people who have made life such a pleasure:

Patty and David Cargill

Katharine Carmichael

Will Carter

Stephen Clark

Jo-Al and John Donovan

Cathy Edleman

Missy and Burt Finger

Mauro Fiorese

Horton Foote

Gail Gibson

Jane and Hugh Goodrich

Amy Graves

Howard Greenberg

Roni McMurtrey

Joan Morgenstern

John Spellos

Cathy Spence

Jason and Liria Staton, Lauren and Larin

Doug and Janna Staton

Meagan Staton

DJ Stout

Connie Todd

Anne Tucker

Clint Willour

Sally and Bill Wittliff

Thank you to my sisters and brothers, and their families:
Eve, Annie, Laura, Katie, Bill, and Joe.

Many people are responsible for the production of a book.
Thank you Joanna Hitchcock, Theresa May, Ellen McKie, and Dave Hamrick
at the University of Texas Press. I am particularly grateful to The Wittliff Collections
for their continued support, and to DJ Stout and Julie Savasky of Pentagram
who collaborated with Bill Wittliff in the design of this volume.

My affection and gratitude to my colleagues and students, past and present,
who have made this such a sweet old world.

THE SOUTHWESTERN & MEXICAN PHOTOGRAPHY SERIES

This series originates from

THE WITTLIFF COLLECTIONS,

an archive and creative center established at
Texas State University in San Marcos
to celebrate the cultural arts of the region.

BILL WITTLIFF

Series Editor

Located on a soggy strip of land hometown Beaumont's claims to hurricanes, the Big Thicket, monster blues musicians (Janis Gatemouth Brown to name a from Houston to New Orleans off before Lake Charles toward might find yourself

near the Gulf of Mexico, my
fame are tied to the oil industry,
Lamar University, and some
Joplin, Johnny Winters, and
few). If you were driving east
and decided for some reason to turn
nowhere in particular, you
in Beaumont.

Among his earliest memories is waking in the middle of the night from a pallet on the floor to see a small orange safelight above the kitchen sink where his mother stands. He steps over beside her then raises himself on tiptoes to watch in wide-eyed wonder as one of her photographic images slowly comes up in the developer. It is magic; indeed it is a miracle — and to this day my friend Keith Carter has never gotten over it.

His father had deserted them when Keith was in preschool. The Episcopal Church gave his mom enough money to keep her little family intact until she could get on her feet. Earlier, before marriage, she had made a bit of a living photographing college and sorority girls in the Midwest. Photography was essentially the only skill she knew that might put bread on the table for her daughter and two young sons, so she picked up her camera again and opened a small studio on Calder Avenue, there in Beaumont. Her forte was children. She'd run $5.95 specials on the weekends, sometimes photographing as many as sixty kids in a single day, then stay up night after night making the 5x7 black-and-white prints in the kitchen sink. It was tough going, but she never complained, never once uttered a bitter word against her former husband for leaving them in this fix. Whatever void his absence left in his children's lives she filled as best she could. . . .

The little studio prospered. In time, Keith — half-heartedly limping toward, of all things, a business degree at the local college — became his mom's part-time framer. One day he chanced upon a photograph she'd made of a little girl wearing a straw hat and holding a basket of kittens. It was a cliché of course, but it stopped him in his tracks. He got down on one knee for a better look. It was not so much the picture itself that grabbed him, but rather the light. The image was backlit and everything in it was absolutely rimmed in light. To Keith it seemed everything was radiating and glowing from within. It was a small epiphany: he had never before realized light — simple everyday light right out of the sky — could be so stunningly, so supremely beautiful.

INTRODUCTION **BILL WITTLIFF**

On just such small and seemingly chance events are lives sometimes shaped and directed.

That afternoon he borrowed his mom's camera and began taking pictures of his own. In truth, those first photographs were no better than one might expect from any beginner, but his mom would study them and say things like "You have a nice eye," or "That's an interesting composition," and Keith felt encouraged and kept at it. He thumbed through photographic magazines until they literally fell apart in his hands, he accumulated a mass of misinformation from the guys at the local camera shop, he devoured every book on photography he could find, and he worked, worked, worked. David Cargill, a sculptor and friend, became a mentor and made his vast art library available. Keith soaked it up like a sponge. Cargill would talk to him about artistic things like form and space, about taking a three-dimensional subject and putting it on a two-dimensional surface. Keith had to go to the dictionary to look up dimensional. Cargill showed him books — Vermeer and other artists who painted much as a photographer sees — then Cargill loaned him Cartier-Bresson's *The Decisive Moment*. It was the first book of really serious photography Keith had ever seen and it electrified him and expanded his still-forming sense of what photography could do. Here was form, concentrated use of space, wit, pathos, content — all infused with intelligence. The realization came rushing up that photography could be art — and the idea set him on fire. He knew what he wanted to do with his life now. He wanted to make art

He kept working. He converted his apartment kitchen into a darkroom just as his mom had done all those years before. He made every mistake it's possible to make with film and paper and chemicals, but some of those mistakes showed him interesting ways to go — ways not in the magazines and instruction books — and little by little he began building his own methodology. He lived and breathed photography. Everything else in his life pretty much took second place, though he still traveled with his mother when she made her twice-a-year trips around the state to photograph the children of her growing clientele. He loaded her film and played the clown to make the unruly little monkeys keep smiling long enough for their likenesses to be taken.

At this point he'd never even seen a fine black-and-white photographic print, so he sold his battered old Triumph motorcycle and bought a Greyhound bus ticket to New

York. It took two butt-bouncing days to get there. He found a cheap room in the Albert Hotel down in the Village, then spent hours each day poring over the luminous prints of the masters in the Museum of Modern Art: Ansel Adams, Alfred Stieglitz, Weston, Atget, all of them — even his hero Henri Cartier-Bresson. As it happened the MOMA opened a retrospective exhibit of Paul Strand's work while he was there. Keith had never heard of him, but he simply couldn't get enough of Strand's prints. They were, many of them, dark and brooding; they were textured; and, though they were black and white, they had an aura of color about them. They were so beautiful, so appropriate to the various subjects, and oh, so very personal. They were exactly how Paul Strand saw the world. They were as much Paul Strand as were Strand's own fingerprints — and to Keith they seemed a mark still far beyond his grasp. But he shoved his doubts into some dark out-of-the-way corner and kept at it. It's important to understand that this was a young man working in almost the complete artistic vacuum of a modest oil refinery town in deep East Texas. Beyond his magazines and books and the occasional visits with David Cargill, there was no instruction and no feedback — and then came Pat

There's a saying I like enormously: Whatever you're looking for is looking for you, too. The catch, of course, is recognizing it when it pops up in front of you. Keith knew almost at first glance that Patricia Royer Staton, formerly of Trinity, Texas, was his other half.

Pat is a lady of great charm and wisdom and humor and independence; she is a lover of poetry and music and animals and art and good conversation — and she is a keen and sympathetic observer of all things human, whether high or low. So is Keith — and like Keith she isn't afraid of work. And work they did, though there were times when hacking out a sparse living shooting weddings and advertising layouts and children's portraits left Keith precious little time to pursue his own dream. It was frustrating; sometimes Keith would think maybe he should chuck the whole damn thing and just get a job. But Pat would tell him over and over, "No, that's why we're going through all of this, for you to make your own pictures." Her confidence in Keith cannot be overstated, nor can one overstate the influence that confidence had — and still has — on Keith. "Your pictures are important," she'd insist, "Keep making your pictures. Don't stop. You're getting there." And he was: his pictures were better than ever before and, too, through experiment and endurance, he'd become a master printer. But he felt he was still essentially making versions of pictures that had been done before by other photographers. He knew he had not yet found his own eyes, his own unique way of seeing — and he also knew that until he did, he had about as much a chance of making real art as he had of hitting the moon with a handful of dry oatmeal.

Then two events sort of fell on top of each other. He was down in Mexico walking through an old cemetery. There were pictures everywhere as there are in almost every cemetery anywhere, but Keith had already made those pictures dozens of times before and had no interest in making them again. Then he happened to glance up: above him the branches of a tree were festooned with tattered wind-blown streamers. To Keith they looked like wispy ghosts trying to take flight. He instinctively raised his camera just to see what they'd look like isolated in the viewfinder, and he was instantly struck by the symbolism. No longer was he seeing the objects themselves, but rather the meaning — the human content — they represented. It was a fine moment; indeed it was another small epiphany: photography could do far more than simply recording external fact

He photographed in a fiery heat for about five minutes, knowing full well the pictures wouldn't be very good, but sensing that he had just taken the first step through the door into that larger realm of his own seeing. Henceforth, the "thing itself" held little interest for him. He knew what he was after now: the inside of things, the symbolism that registers not so much in the intellect, but rather resonates in those deeper and more authentic chambers of the subconscious.

It was his first glimpse through his own true eyes, and the possibility of making art loomed: he knew how to look now, he just didn't know where. Shortly thereafter it would be that fine gentleman and celebrated playwright Horton Foote who would inadvertently tell him

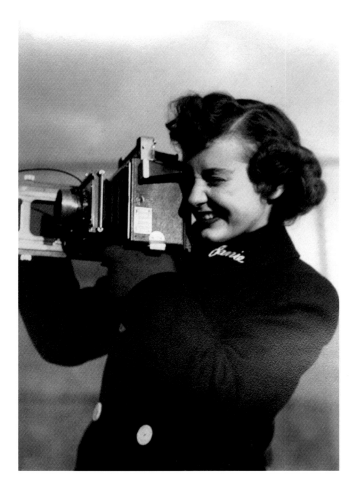

Top: *Family photograph of Keith's mother, then Jane Davis, circa 1944. Photographer unknown.*

Bottom: *Family photograph of Keith's father, Keith D. Carter, circa 1948. Photographer Jane Davis Carter.*

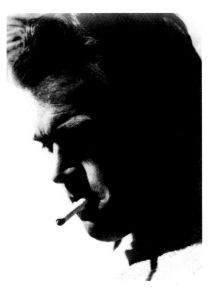

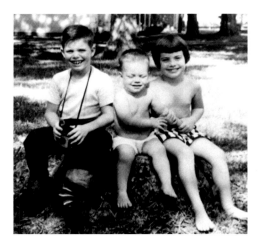

Keith was at a film festival in Galveston, fighting to stay awake at a panel discussion and wondering what the hell he was doing there anyway. Then it was Horton's turn to speak. Horton said that when he was a boy in Wharton he had wanted to make art, and he was told that to make art you had to know the history of your medium, you had to know everything that had come before you. Keith nodded to himself. Yep, he thought, I know that. Horton went on: you had to be a product of your own times and write about your own generation. Keith thought, yep, I guess so. But then Horton said, "But for me that wasn't enough. For me, I had to belong to a place." Keith sat straight up. "Oh Jesus, belong to a place . . ." He'd never really thought about it. He'd always blindly assumed he'd eventually have to go across great oceans to far-off lands to make important pictures. But now . . . well, now he realized he was already living in one of the most exotic places on earth, a place chock-full of history and variety and beauty and meaning and potential. . . . It was almost like hearing his own heartbeat for the first time and he said as much to Pat. She gave him a funny look, surprised he was just now catching on to what his own piece of ground had always held and was holding still. "Well, yeah," she said.

But for Keith it was a revelation, and he took everything he had learned over the past fifteen years and began applying it to what before had seemed the most ordinary of places and things. . . .

He was ready to be astonished now, and the world he had known all his life bent to serve him. He found wonder everywhere — in a fly on a backdrop, in a naked light-bulb hanging on a twisted wire, in an old woman watering her grass with a garden hose. All things became equal before his lens. His was a democratic way of seeing, and he placed no hierarchy of values on his subjects, made no distinctions in terms of importance. To Keith, a person or an animal or a tree or a shimmering reflection in a body of water were all notes in the same grand symphony. For the first time he felt he was really finding his own true self as a photographer.

On their tenth wedding anniversary Keith and Pat hatched the idea of traveling to a hundred small Texas towns — each with a catchy name — and making one, and only one, photograph in each. Most of the towns — towns with names like Earth and Splendora and Rising Star — were way out there in the middle of nowhere. There were no hotels, sometimes not even a hamburger joint or a public restroom — and there was no time ever to just sit around and wait for the best light. They'd hit town, find the picture Keith wanted to make, shoot it in whatever light was available, then go hightailing it down the road to the next town. The one-town-one-picture commitment they'd made forced Keith to try things with light and composition he'd never dared try before. What he found in the process was creative license and freedom — and a whole new confidence in his own abilities as well. He knew now he could make a picture anywhere, anytime, and under any circumstances. In 1988, the pictures were published in *From Uncertain to Blue,* Keith's first book. Horton Foote wrote the introduction, and Pat documented the whole adventure in a beautifully felt and delightfully written section of notes which accompanied the images.

Several years later, in 1992, Keith made "Fireflies," in my view his first truly transcendent image. It is a photograph of two young boys in a creek bottom. They are leaning over a jar held between them. Light glows from inside the jar — the magic light of the fireflies the boys captured at dusk on that warm summer evening. It is a picture of Keith and his brother. It is a picture of my brother and me. It is a picture of your brother and you. It is a picture of all of us when we were still new in this world, still able to be mesmerized by the most ordinary and daily of things. It is a picture to conjure memories that in most of us have lain dormant for an eternity — remembrances of having once been at one with the natural world. Only at a glance at "Fireflies" and we're back there again, our eyes full of wonder, walking barefoot through that continuous miracle that is life, and we are exalted by the experience. That is what art at its most sublime can do.

Other important images followed. Keith was trying to express ineffable things now, things like his love of music and myth and mystery, things like the internal lives of

Top: *Family photograph of Keith, Bill, and Katie Carter, Beaumont, Texas, circa 1954. Photographer Jane Carter.*

Bottom: *Diddy Waw Diddy 1986*

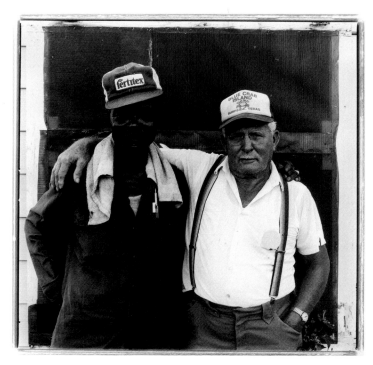

animals, things like those fragments of universality that can sometimes be gleaned from between the lines of great poetry. The resulting photographs were not so much asking you to observe, as before — now they were inviting you to participate, to open the door and come on in.

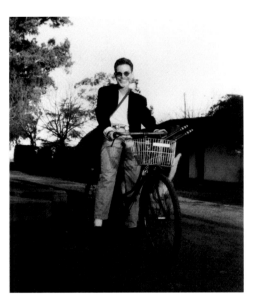

Look at "Open Hand" or "Wizards" or "Boy and Hawk"; look at "Radio Flyer" or "Phonograph" or "Hillside" or "Mezzanine" . . . It's not that these pictures are telling you things you didn't already know, but rather that — like "Fireflies" — they're reminding you of things you've deep down always known but somehow forgotten, because life has a nasty habit of simply becoming too daily, too dependent on thought at the expense of feeling. These photographs fill you up and become a part of your inner life, depending on the depth of your own capacities. The proof is that the first response to the best of Keith's images — and to all great art — is almost always instantly YES, an instant recognition of that which was already there inside you on some profound connecting thread that runs through the very core of all of us fellow travelers on this spinning globe. That's how great art in any medium slips past all boundaries of time and space and cultural differences to deliver the goods.

It's a decade and more since Keith found his eyes while wandering through that little Mexican cemetery. His images are regularly celebrated in exhibitions all over the world now. Major collections — both public and private — treasure his prints as they do their holdings of other masters, including, yes, Henri Cartier-Bresson and Paul Strand. Prestigious galleries vie to represent him. Amateur and professional photographers alike pay hard cash to attend his workshops; students fill his classes at Lamar University; and magazine editors seek him out for portfolios and articles. Certainly Keith finds all this attention pleasing, but I do not believe he will ever find it entirely satisfying. At heart he is a working man; he's up at first light each morning with his talent and his tools, trying to make art out of whatever the world and his imagination conjure up at the moment. If there is satisfaction for Keith it's in the doing of the work itself, in the never-ending search to see deeper and fuller into the heart of the matter. This is a risky business; it's much easier to fall flat than it is to succeed. All true artists live daily with the fear that they may not be up to the challenge. Some reach certain plateaus and rest on their past accomplishments. Others embrace their fear and use it like a whip to drive themselves forward toward what may finally well be unobtainable anyway. This is what Keith has always done and is doing still. A recent effort — photographing graveyards of military airplanes and ships — is a prime example. Where others see those mothballed behemoths as nothing more than decaying remnants of the past, Keith dares to see in them fellow-creatures — fellow-creatures that once soared and sailed and voyaged, perhaps heroically, but that now lie broken and abandoned, desperately gasping for one last great breath of air like some heartbreaking empire of lost souls. Just possibly, one might argue, these images represent memories of our own future. . . .

I do not know where Keith's passion to see will take us next. I do know Pat will be the first one there with her always insightful and honest reaction to the work; and I know, too, that hit or miss or in-between, Keith will soon be off again on his great adventure of making art. That is his bent: to keep moving, to keep working, to keep challenging himself to go ever deeper, to keep risking the horror of losing his way because there's no map or chart beyond his own instinct to guide him — and there are never, ever, any promises in the end. Believe me, you've gotta have a lot of ass in your britches to live with these kinds of uncertainties on a daily basis.

So what is it that relentlessly drives Keith Carter? For a certainty he has a soul-deep itch to create, to make art, to elevate others and be elevated himself by the issue of his own gift — but I cannot say from what source that itch in Keith or in any other artist comes, though there are times I am convinced it is self-chosen before the artist ever draws breath and the wish granted by some benevolent god. Finally, of course, it is unknowable — it is one of the great mysteries. And perhaps the proper response to such great mystery is simply to stand there in awe of the work — as I do of my friend Keith's — and gratefully accept its blessings.

Top: *Keith on photographic excursion outside Buenos Aires, Argentina, 1995. Photographer unknown.*

Bottom: *Fireflies 1992*

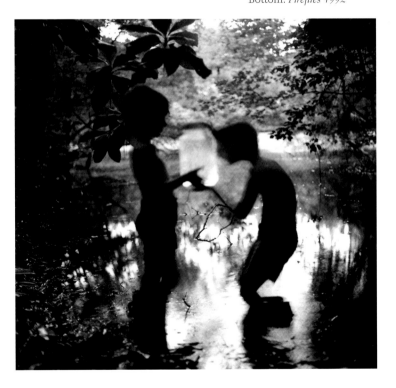

THE PLATES

I was around six when I was

disappearing coins or rabbits

would turn our apartment kitchen

make a pallet on the floor for

Sometimes I would stand on a

before falling asleep in that

orange light is the

first introduced to magic. No
pulled from a hat. Mom
into a darkroom at night, and
my brother and sister and me.
chair and watch her make prints
peculiar light. I still think
color of magic.

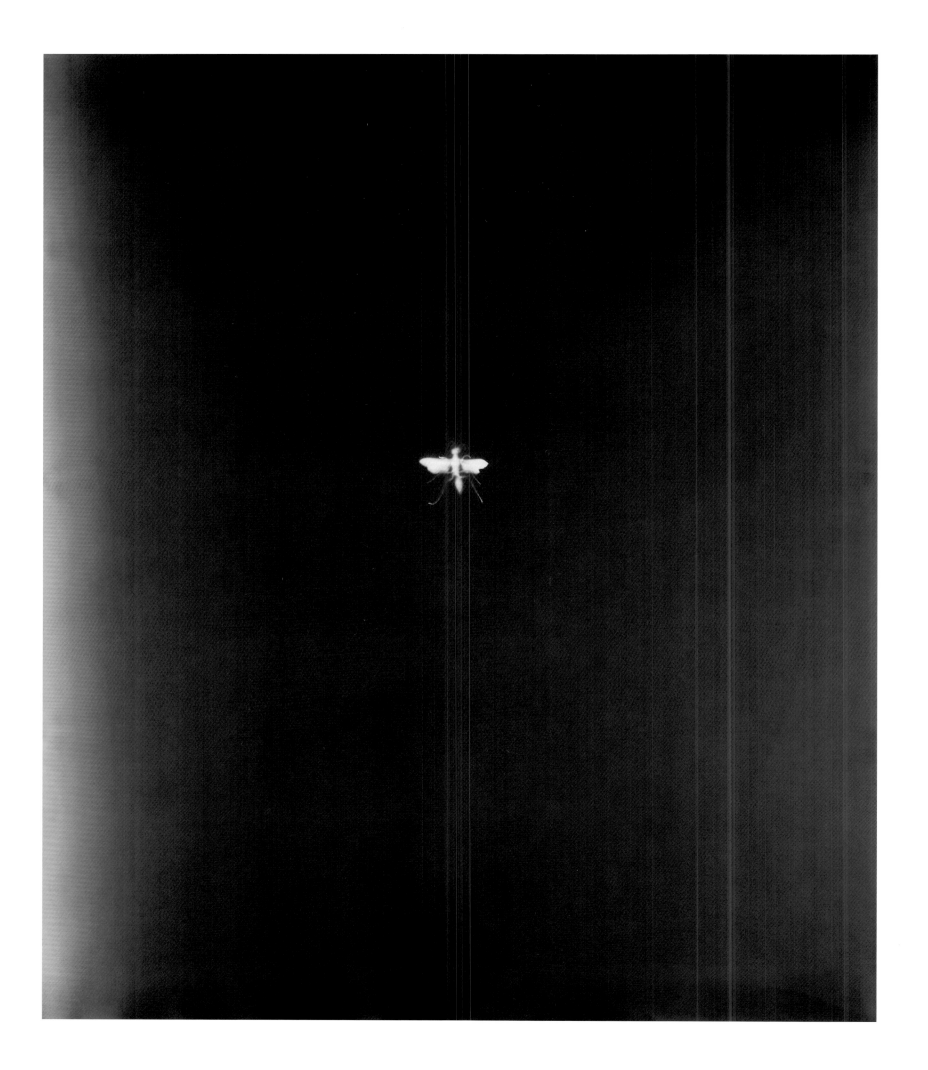

3 **DAINTY WASP** 2 0 0 2

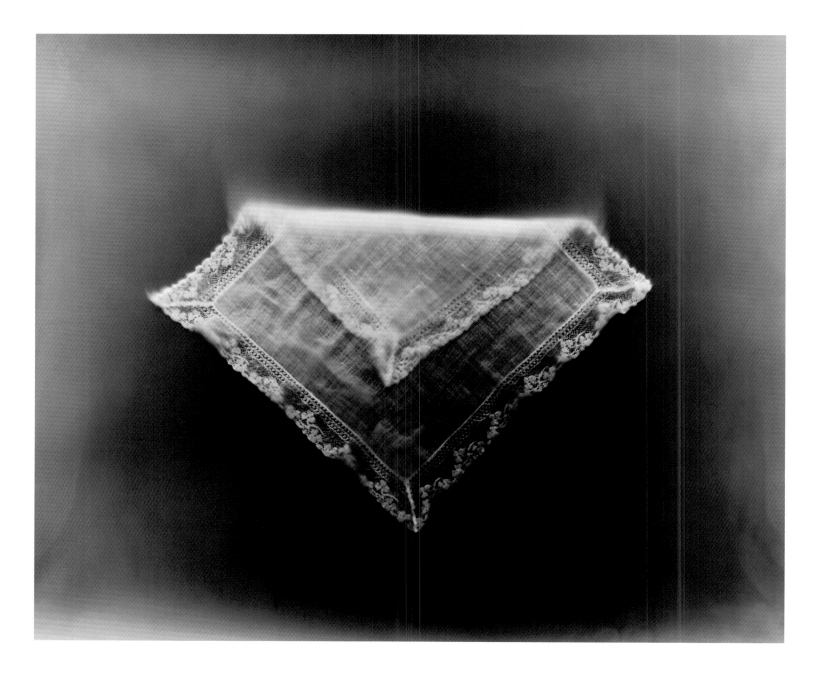

4 **AURELIA'S HANDKERCHIEF NO. 2** 2002

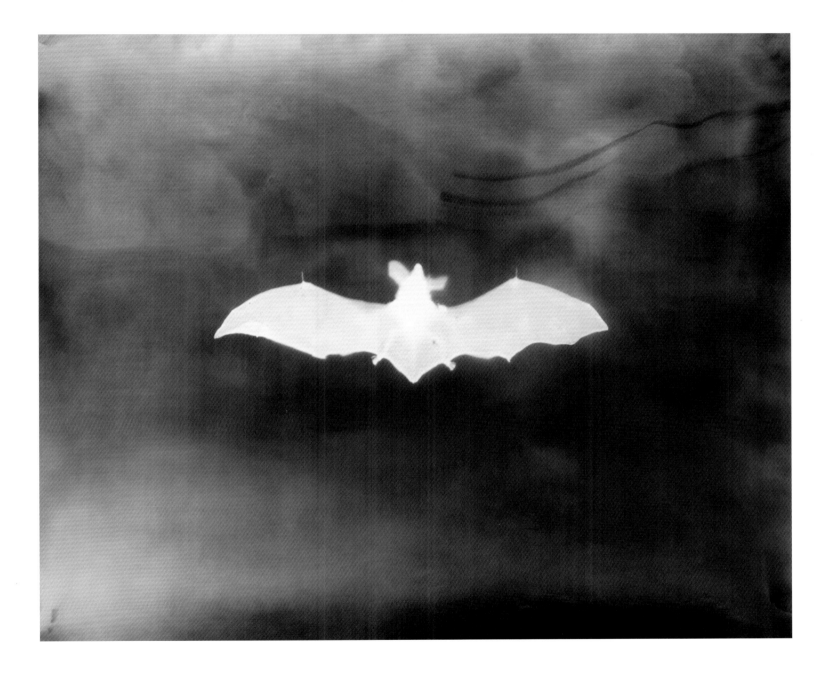

5 **BAT** 2002

6 **LUNA MOTH** 2002

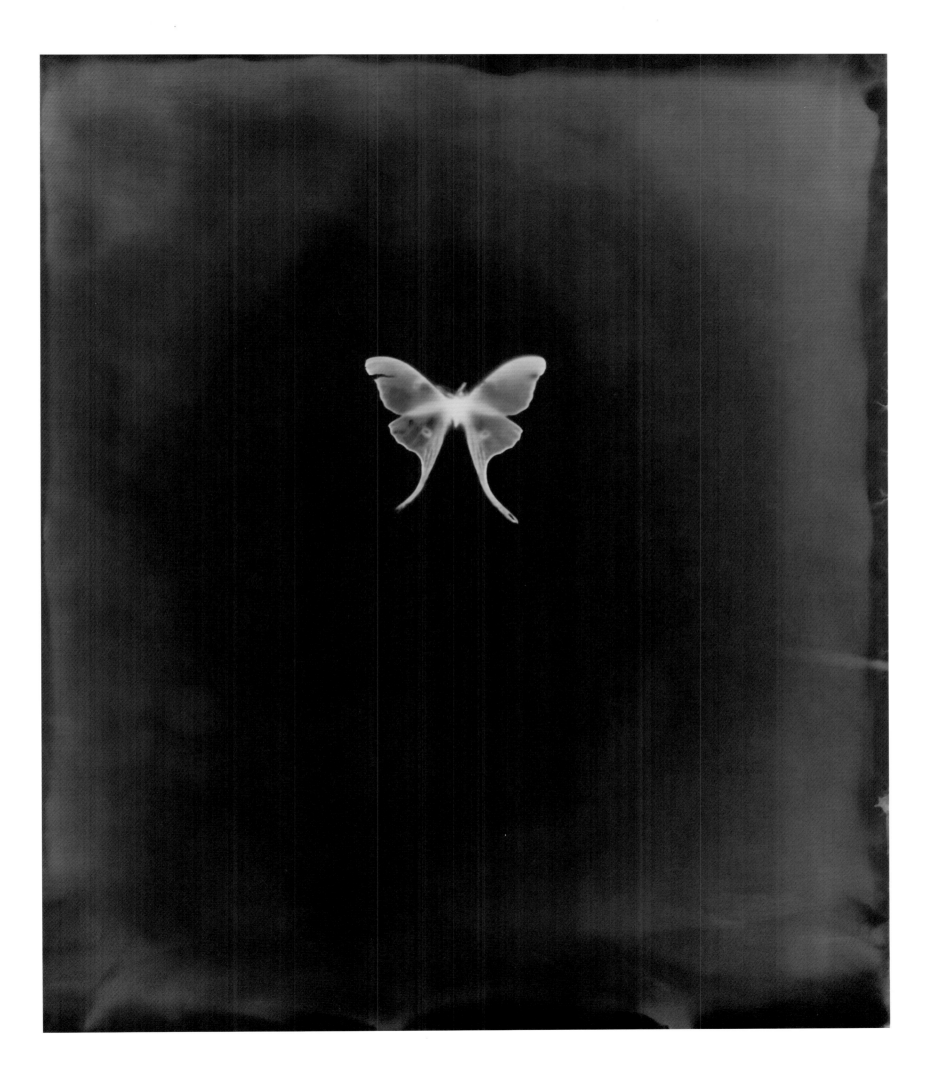

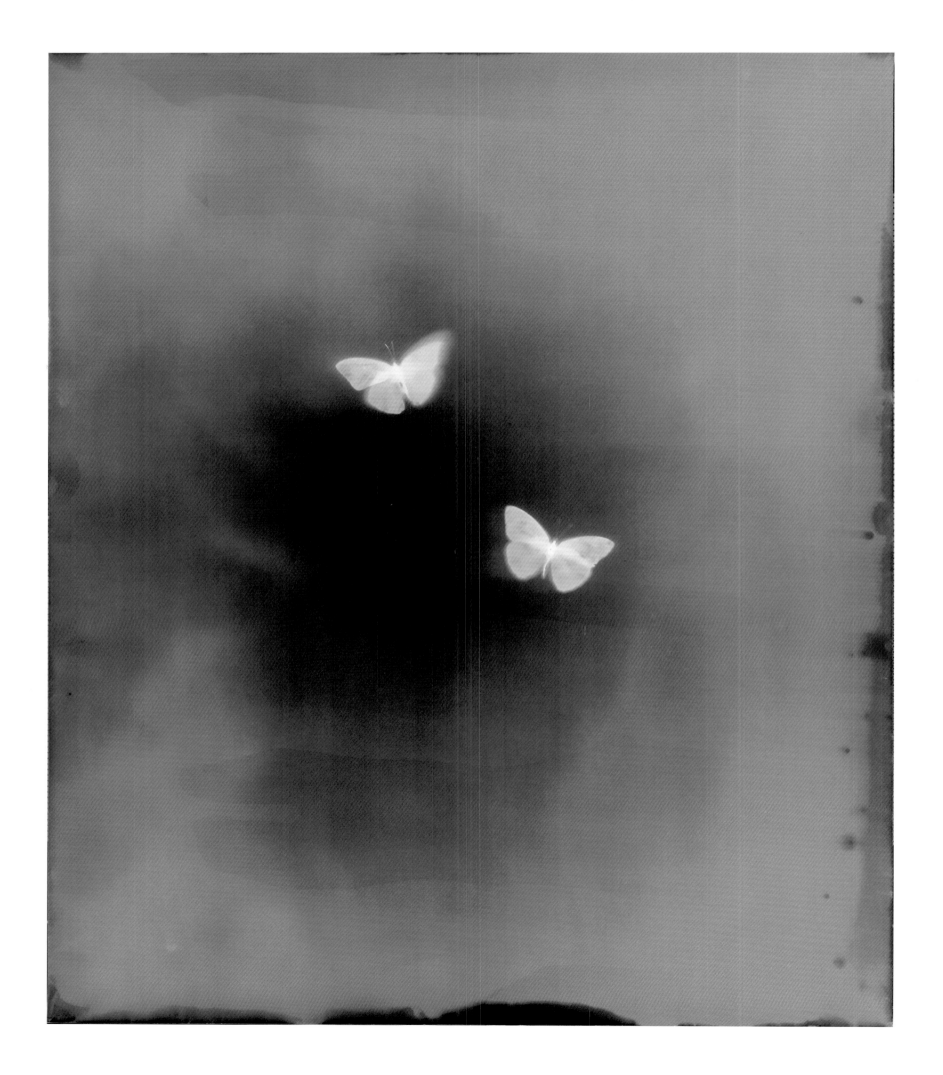

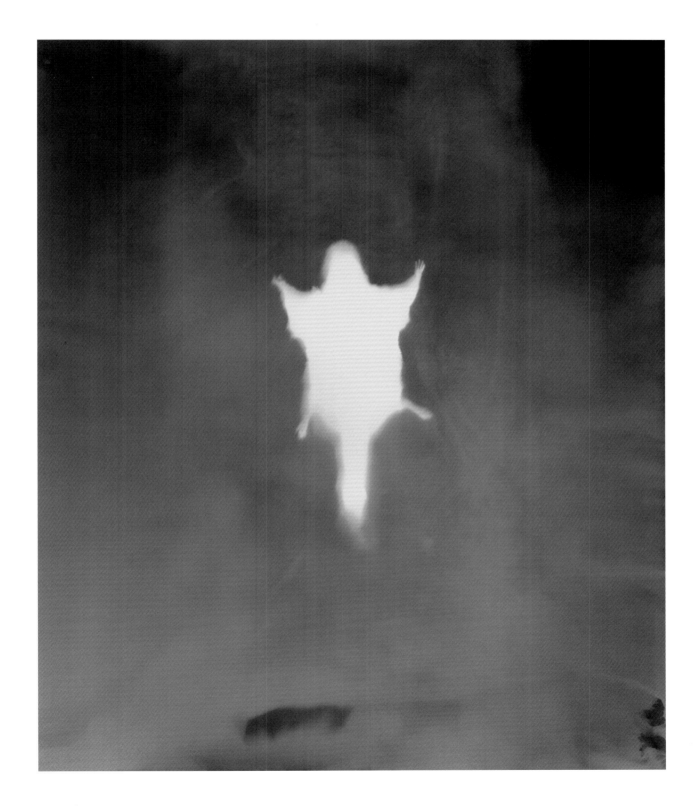

7 **TWO SULPHURS** 2002 | 8 **FLYING SQUIRREL** 2002

9 **FAMILY OF SPHINXES** 2002

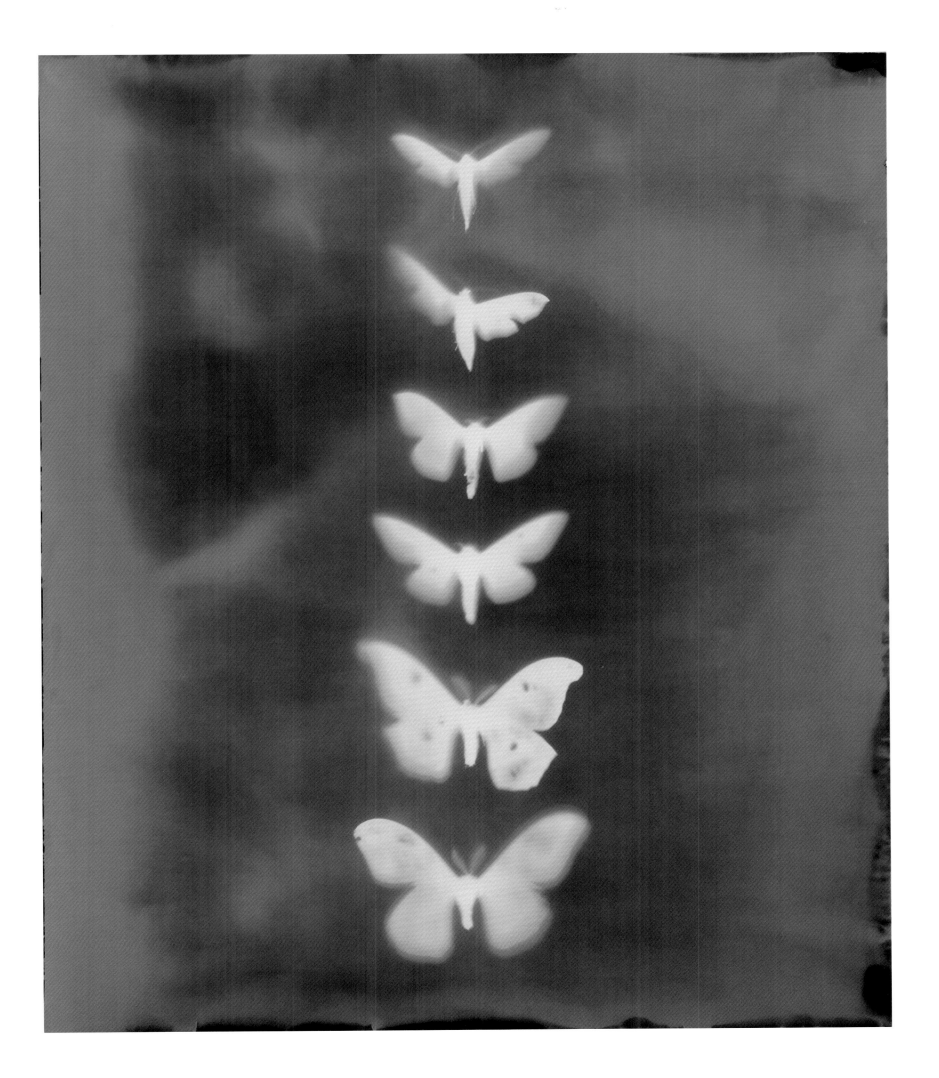

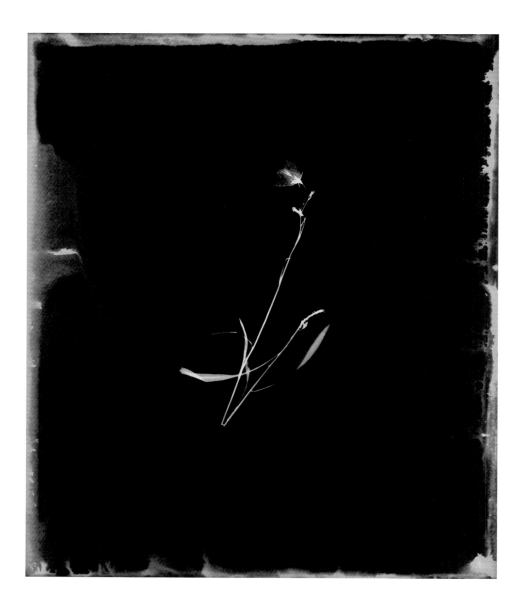 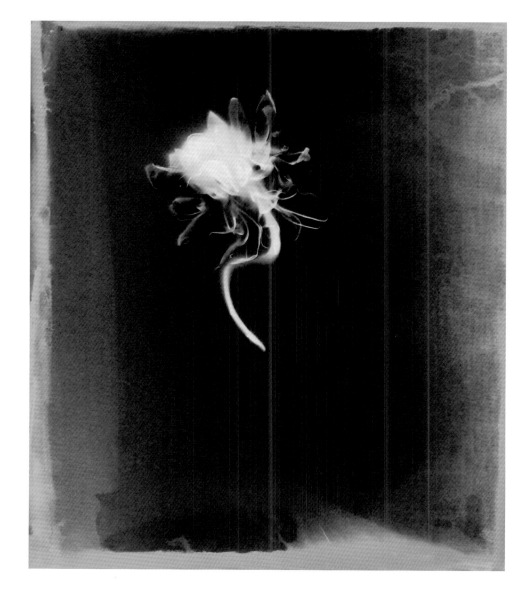

10 **CAMPANULA NO. 2** 2002 | 11 **NIGHT BLOOMING CEREUS NO. 2** 2002

12 **PLANT SPECIMEN NO. 4** 2002

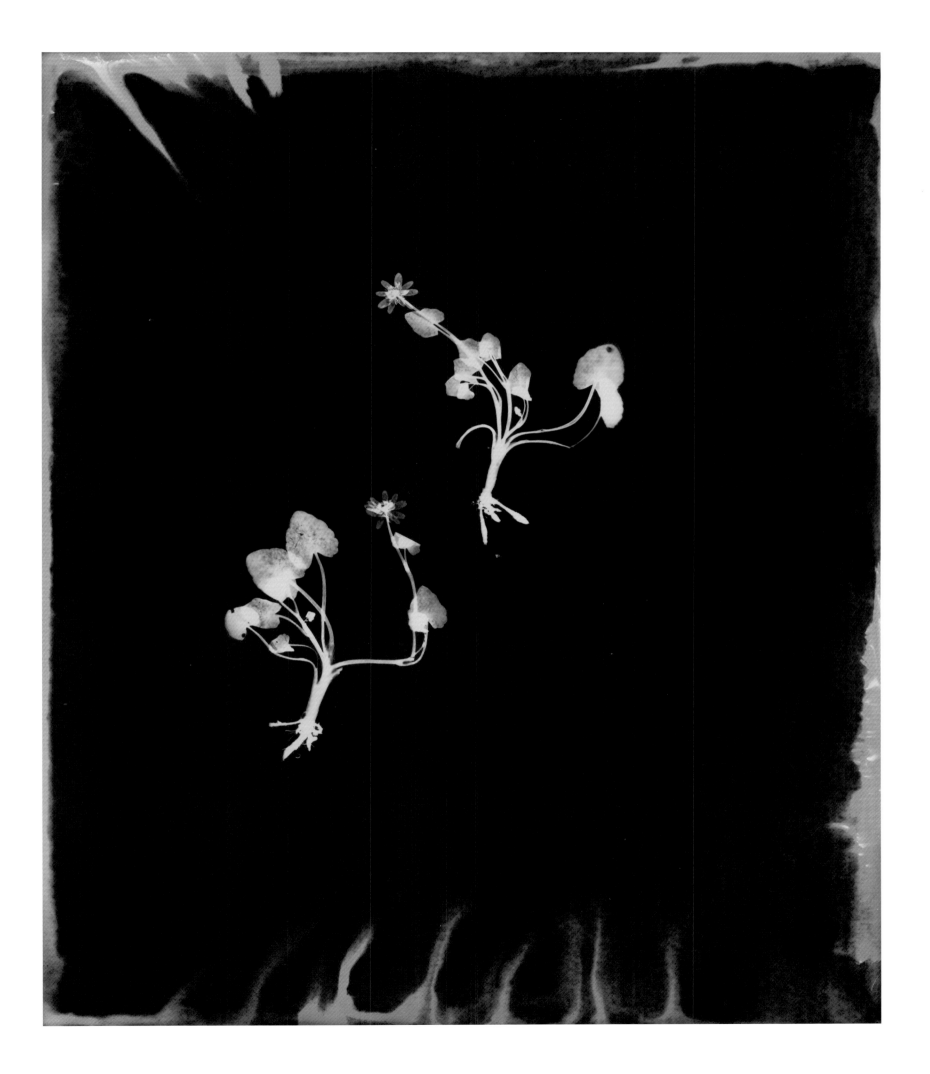

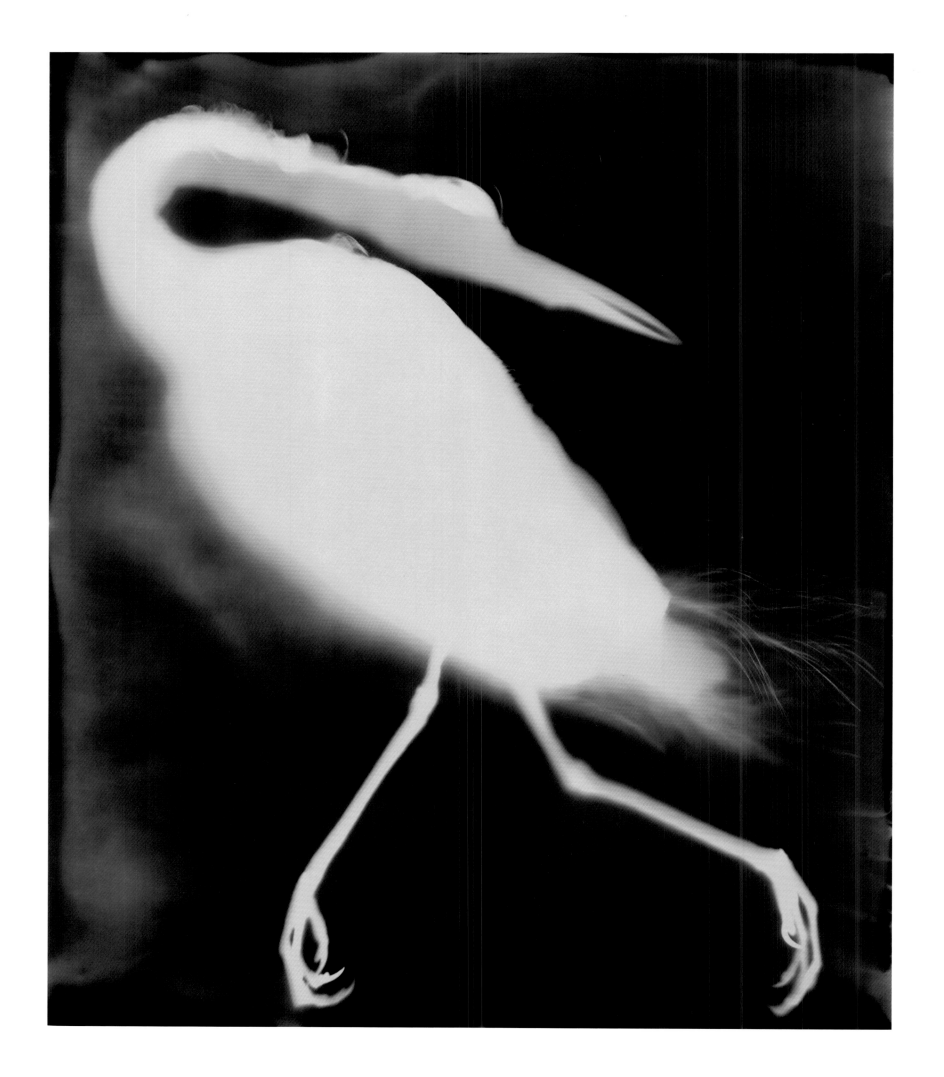

13 **BLUE HERON** 2002

14 **CROSSED FINGERS** 2002

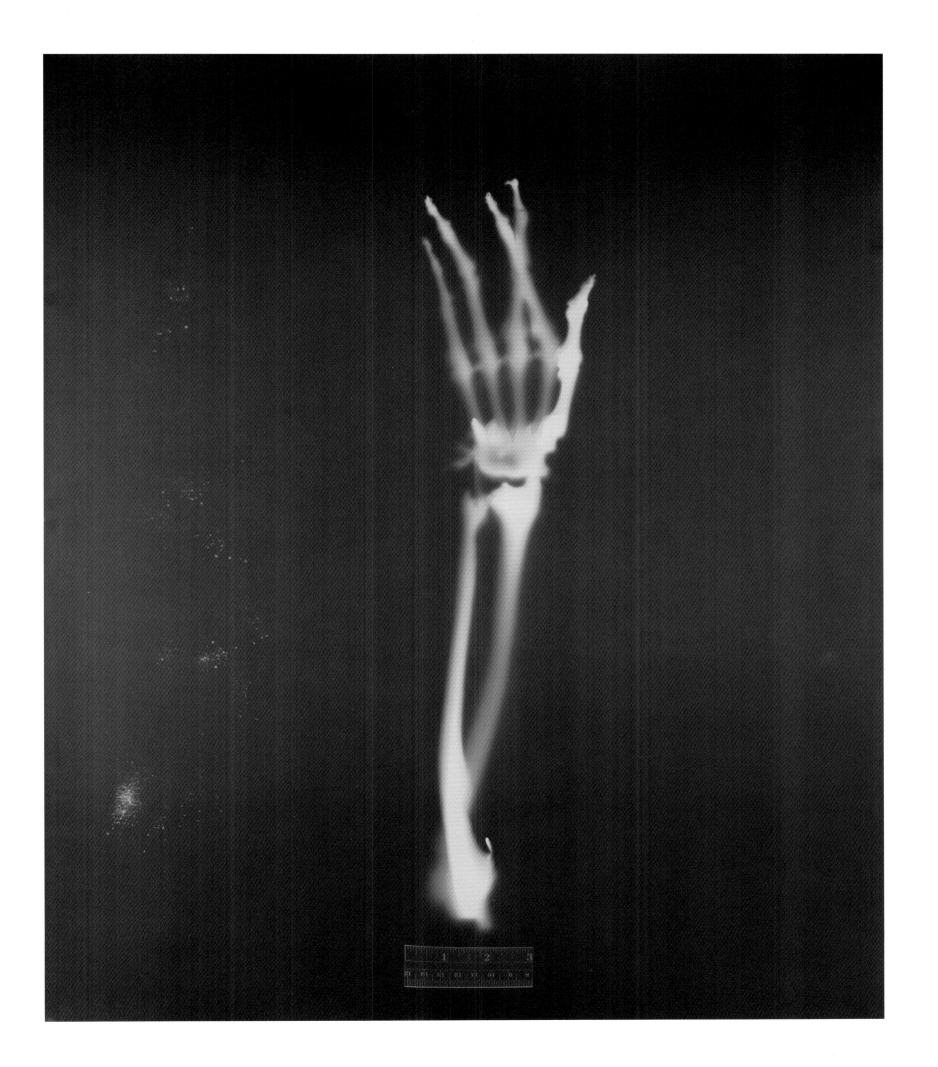

My photographs evolve people's lives, animals. I don't reality itself; I look around the moments—the ones that slightly awkward,

around folklore, literature, poems, just look at the thing itself or at edges for those little askew make up our lives—those lovely moments.

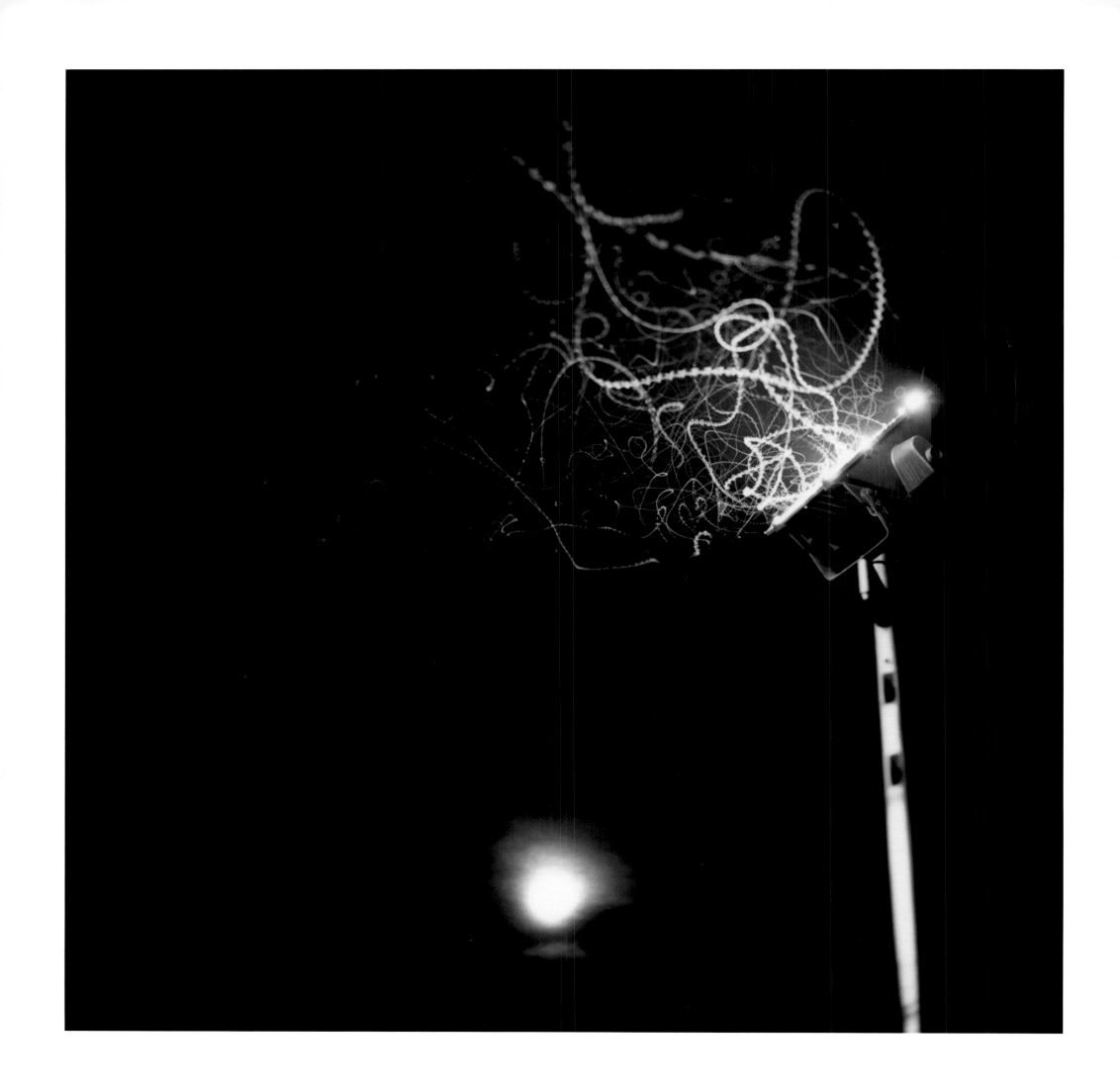

15 **LIGHT TRAILS** 2001

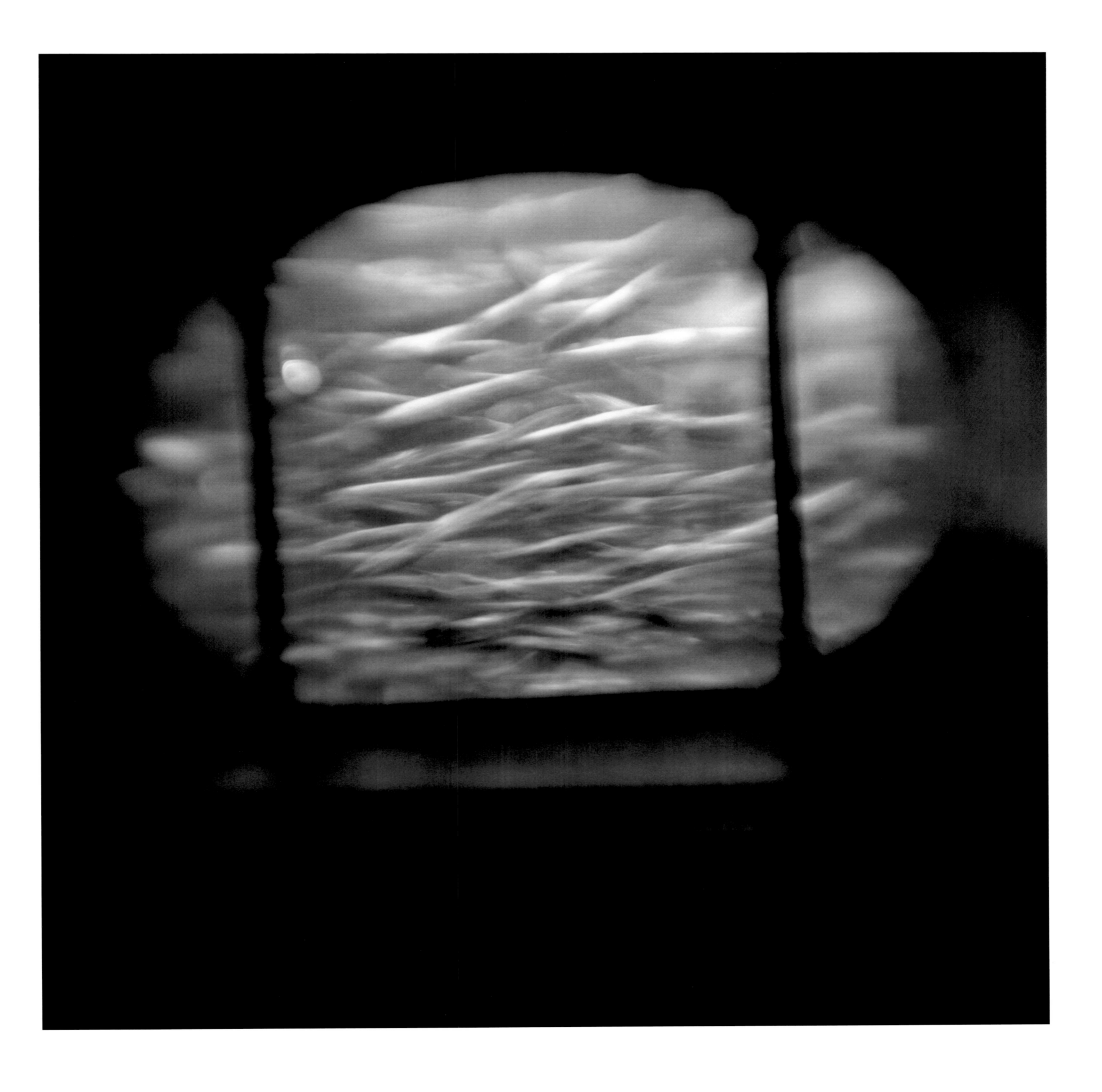

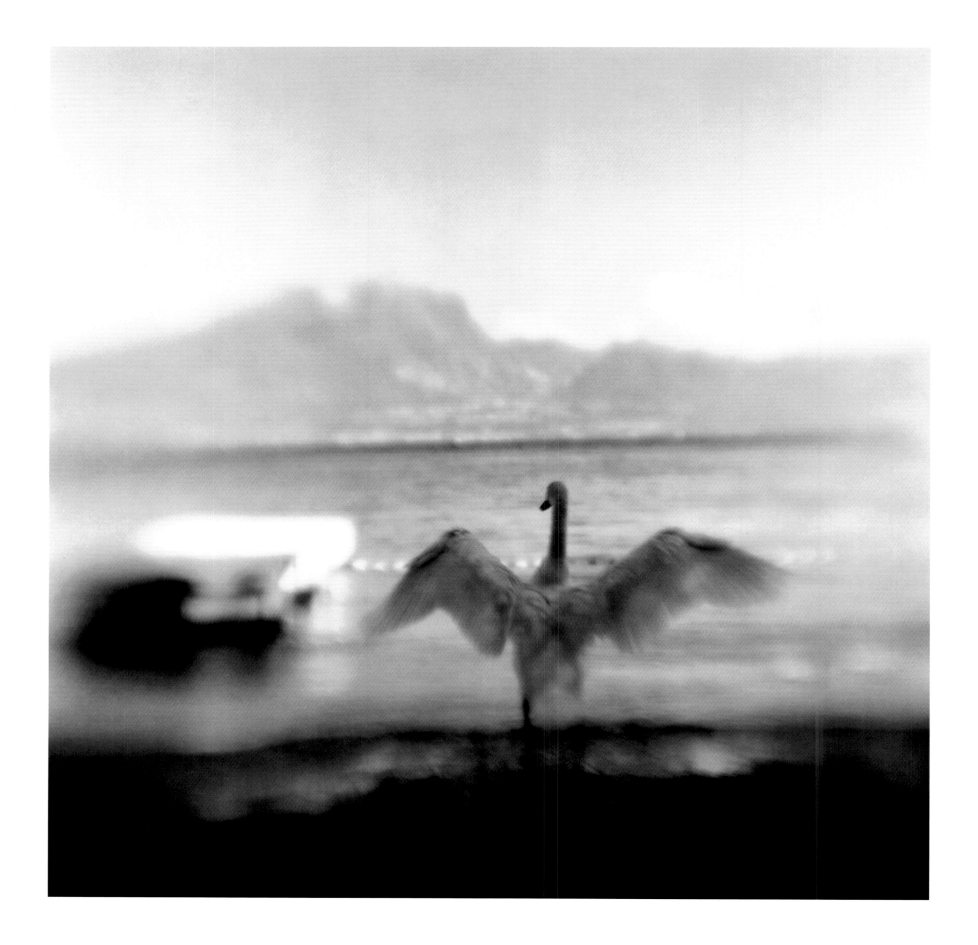

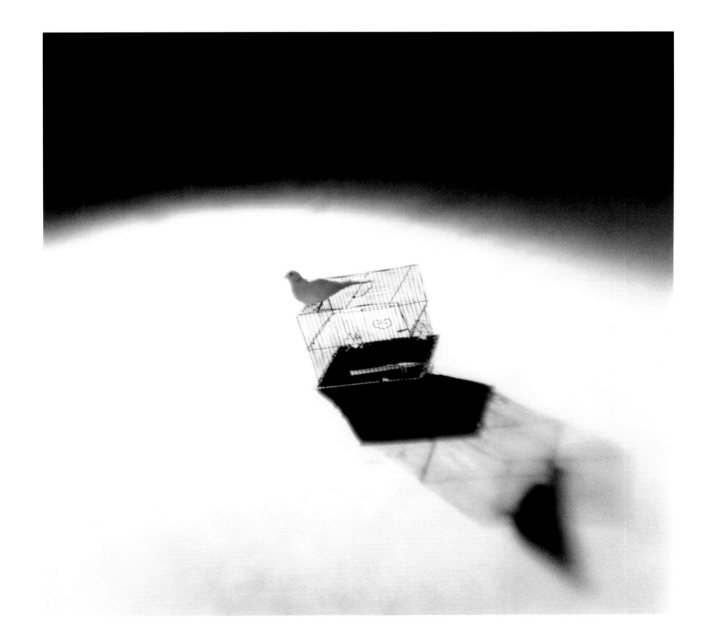

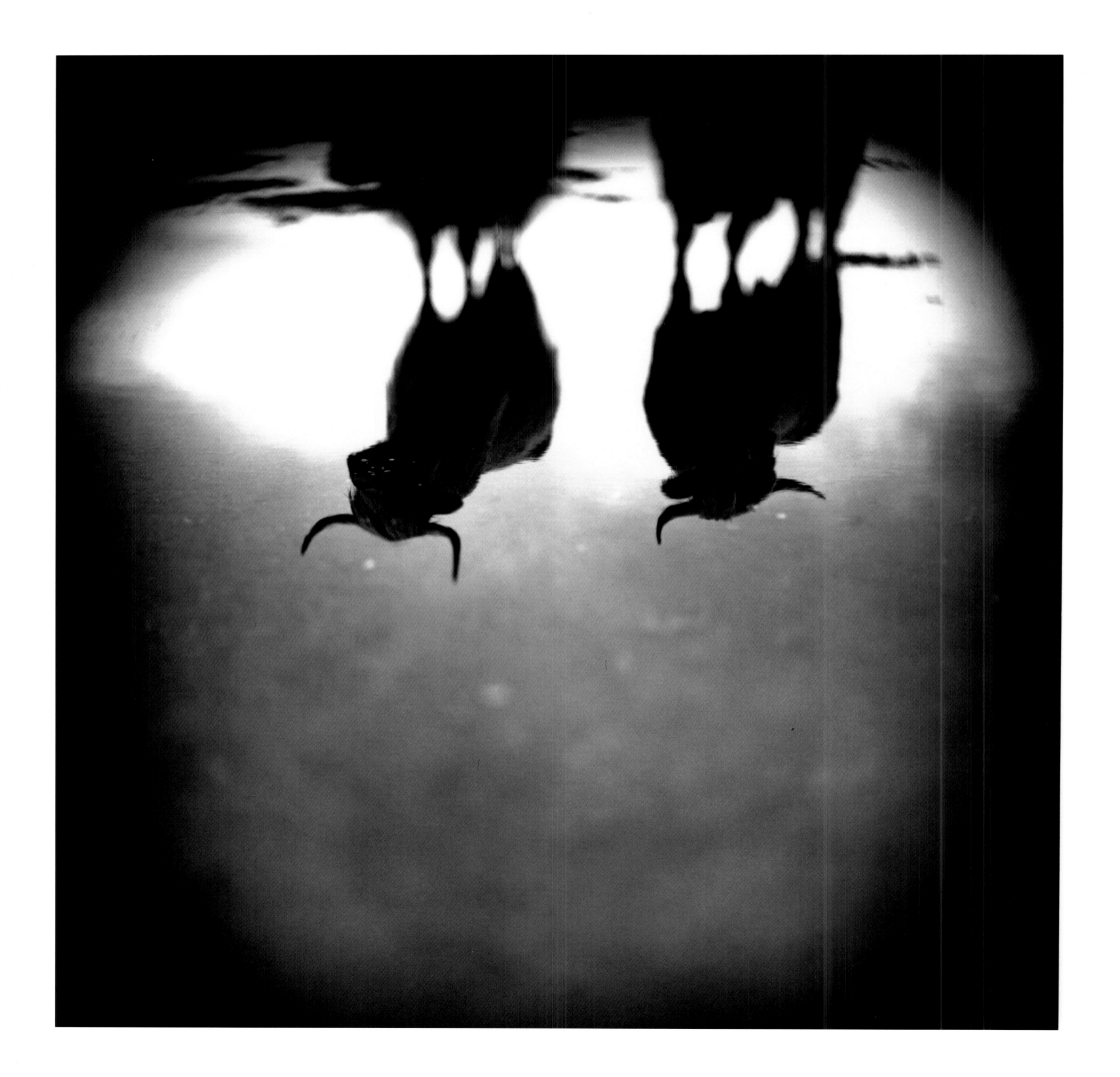

19 **TIDEWATER** 2000

20 **COTTON EYES** 2006

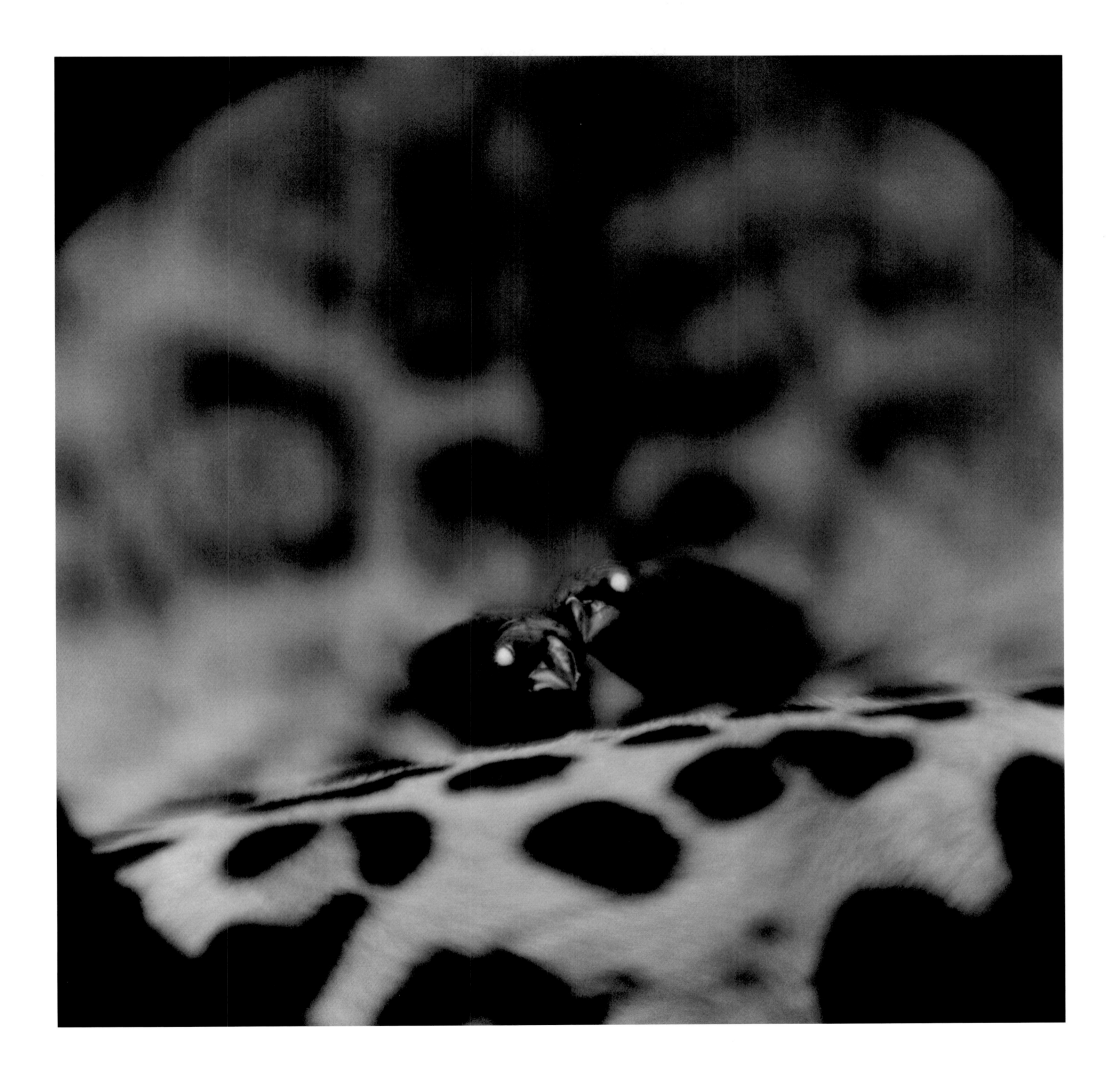

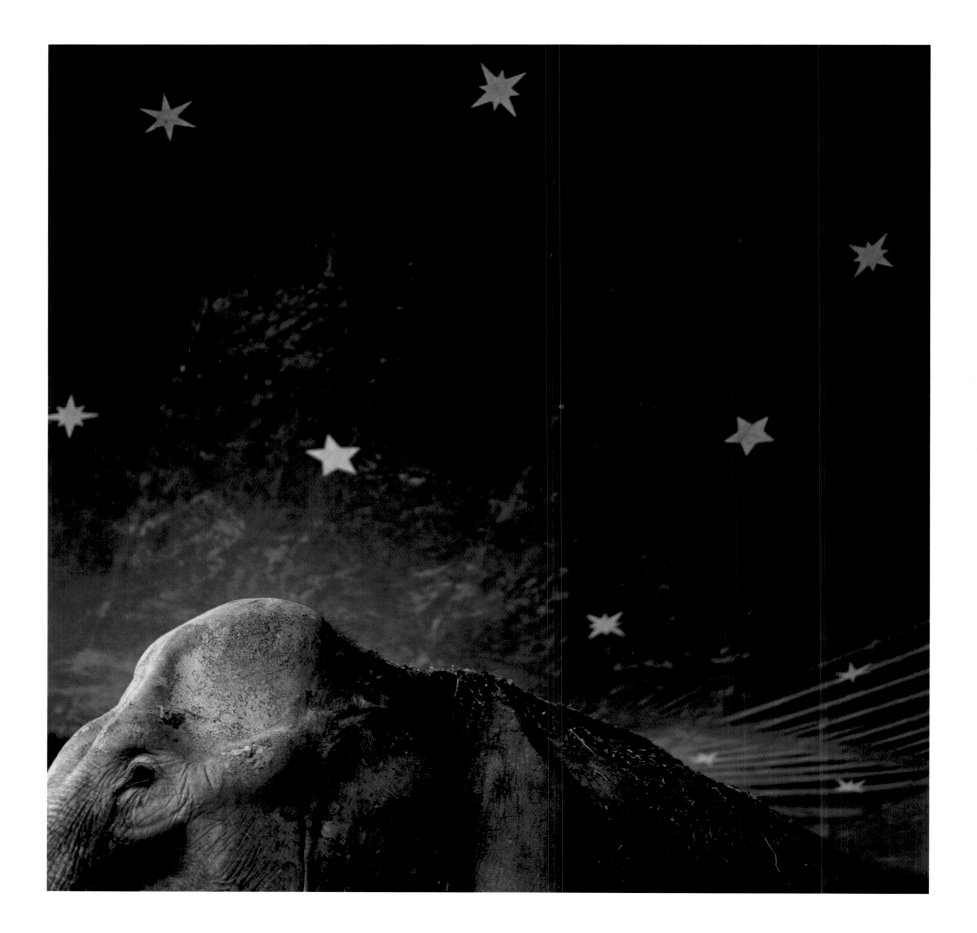

21 **ELEPHANT AND STARS** 2001 | 22 **TWO DEER** 2004

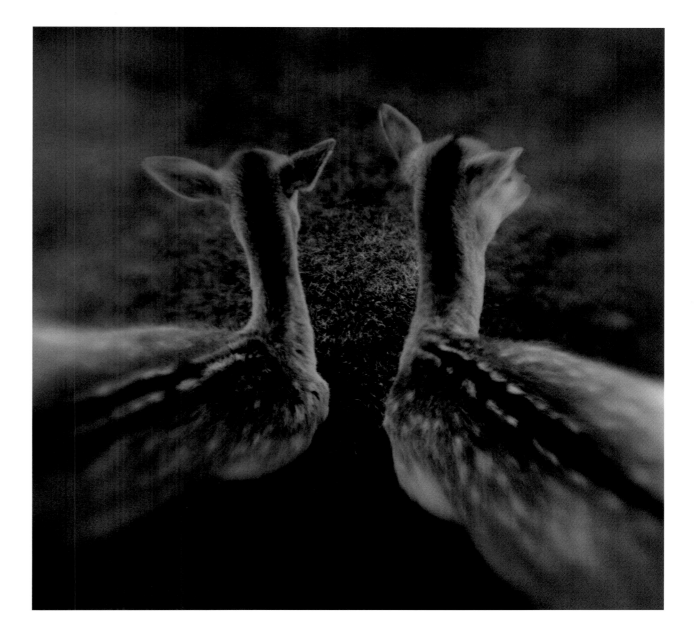

23 **BIRD'S EYE** 2006

from the storytelling culture make images with an implied tales of dog ghosts, bottle trees, mythology, deep-south children, my own white background, and tried to weave structive, eloquent, and enduring.

26 **NORWEGIAN PONY NO. 1** 2005

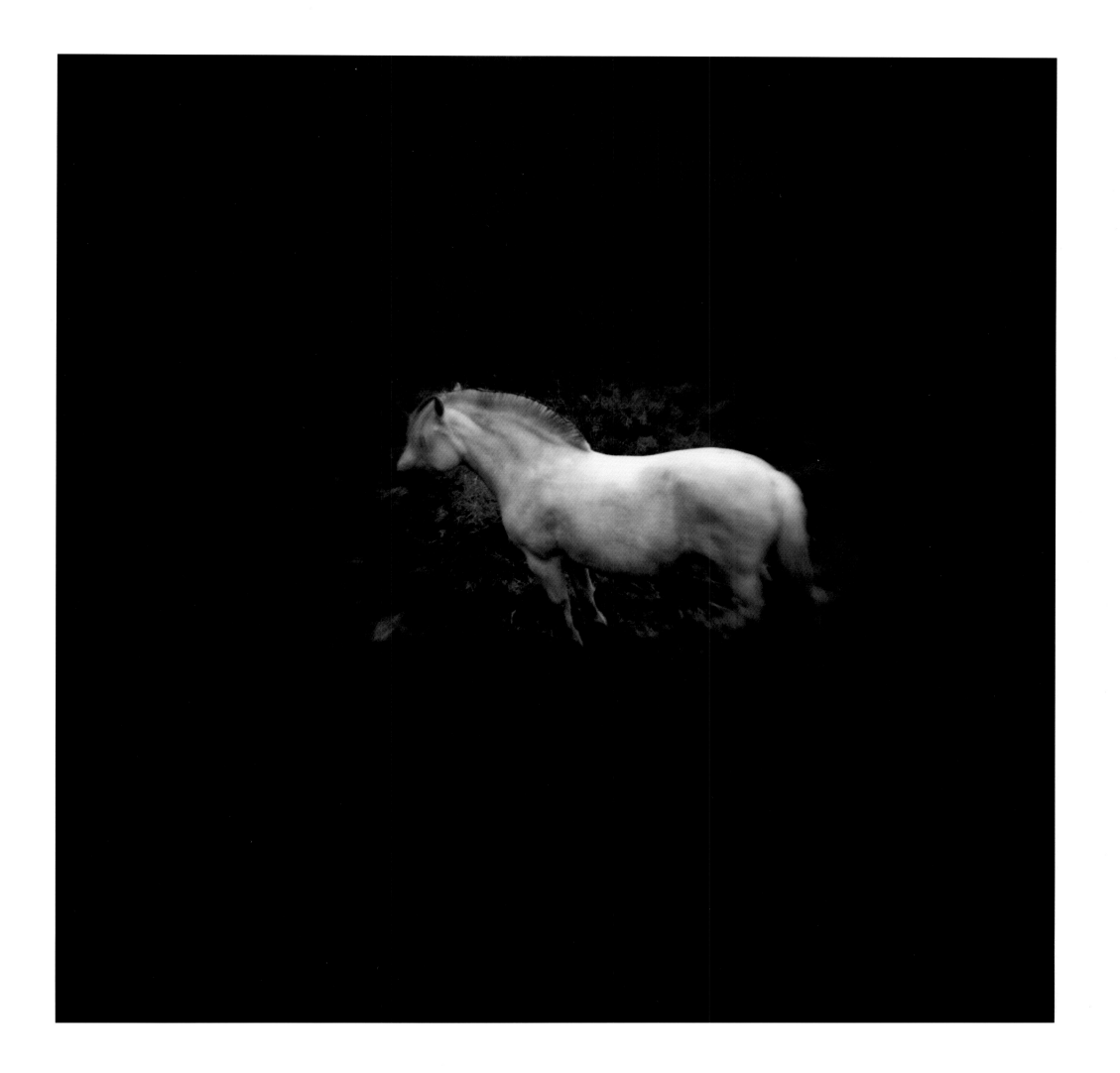

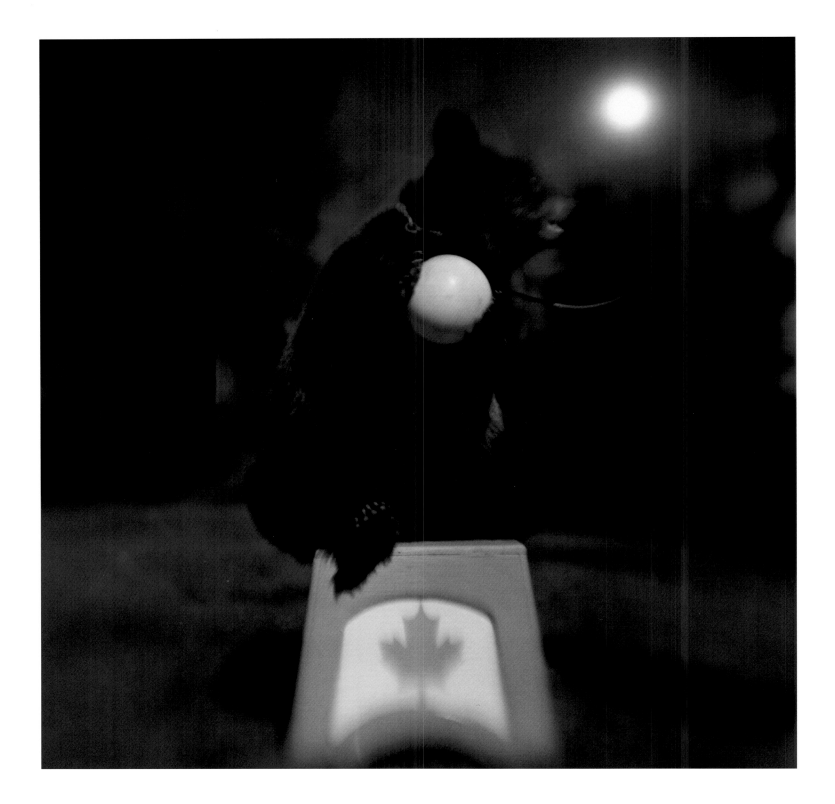

27 **BEAR AND MOON** 2007

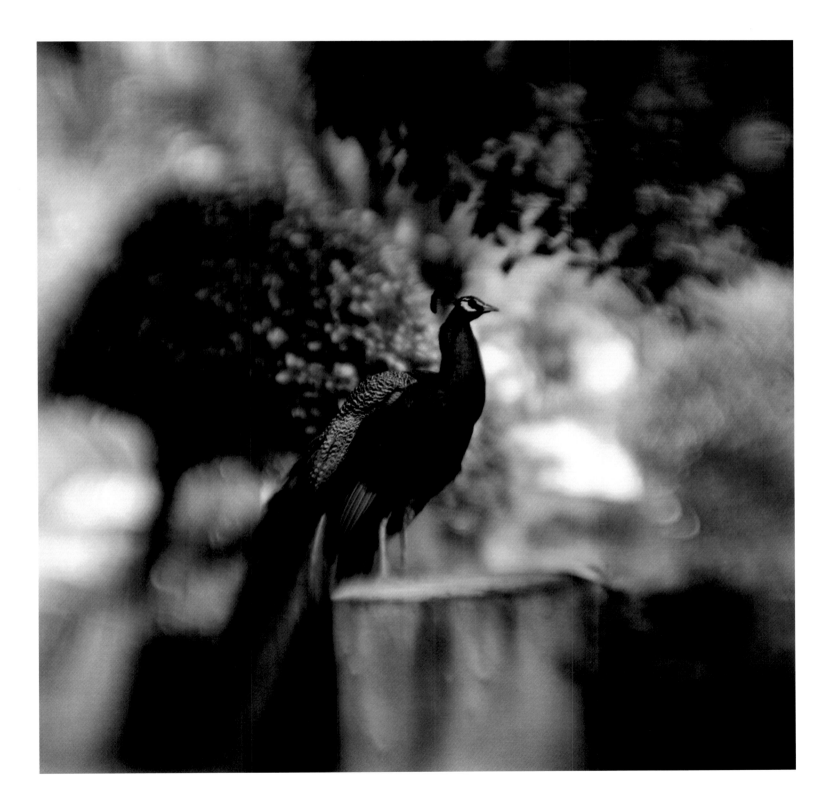

28 **PEACOCK NO. 2** 2004

29 **ANCESTOR** 2001

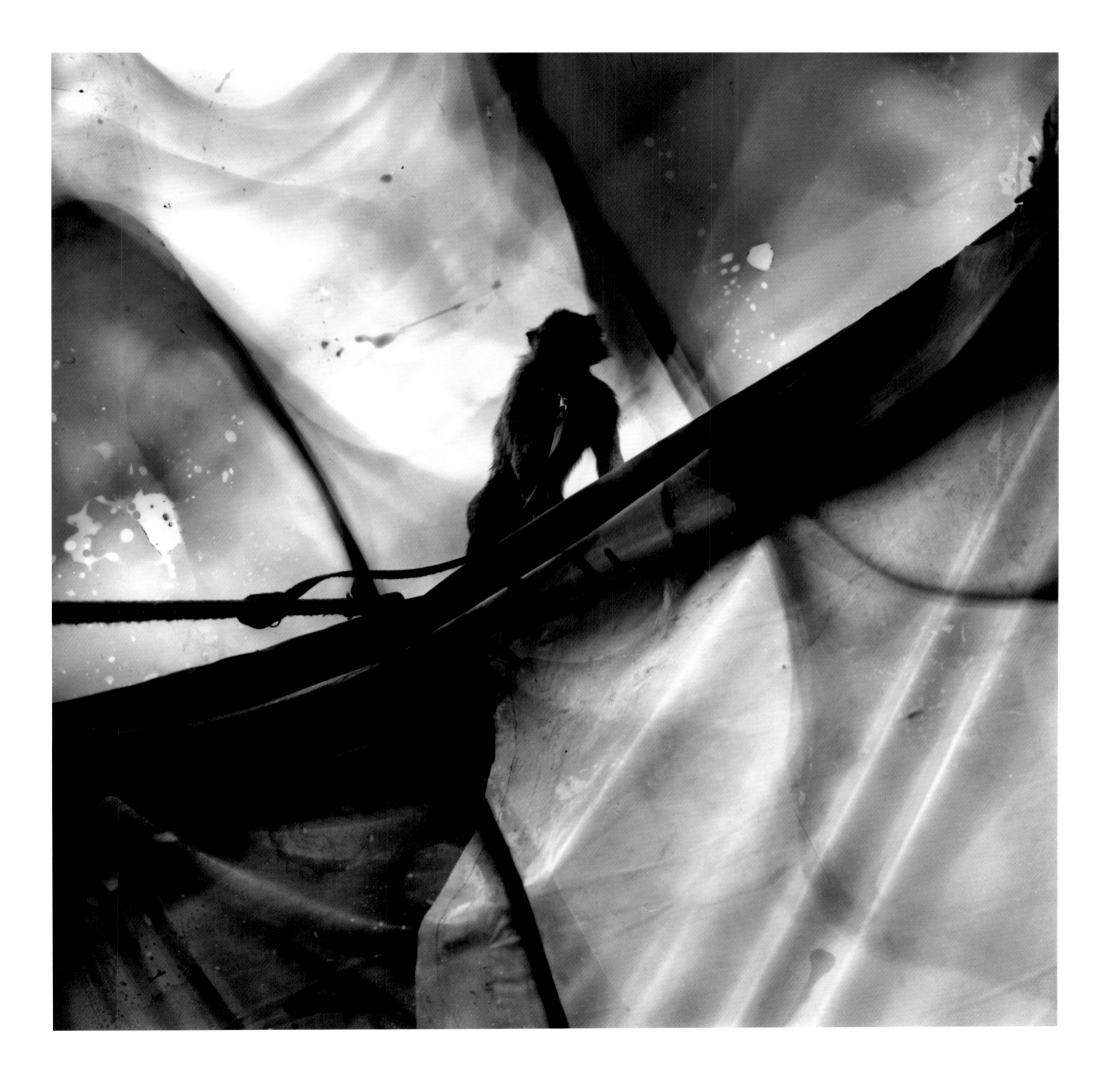

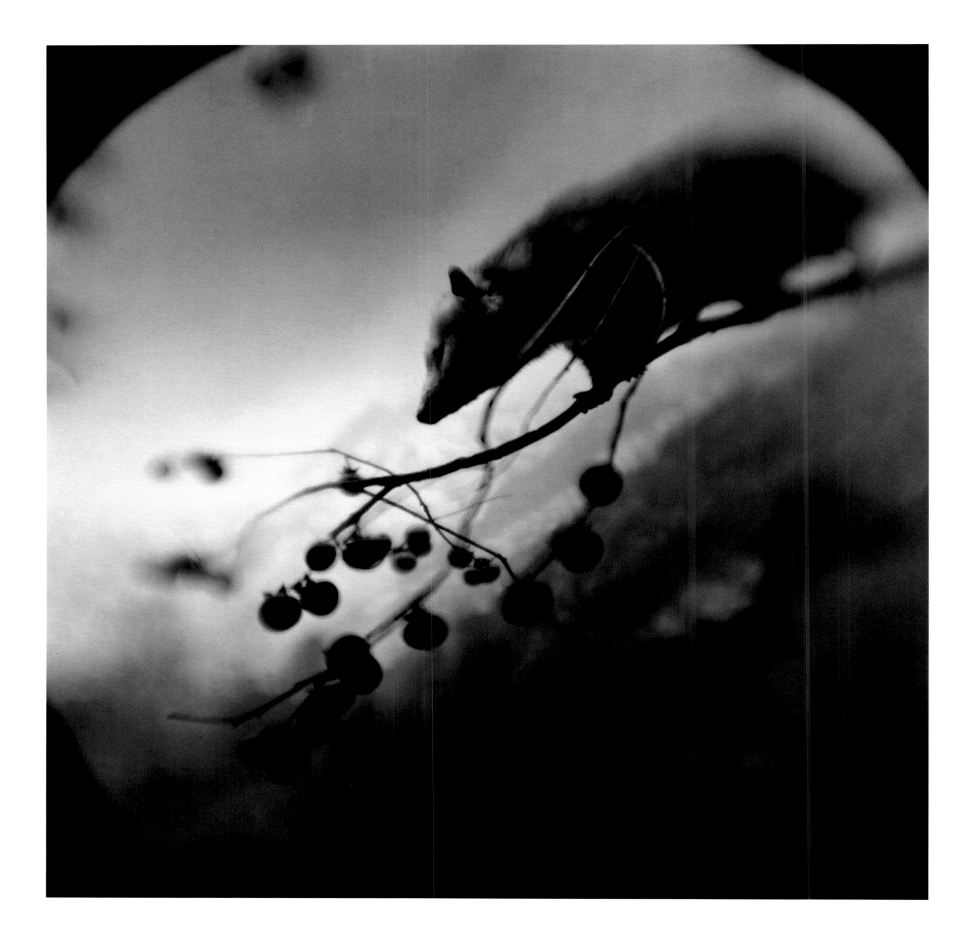

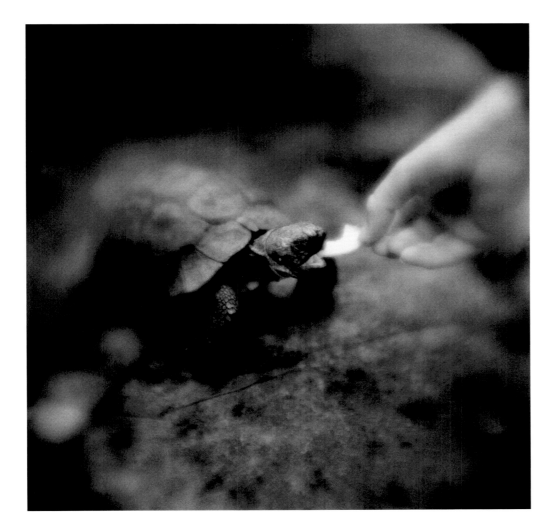

30 **POSSUM** 2004 | 31 **APPLE SLICE** 2004

32 **OPEN HAND** 2004

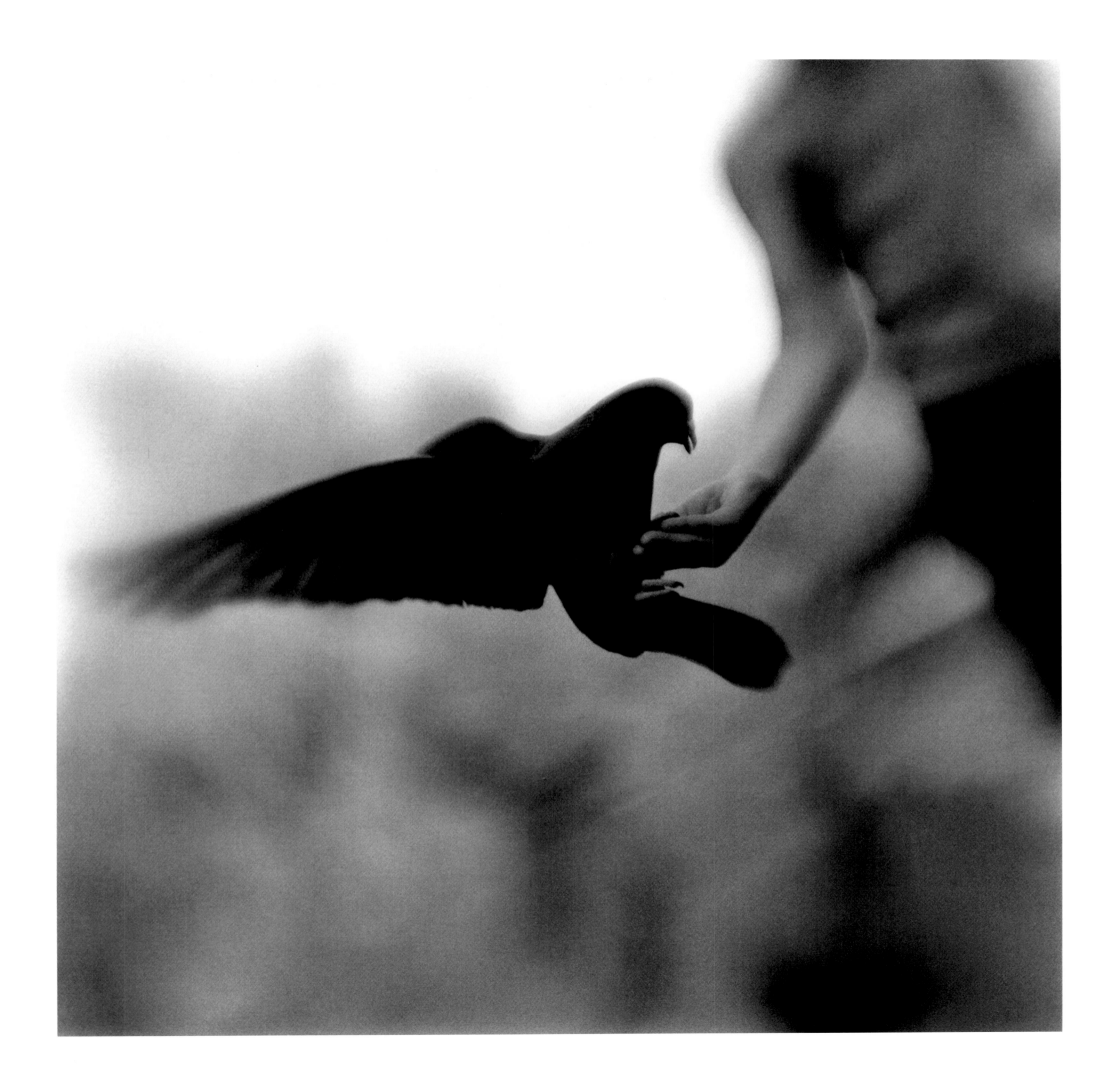

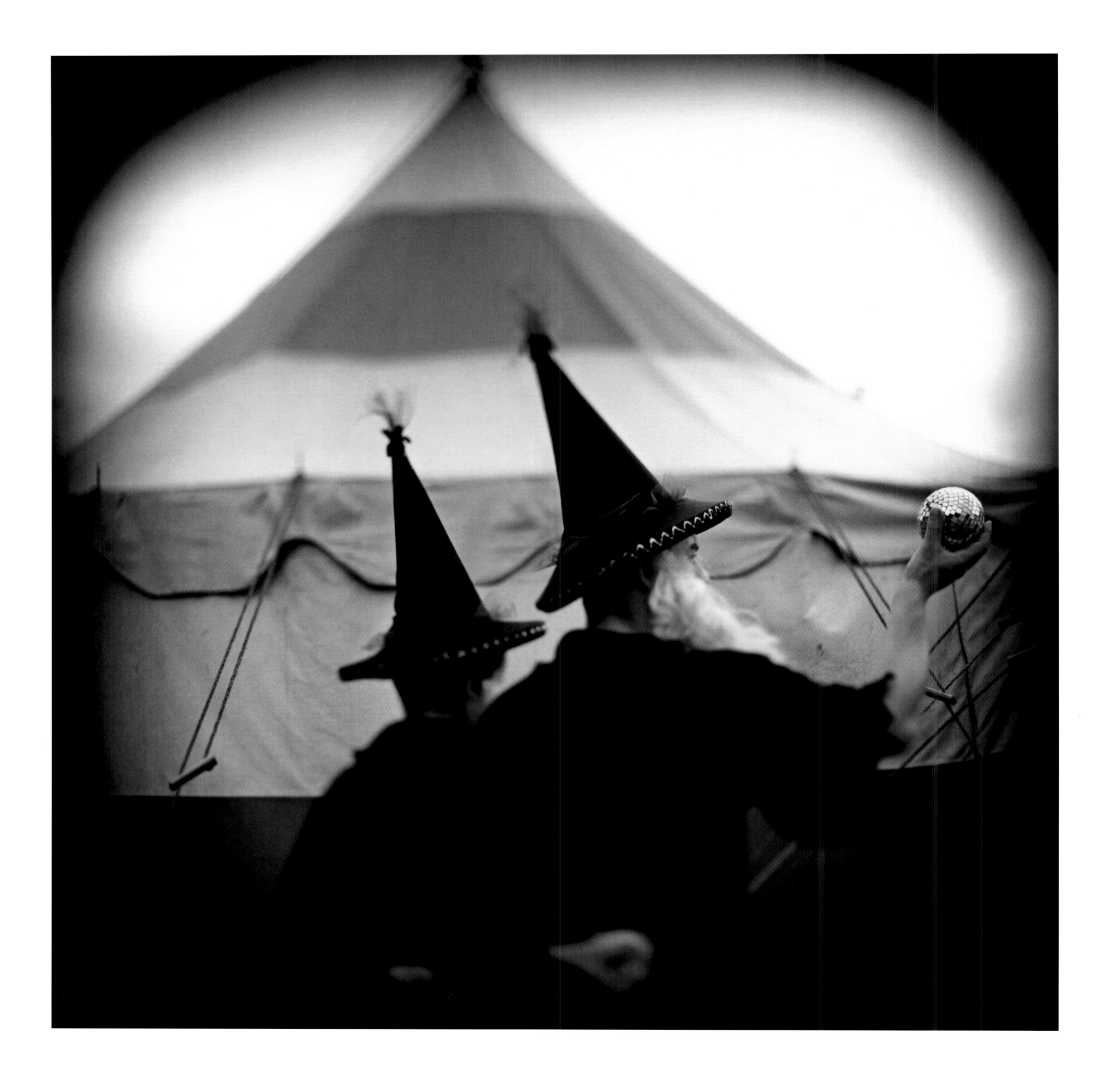

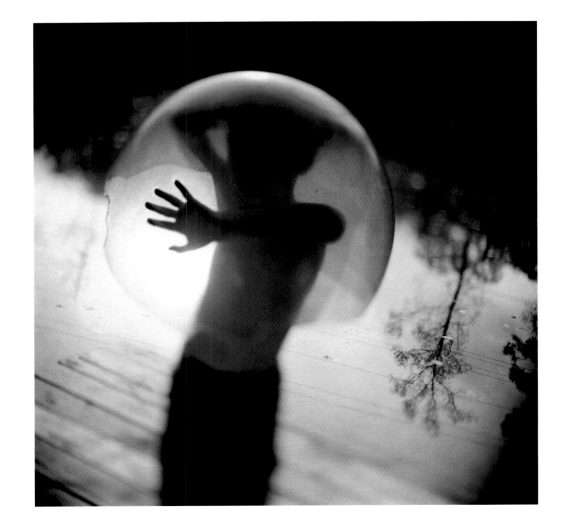

33 **WIZARDS** 2000 | 34 **BUBBLE** 2003

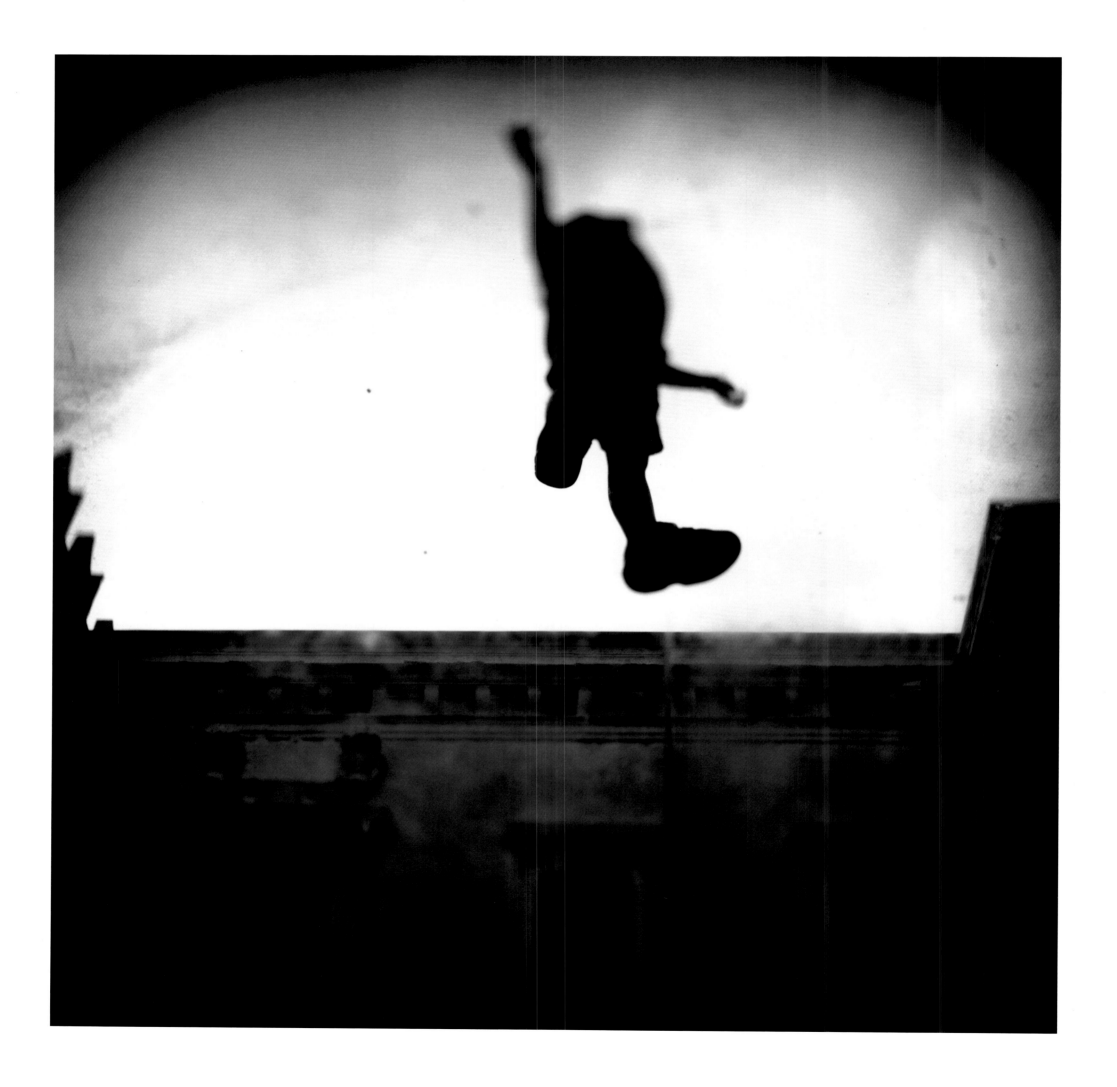

35 **LEVITATION** 2001

36 **BOY AND HAWK** 2005

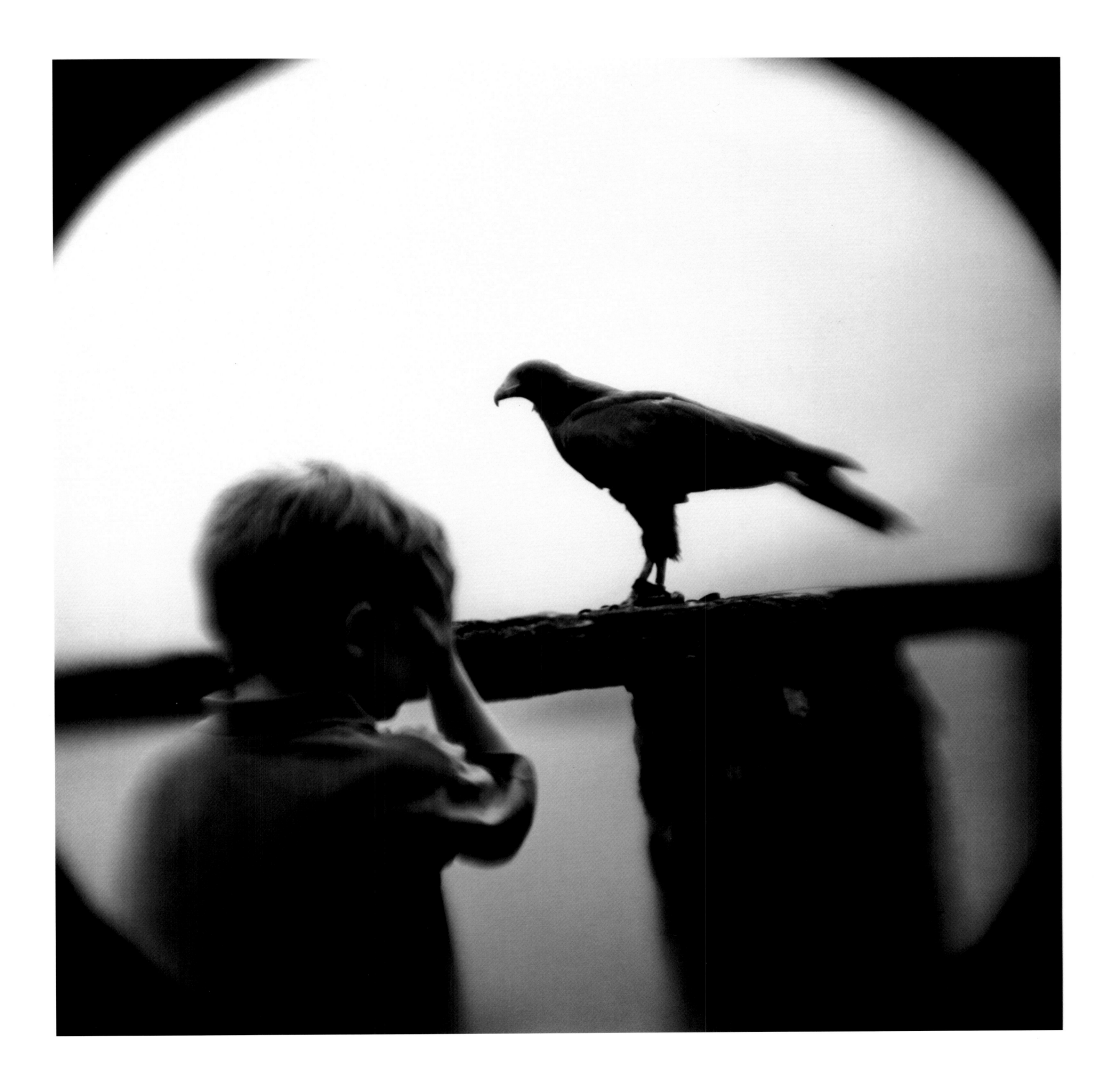

Improbable marvels appear

as your immersion in

with the same regularity

the richness of life.

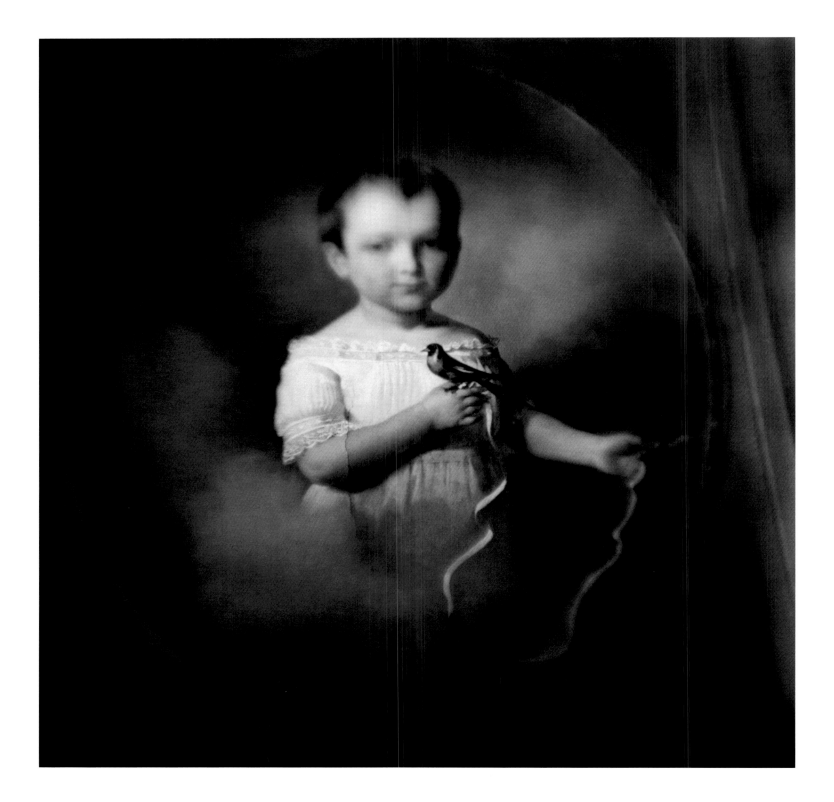

37 **BIRD AND RIBBON** 2006

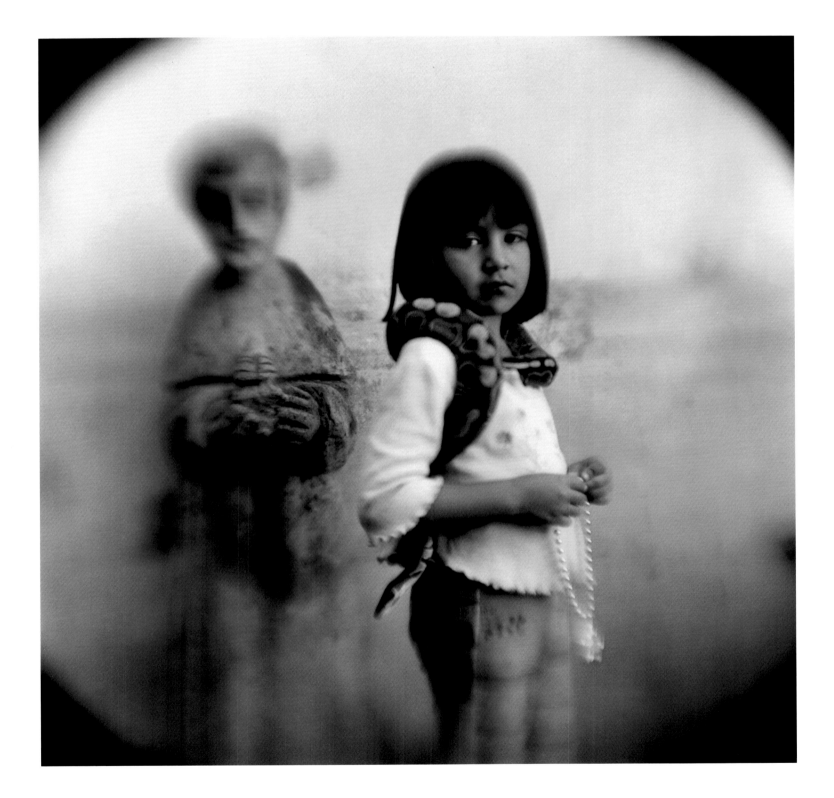

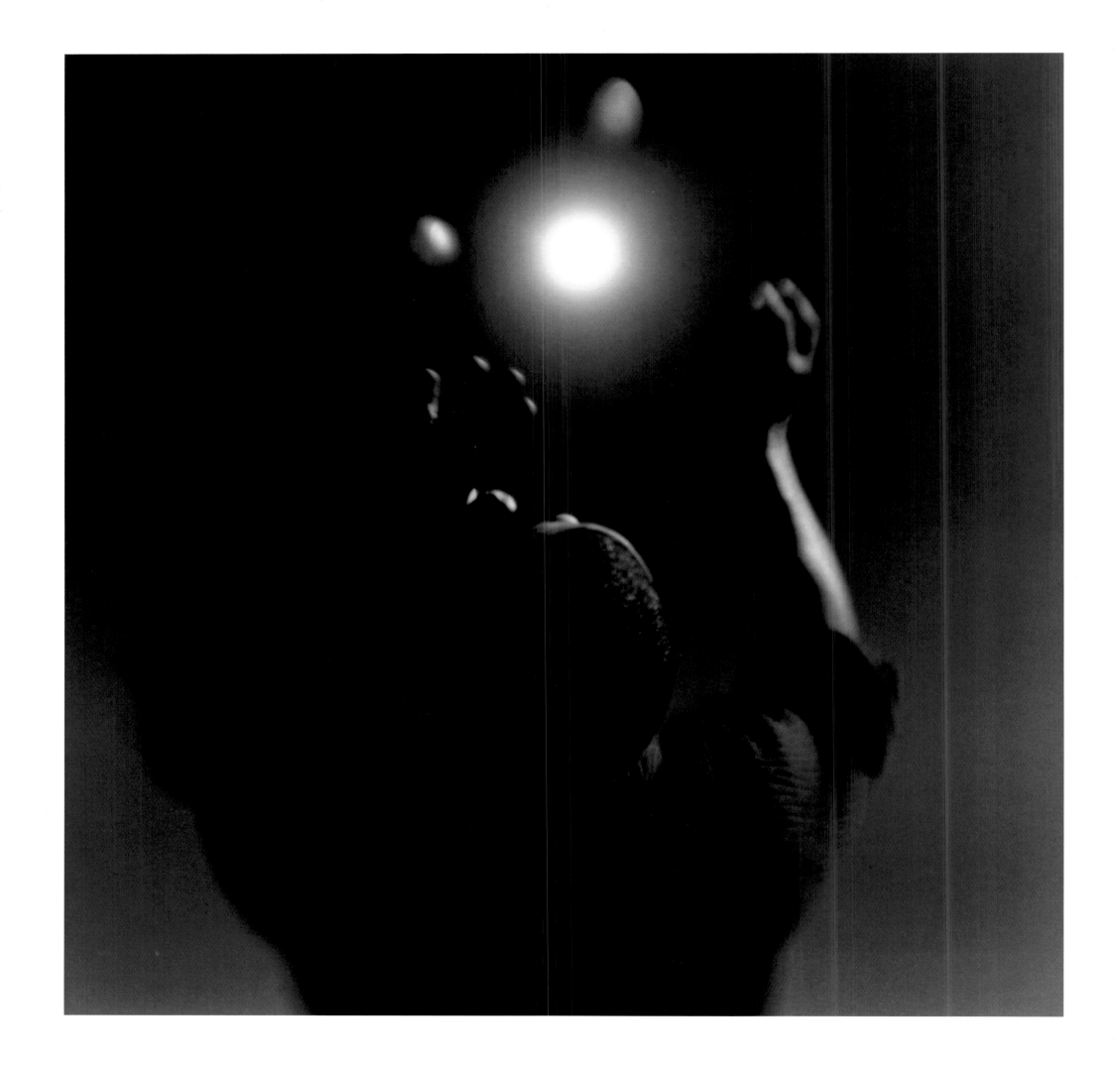

39 **JUGGLING WITH THE MOON** 2007

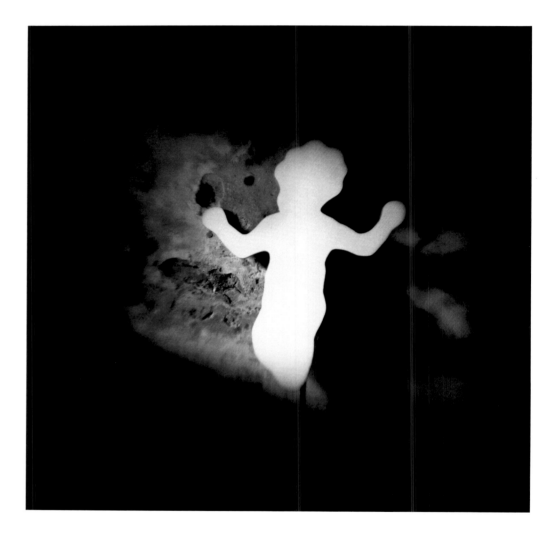

40 **APPARITION** 2005 | 41 **GIRAFFE** 2006

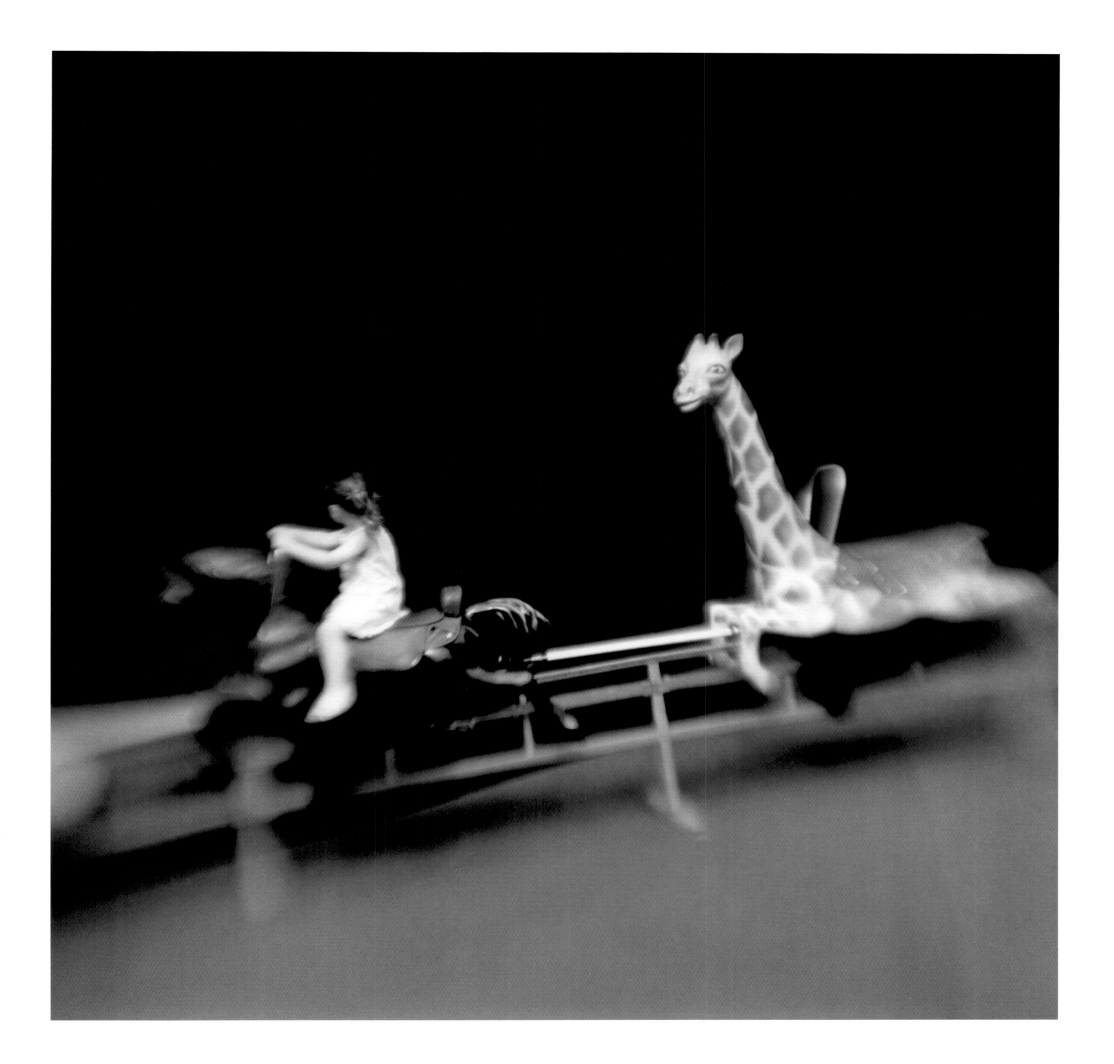

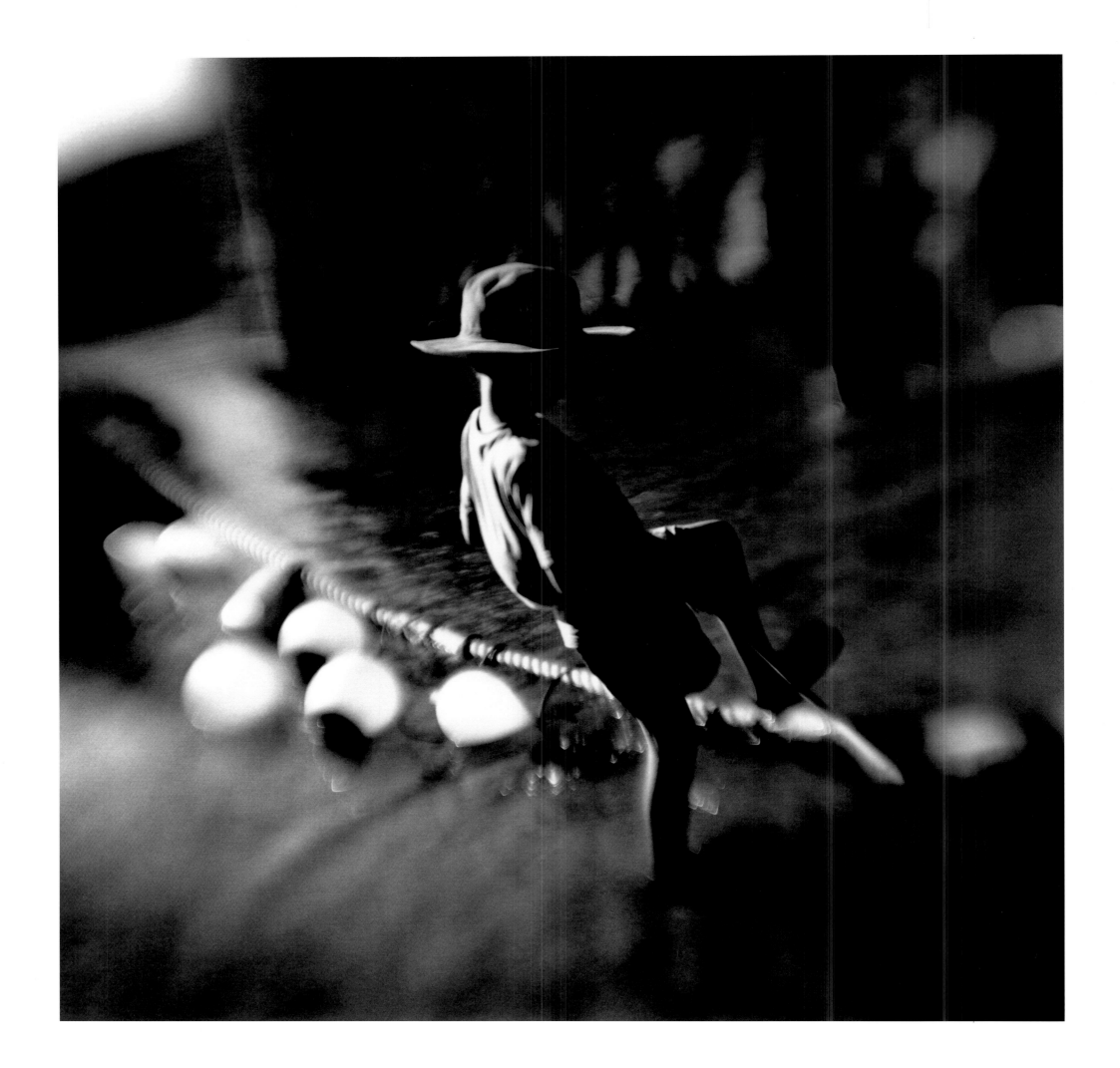

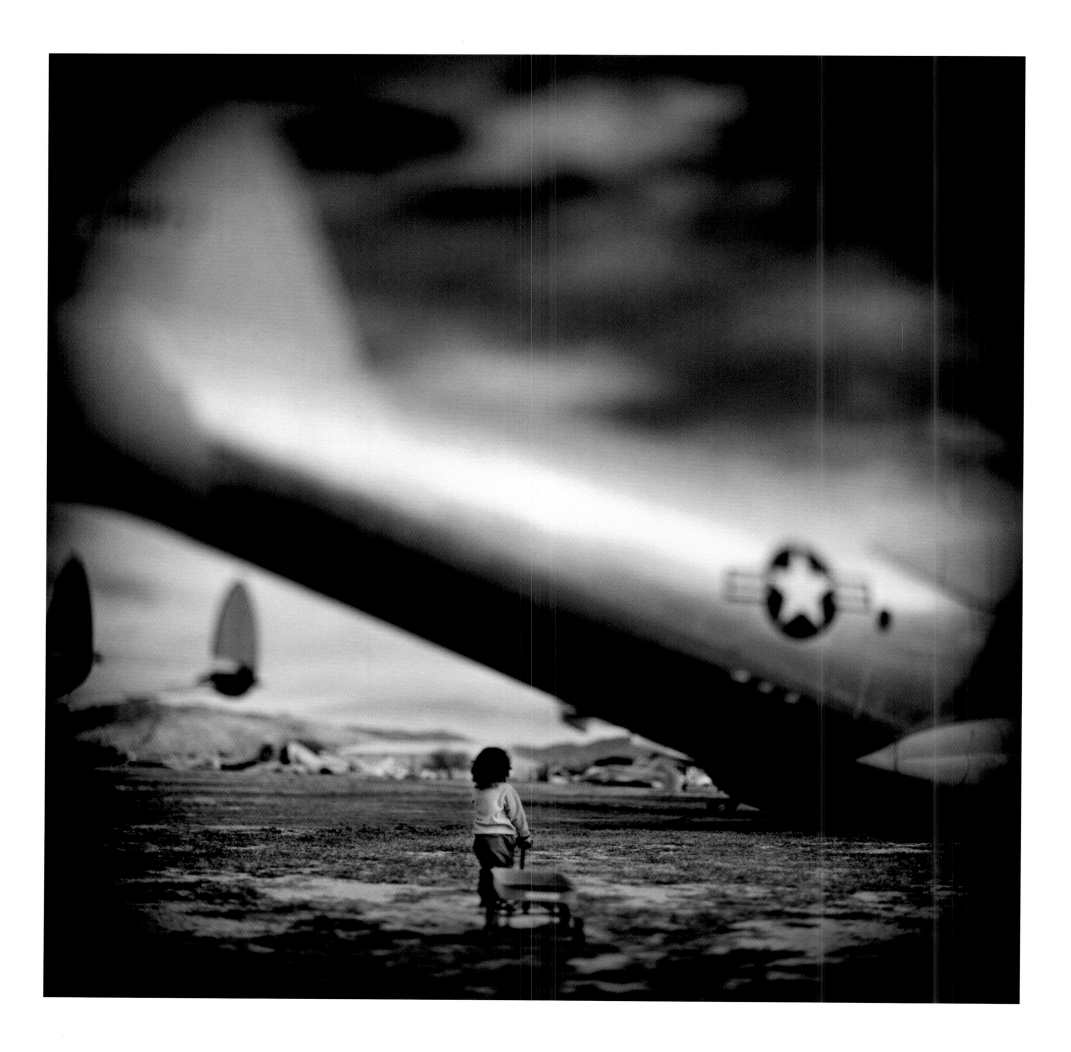

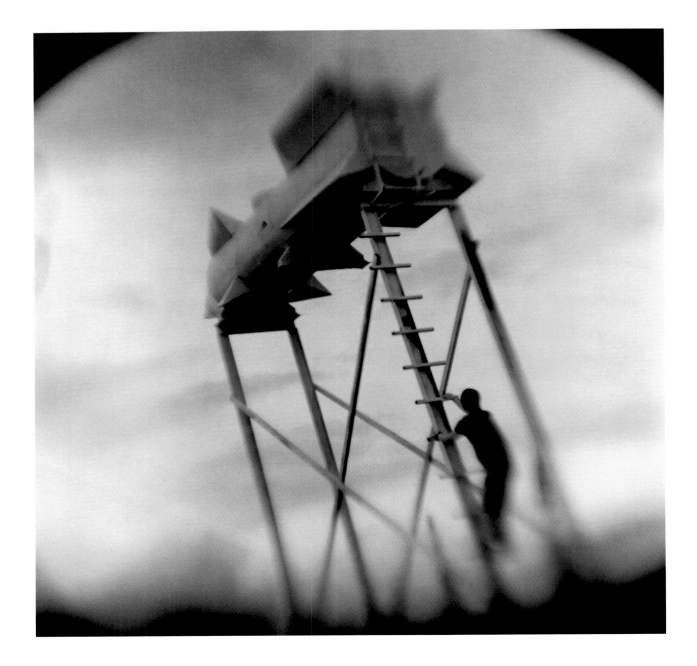

43 **RADIO FLYER** 2000 │ 44 **ROCKET MAN** 2004

I believe in the "things happen

when you work" art theory.

45 **TRAPEZE** 2003

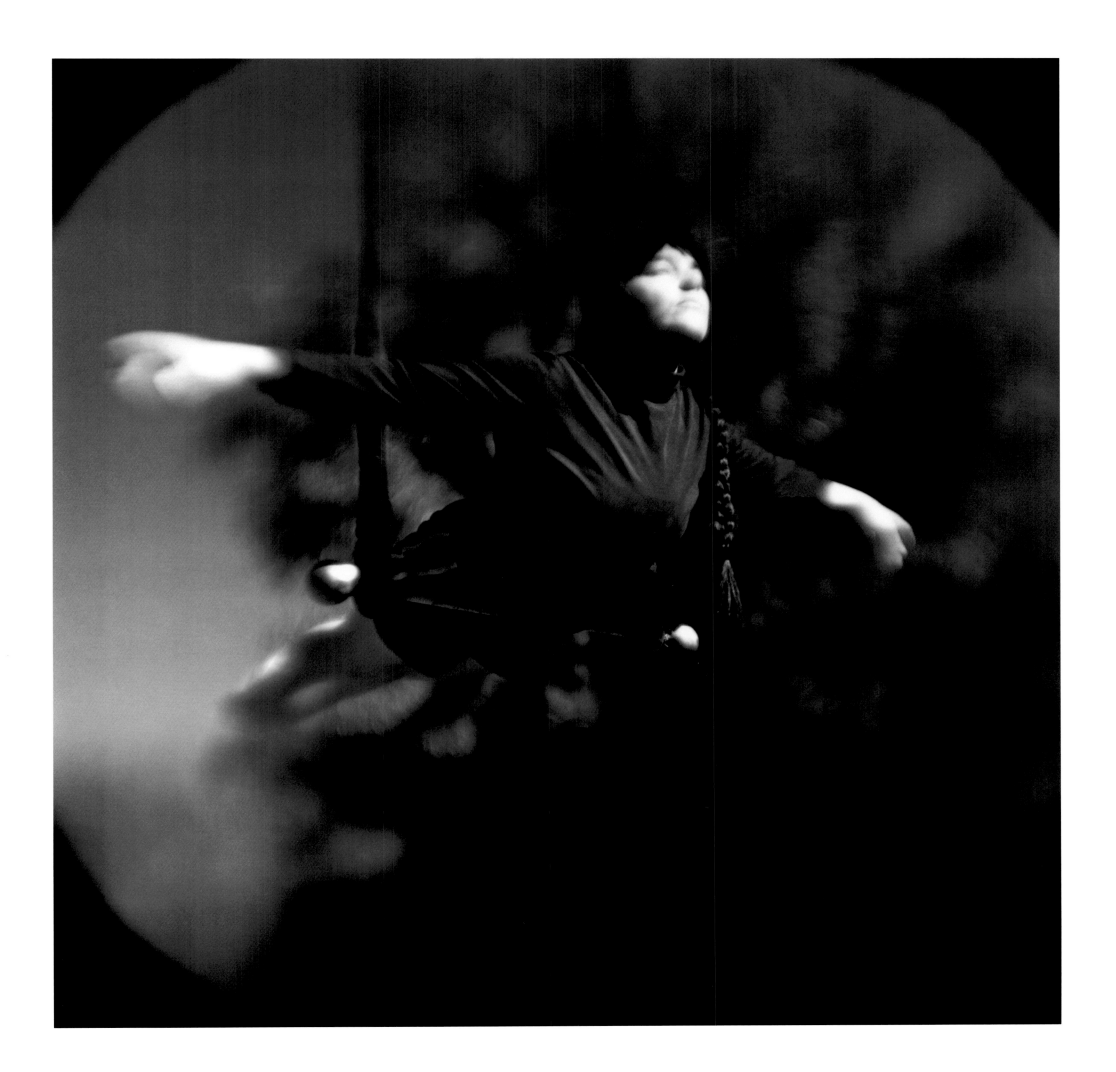

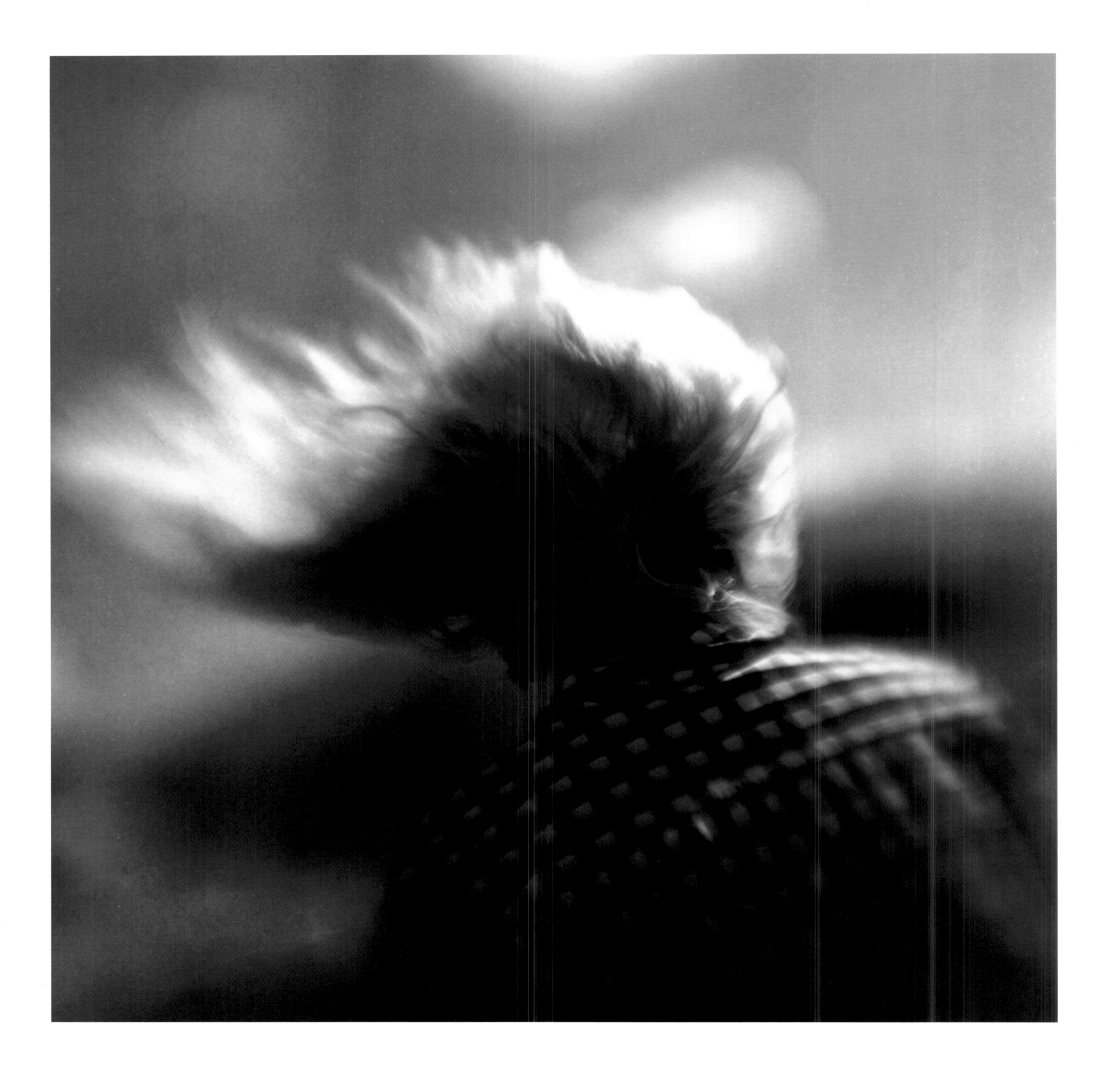

46 **WINDBLOWN** 2007

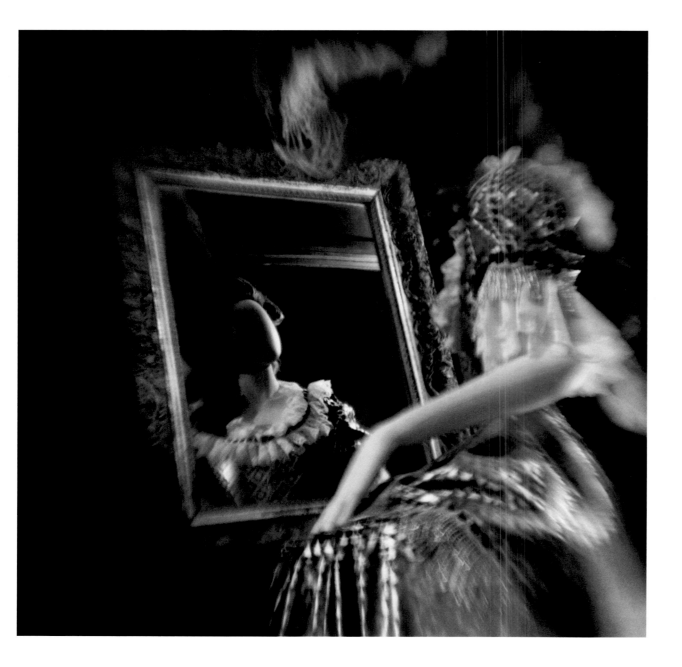

47 **FACELESS** 2005 | 48 **CAFÉ FLORIAN** 2005

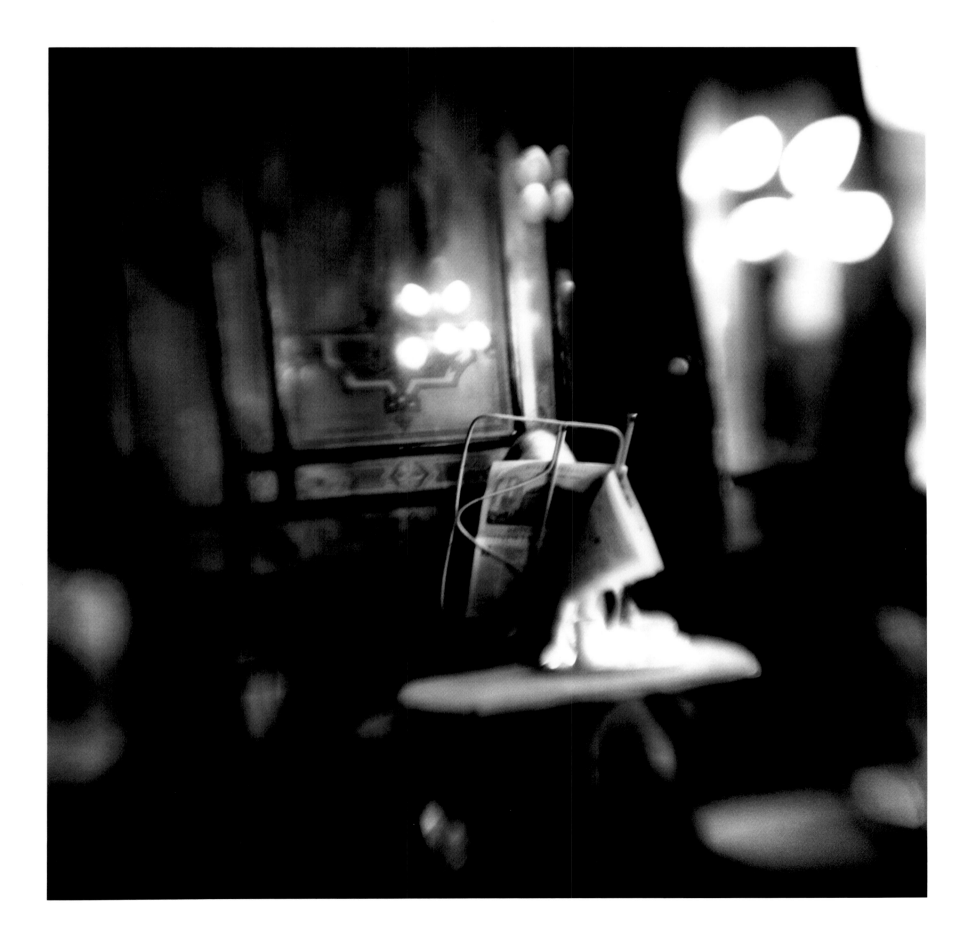

49 **TWO UMBRELLAS** 2001

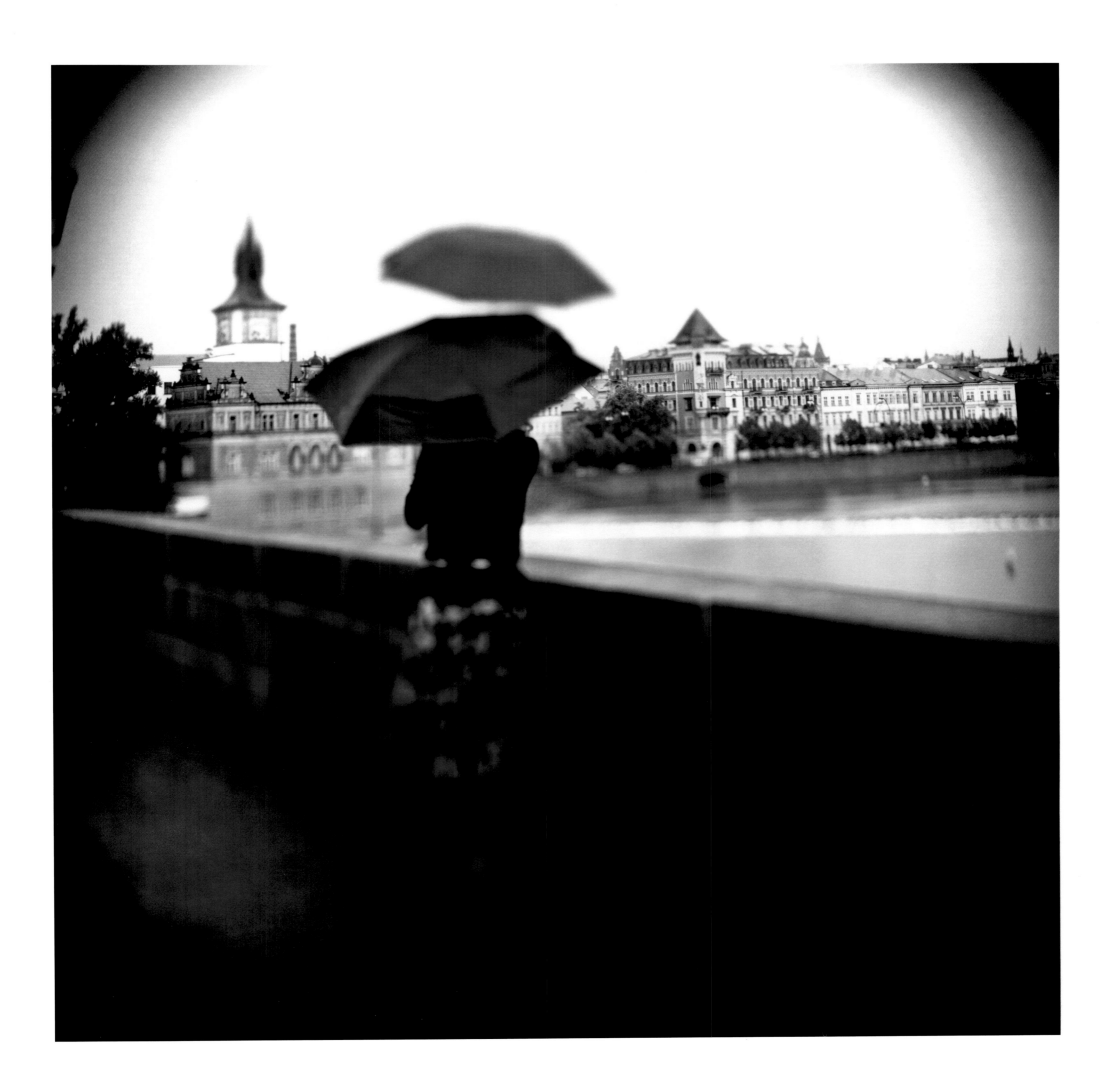

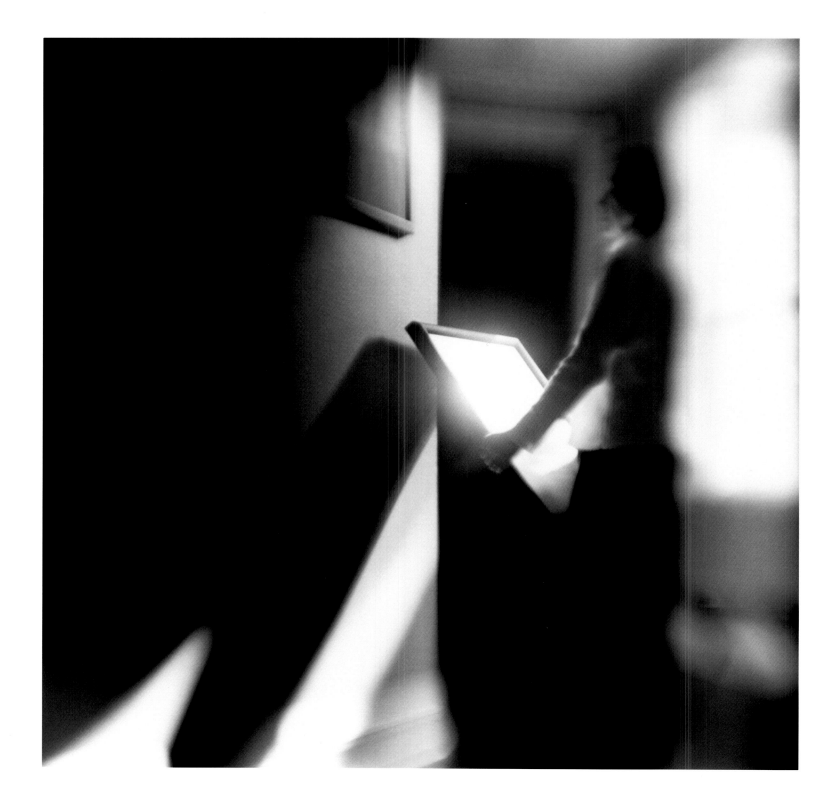

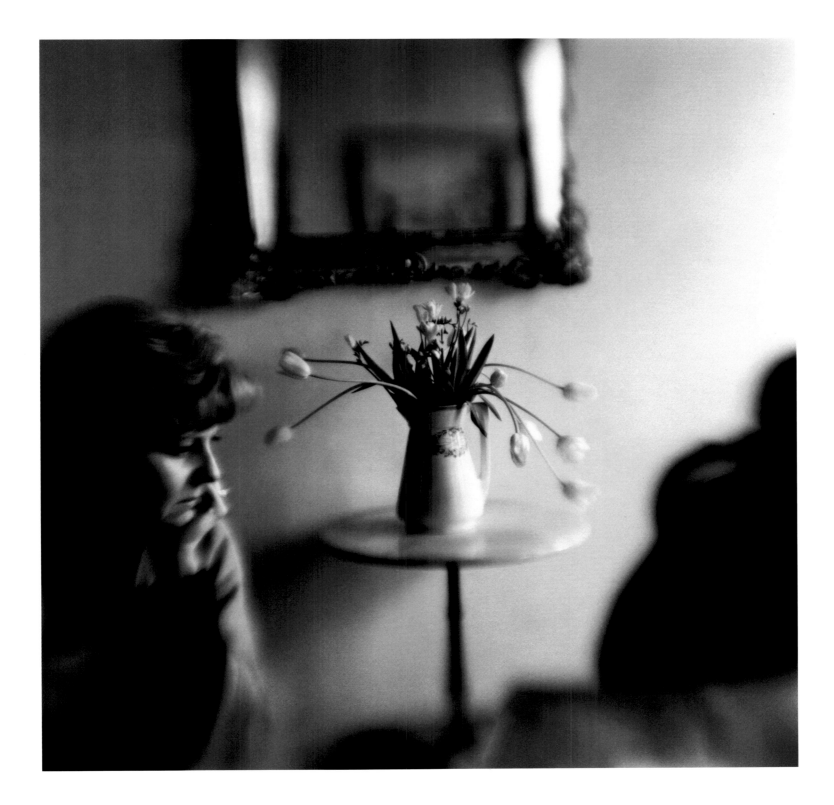

51 **VASE OF TULIPS** 2005

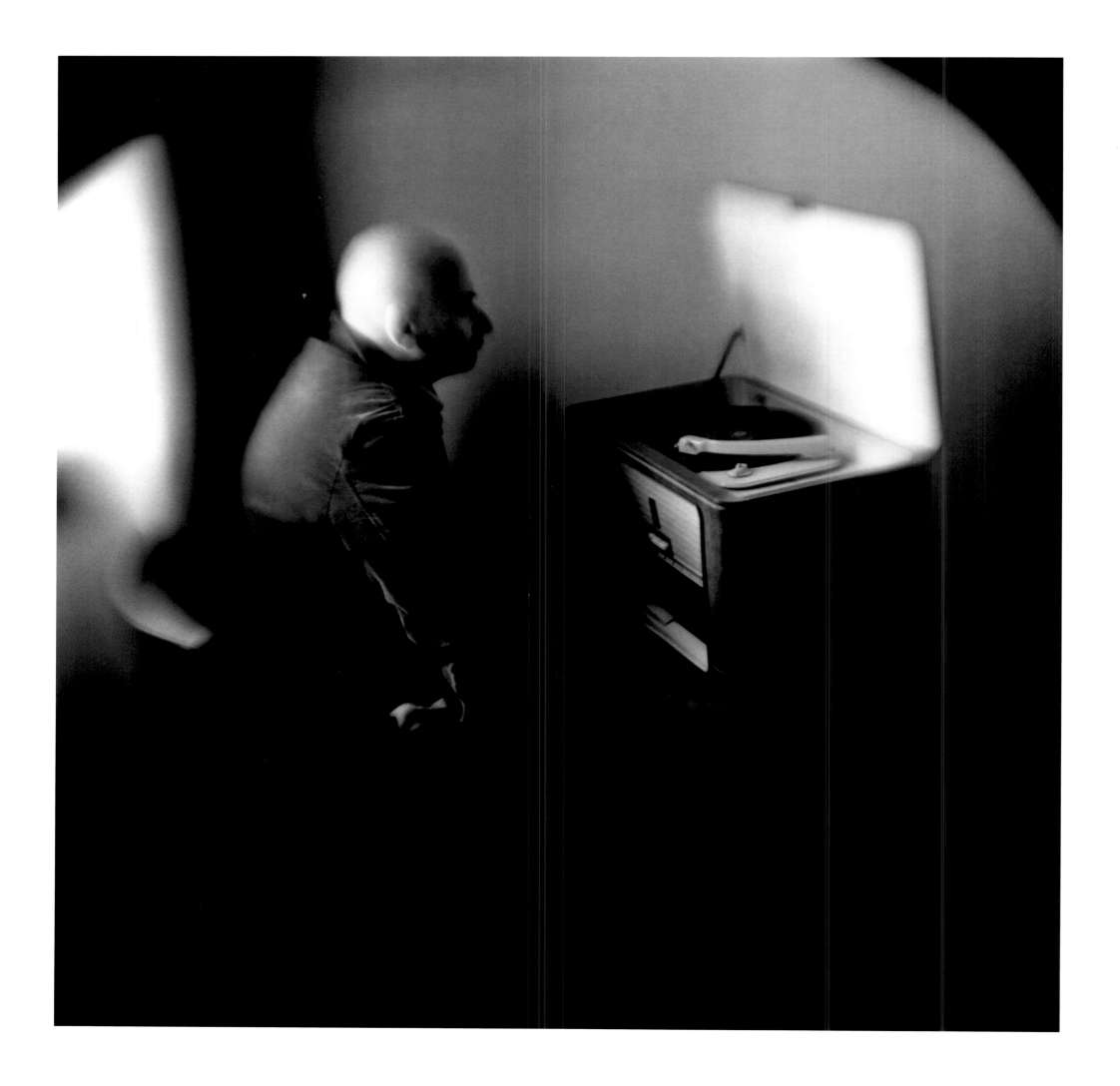

52 **PHONOGRAPH** 2005

53 **LUKAS** 2005 | 54 **PROMENADE** 2006

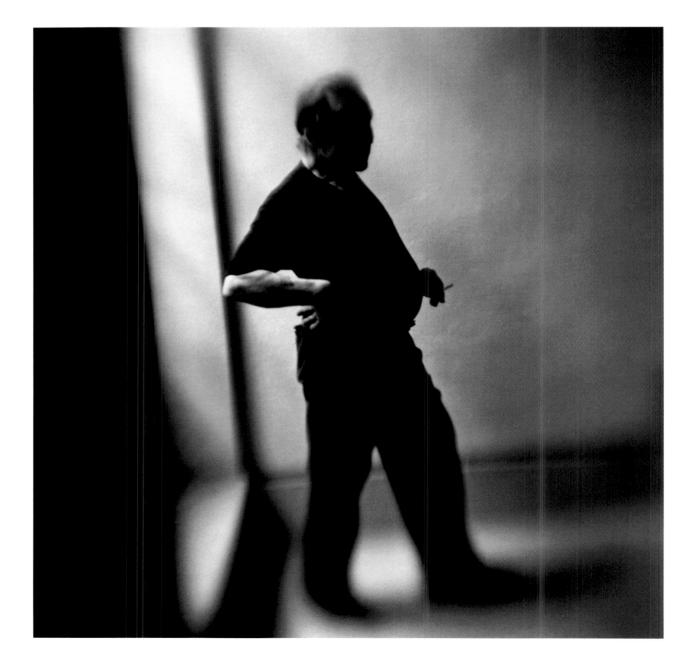

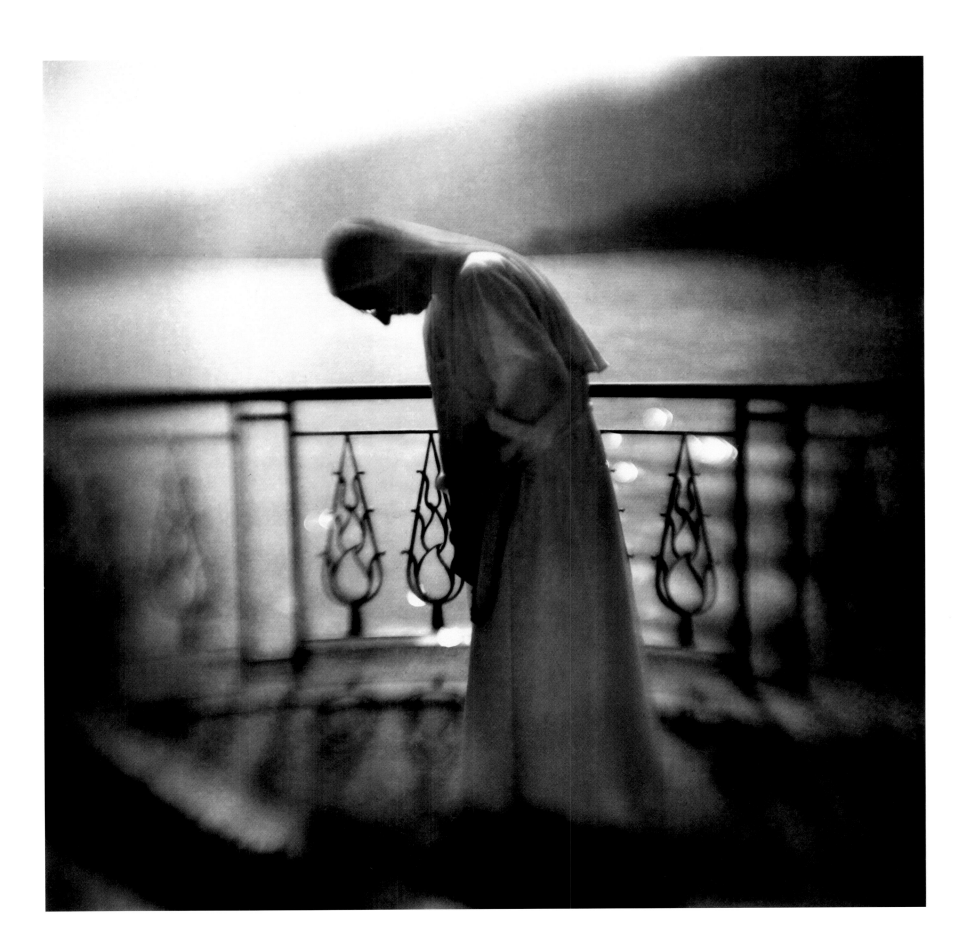

I feel about light the way

writers feel about words.

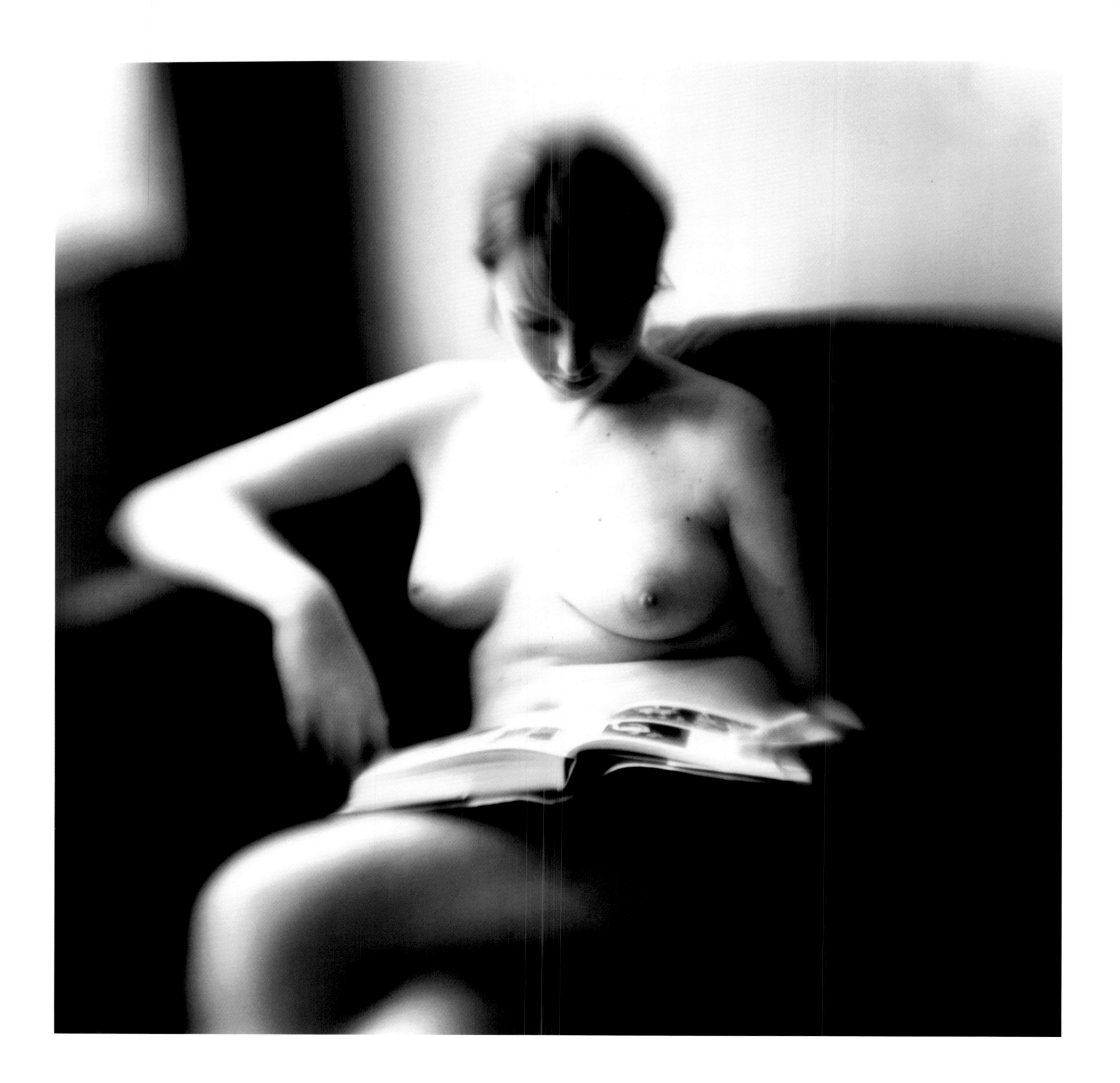

55 **READING** 2006

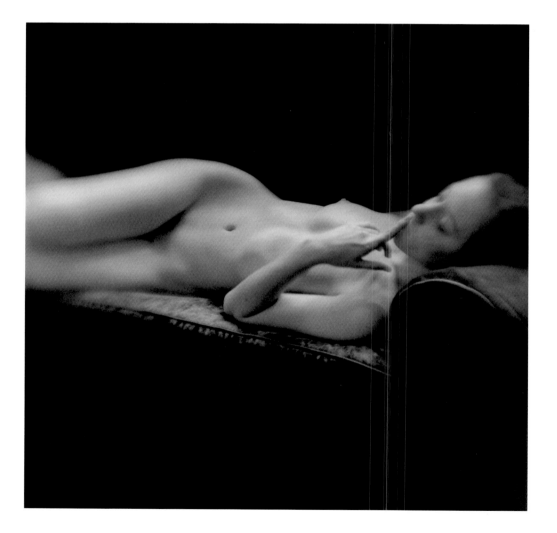

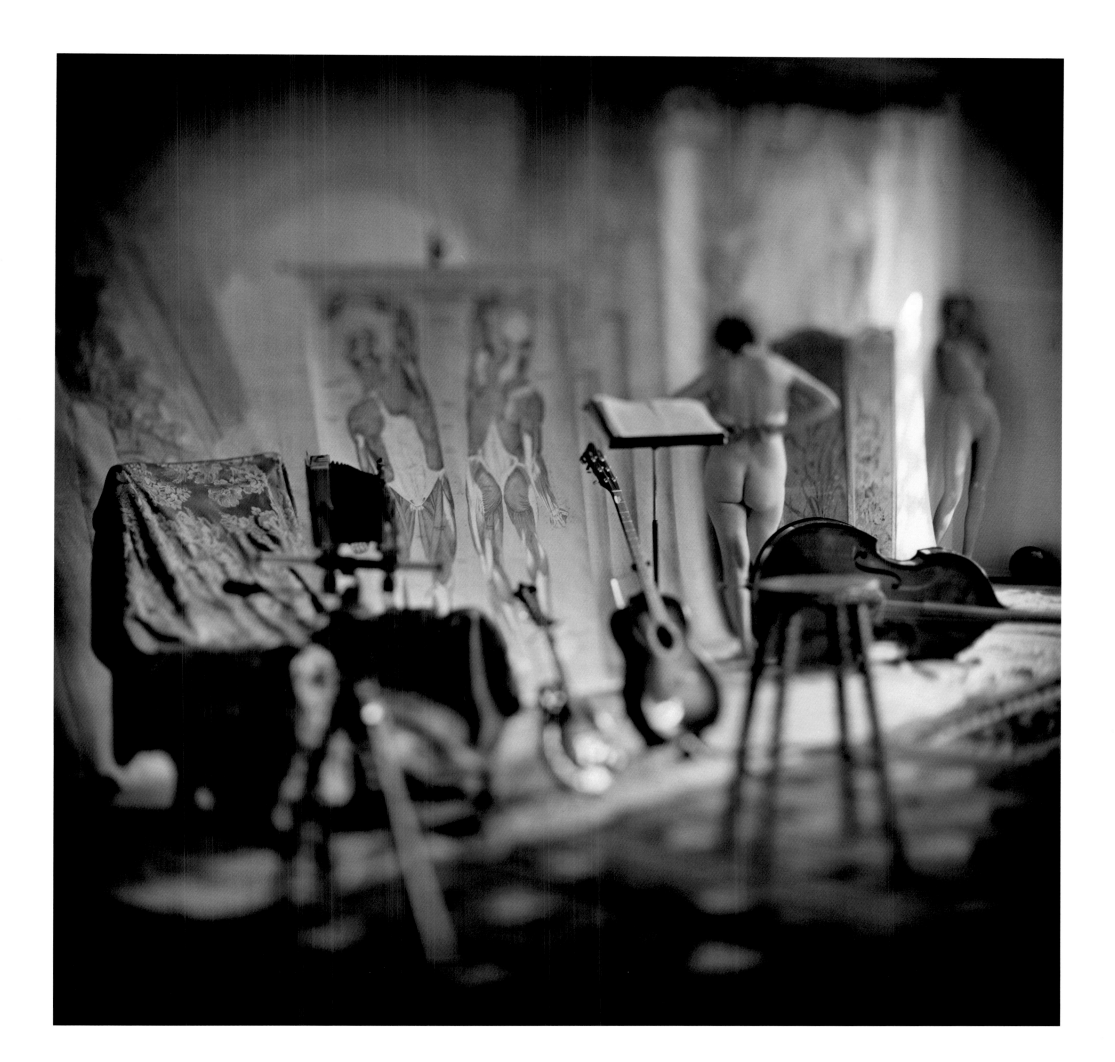

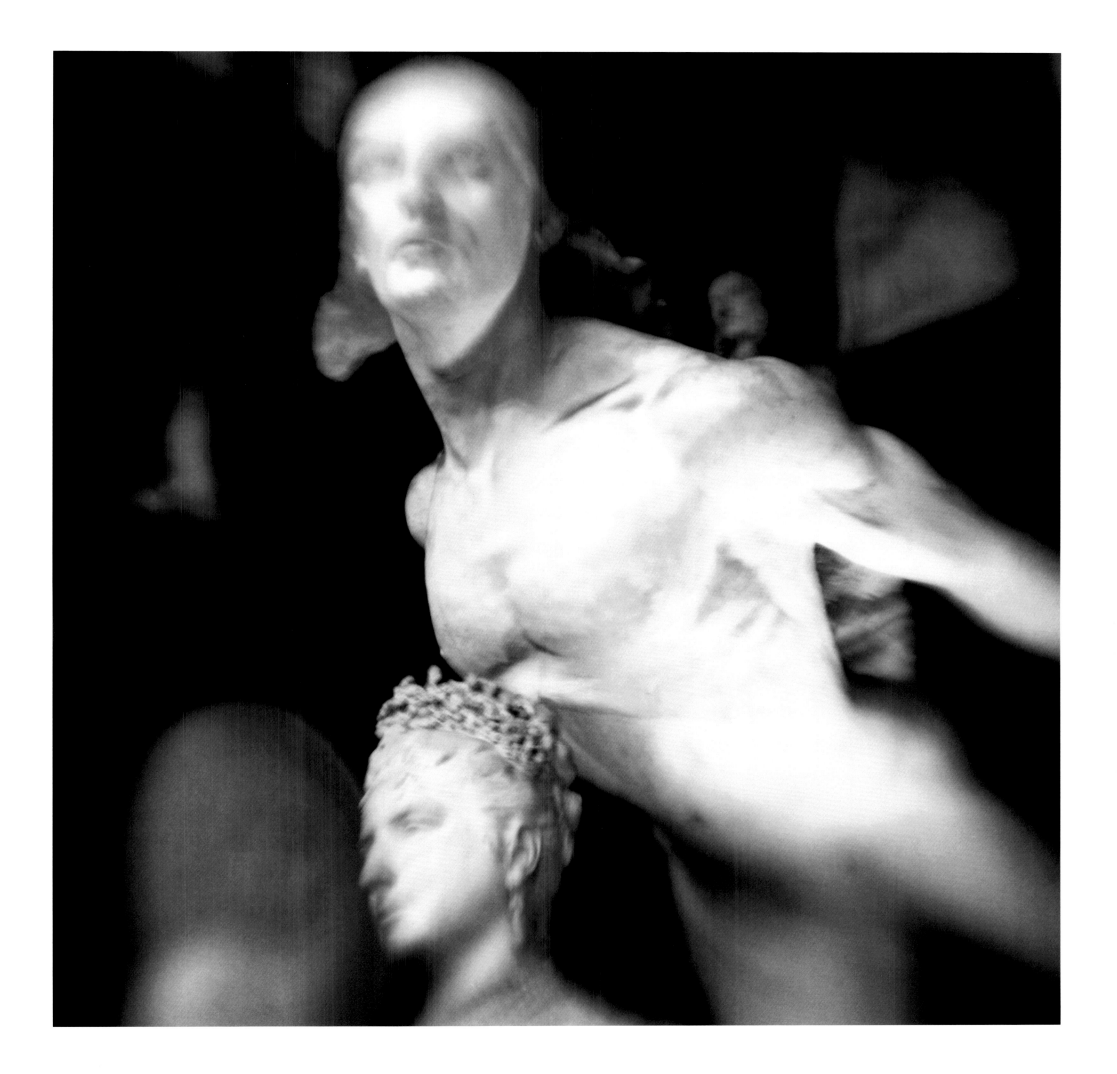

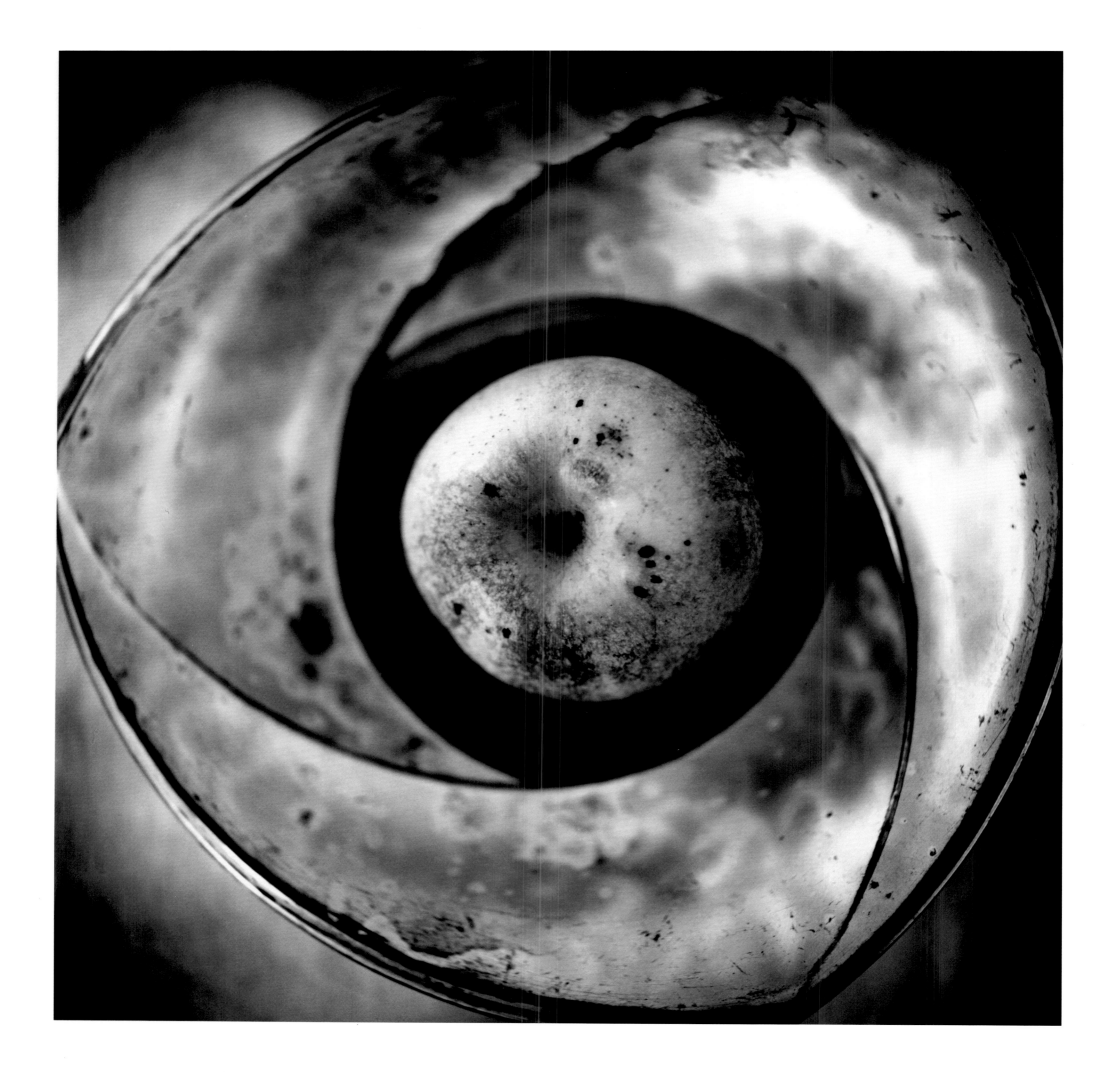

61 **THIRTY PLATES** 2004

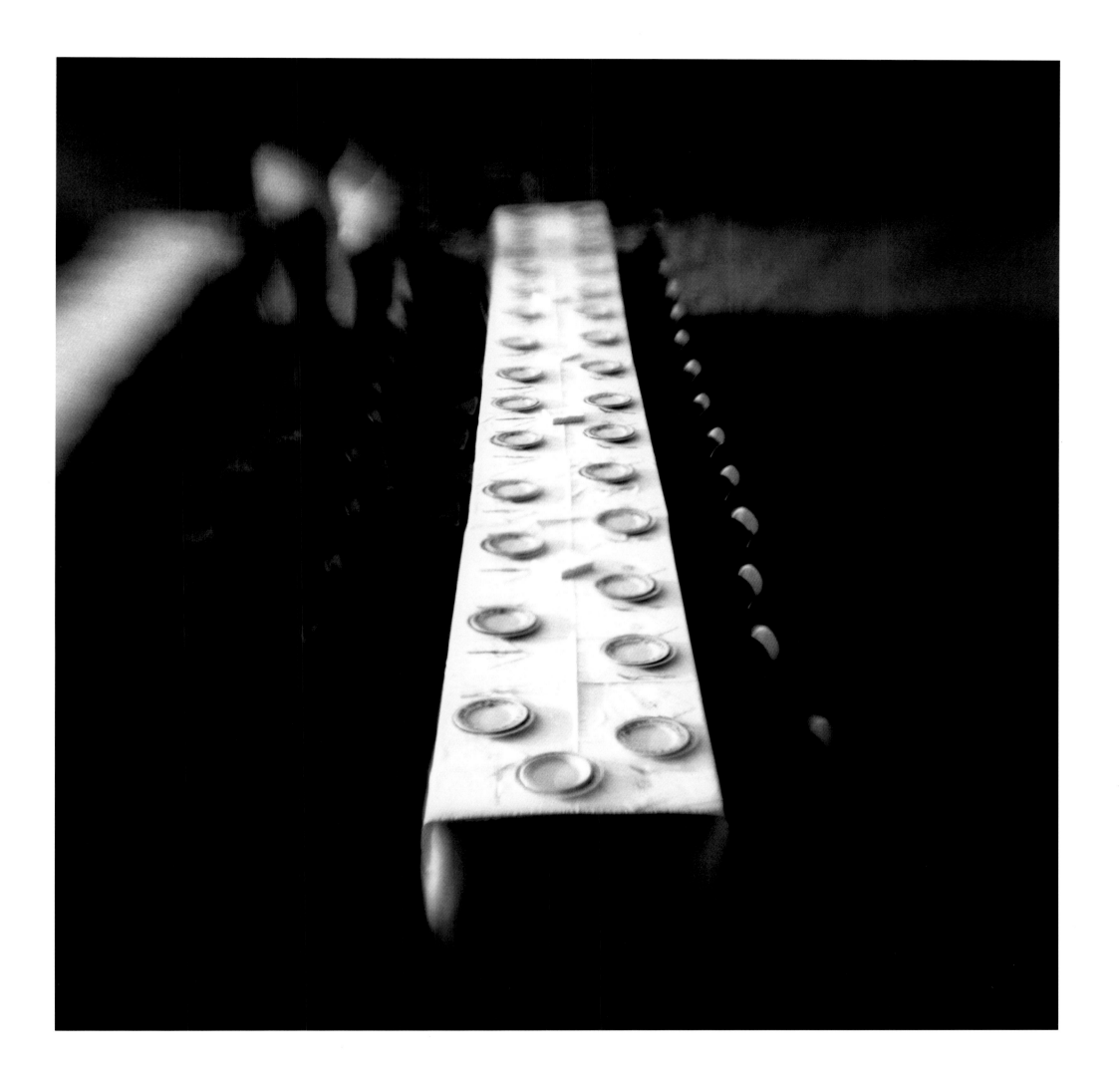

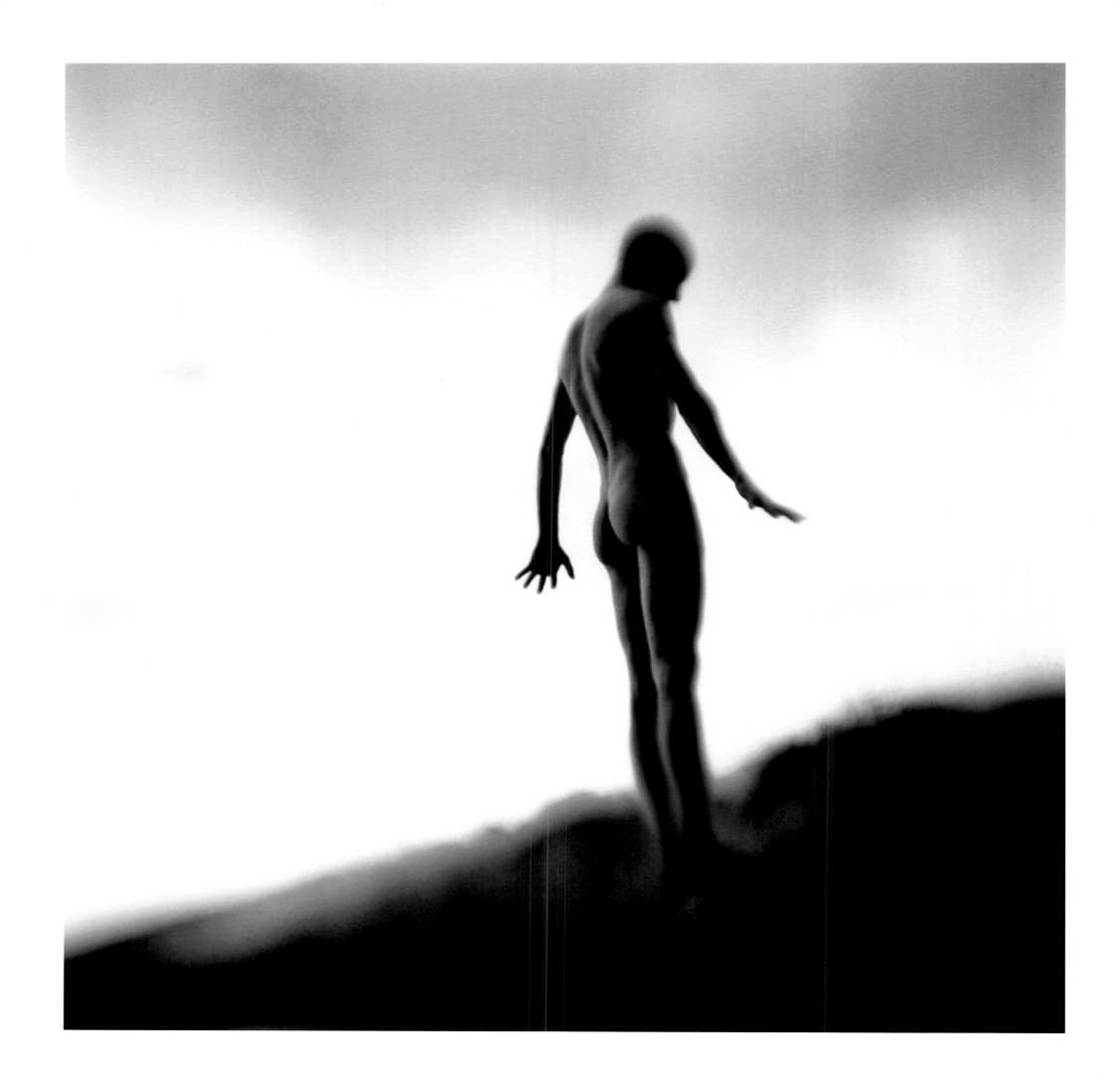

62 **MALE FIGURE NO. 1** 2005 | 63 **WHITE STONES** 2000

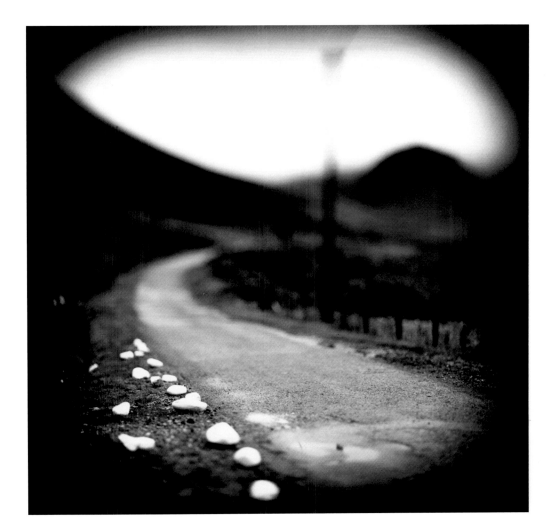

I try to put myself in positions—

the possibility exists

in physical locations—where to be astonished.

64 **HILLSIDE** 2005

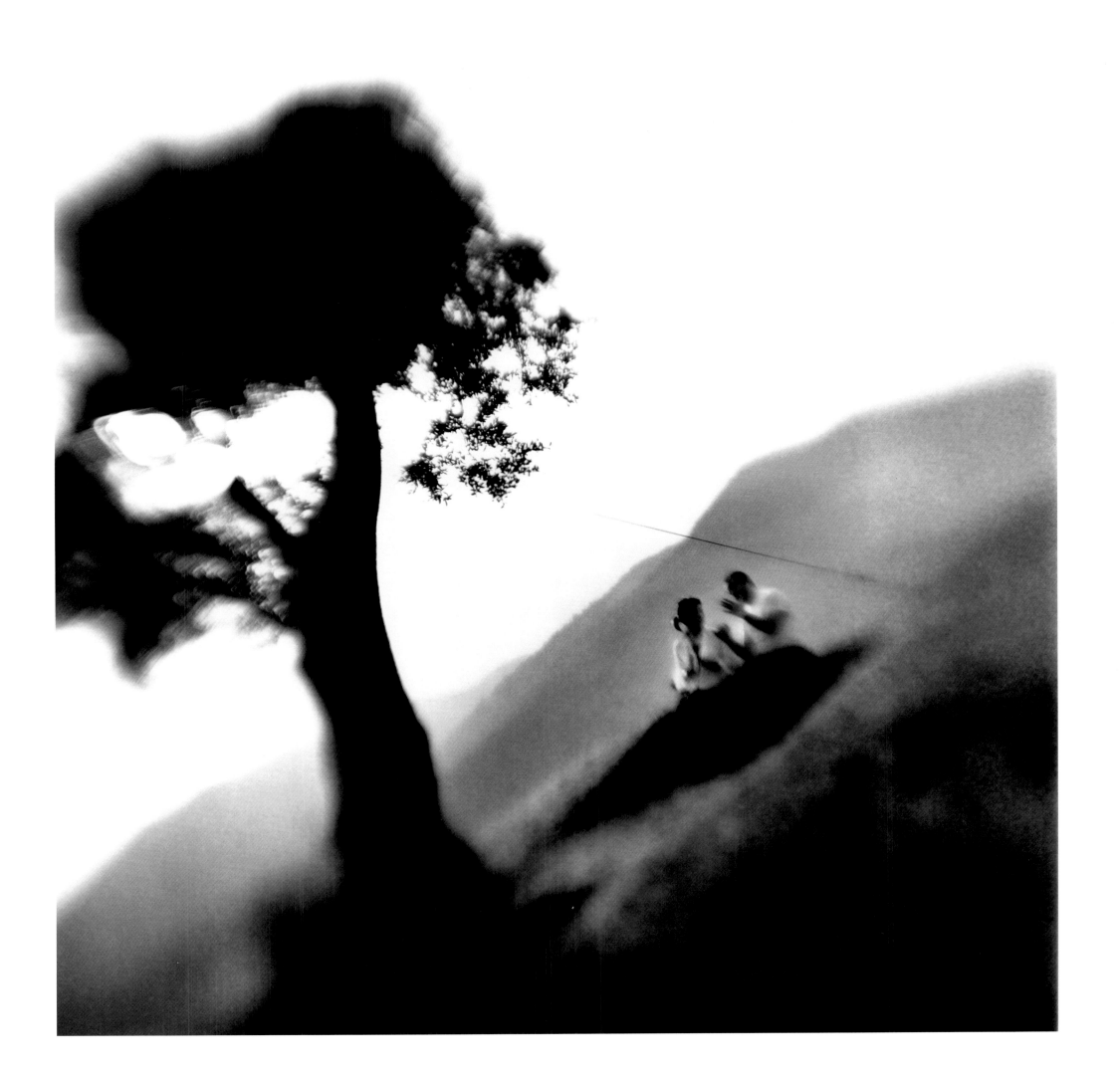

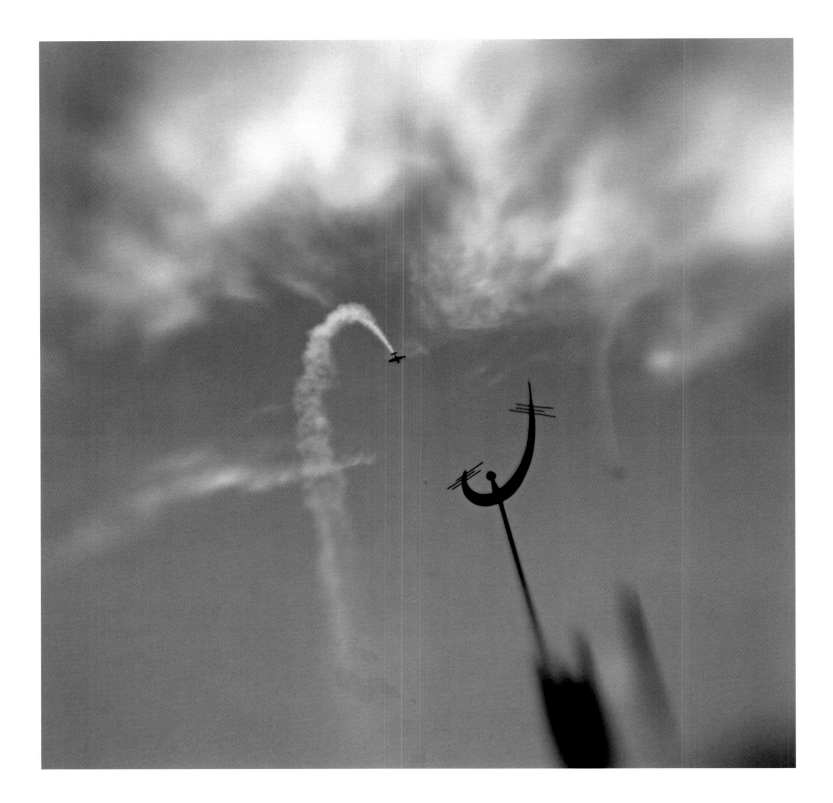

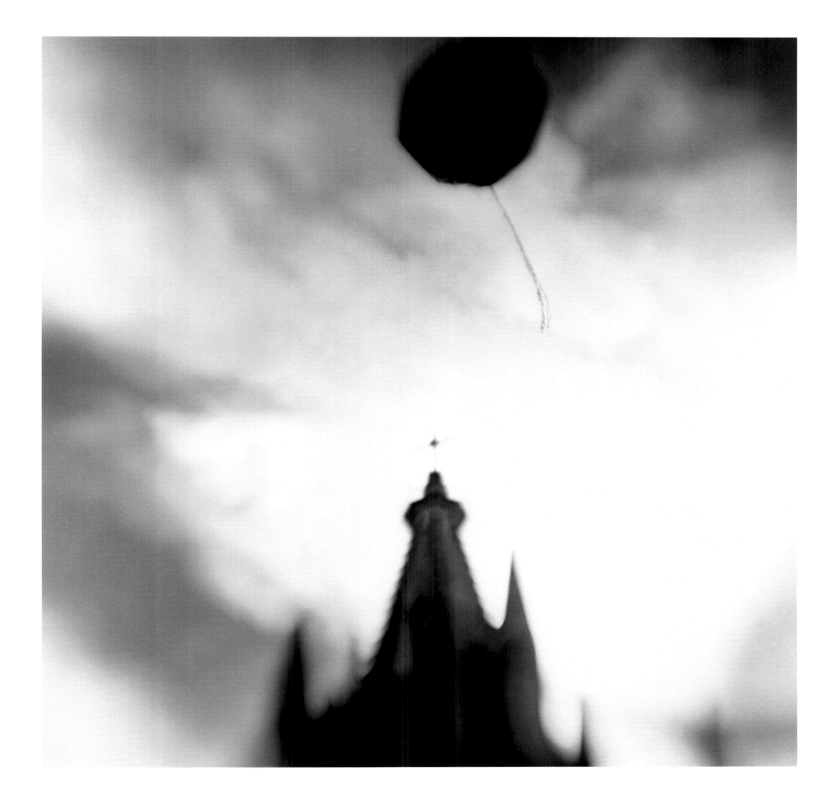

67 **DAWN** 2005

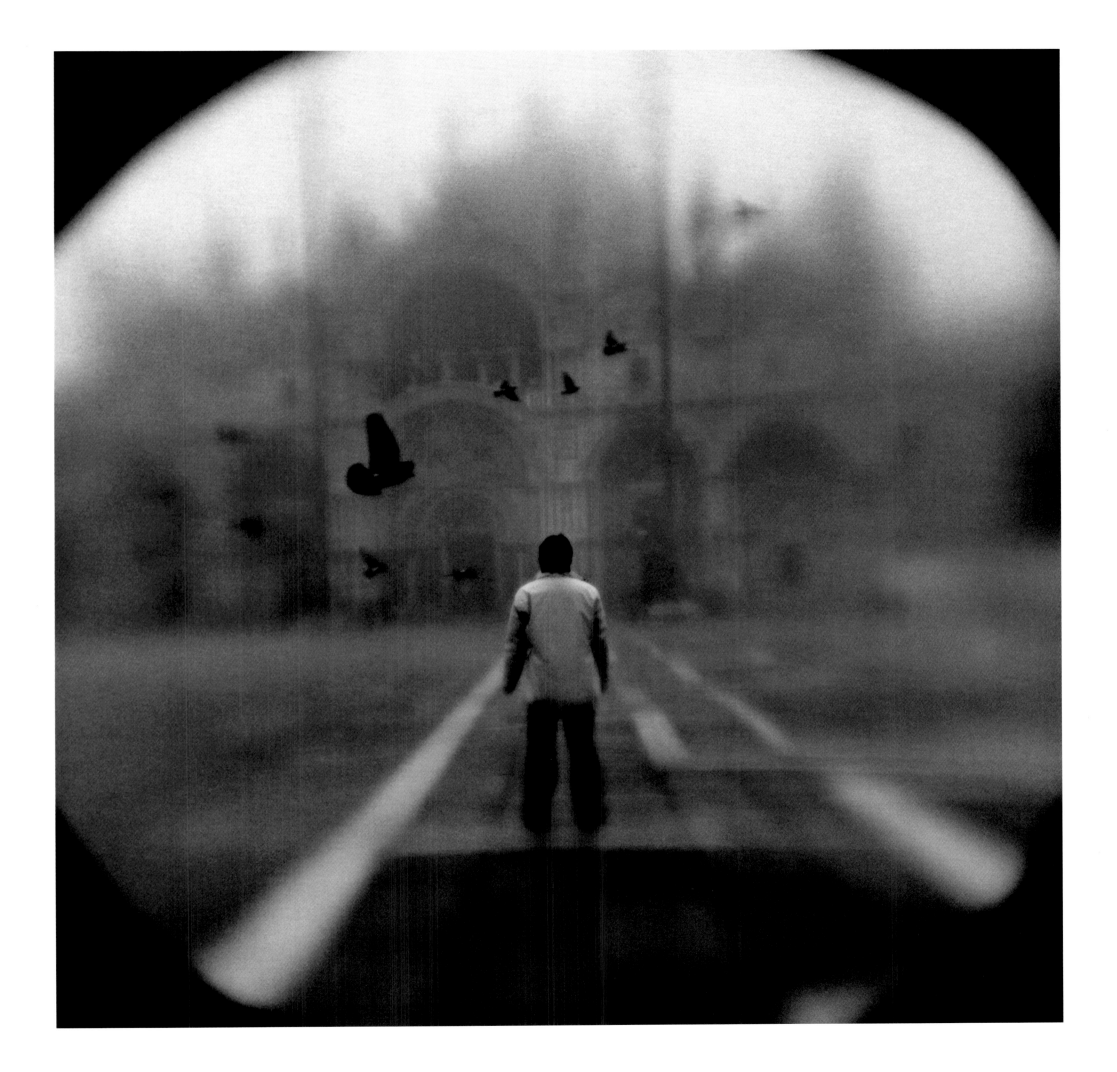

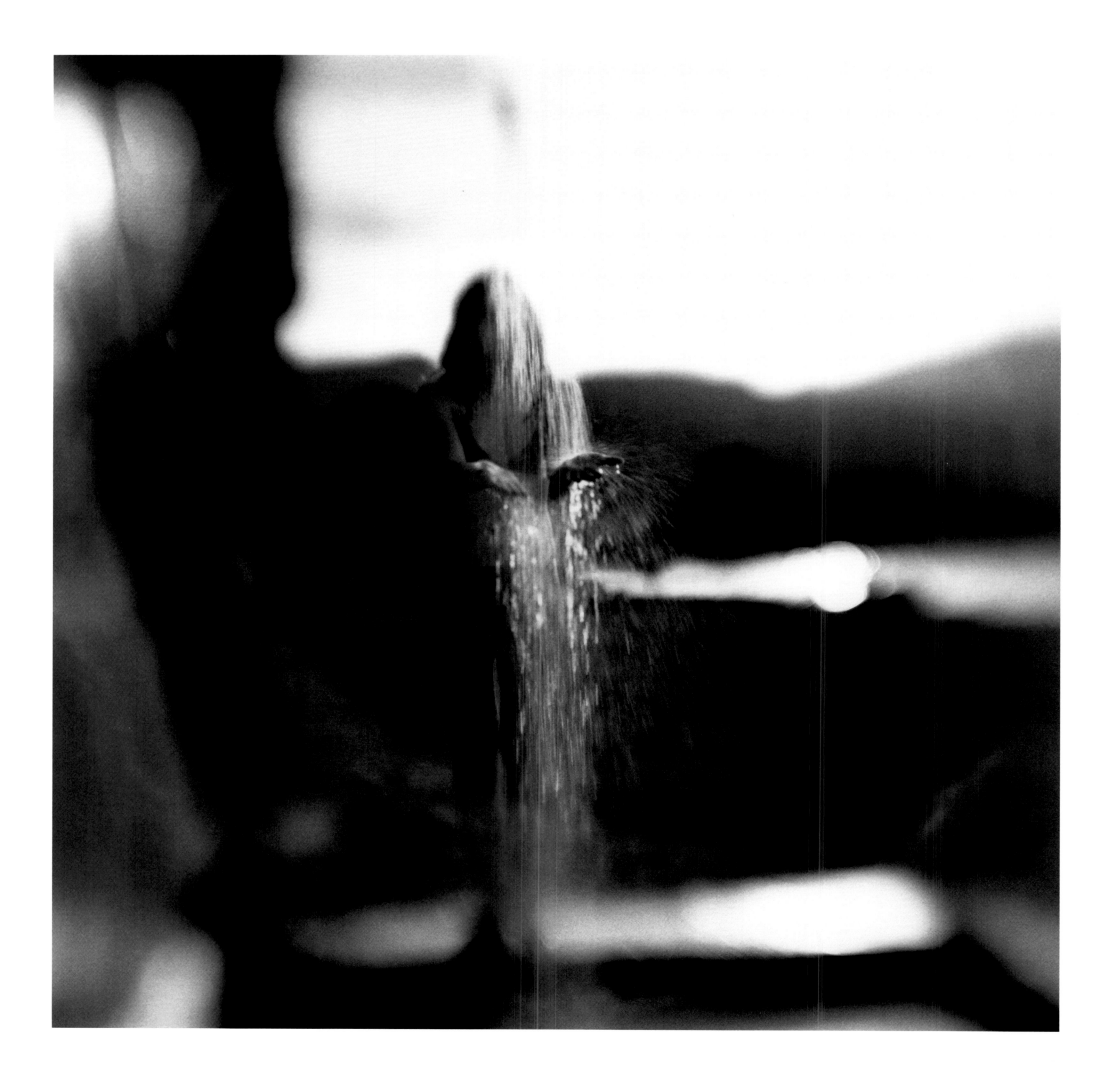

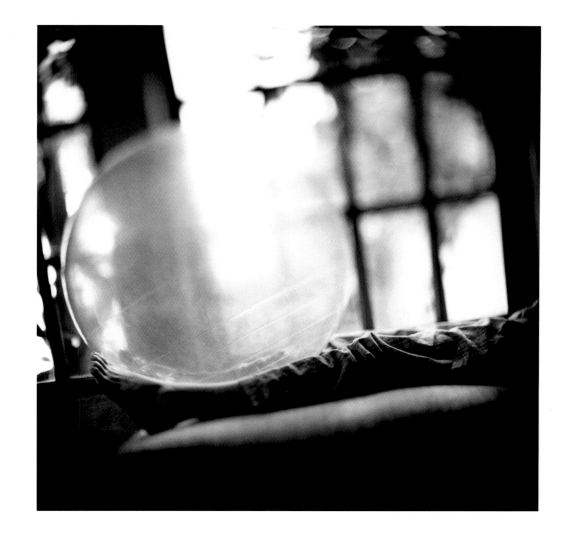

68 **SHOWER** 2004 | 69 **DAYDREAM** 2002

70 **DANCING BEAR** 2002

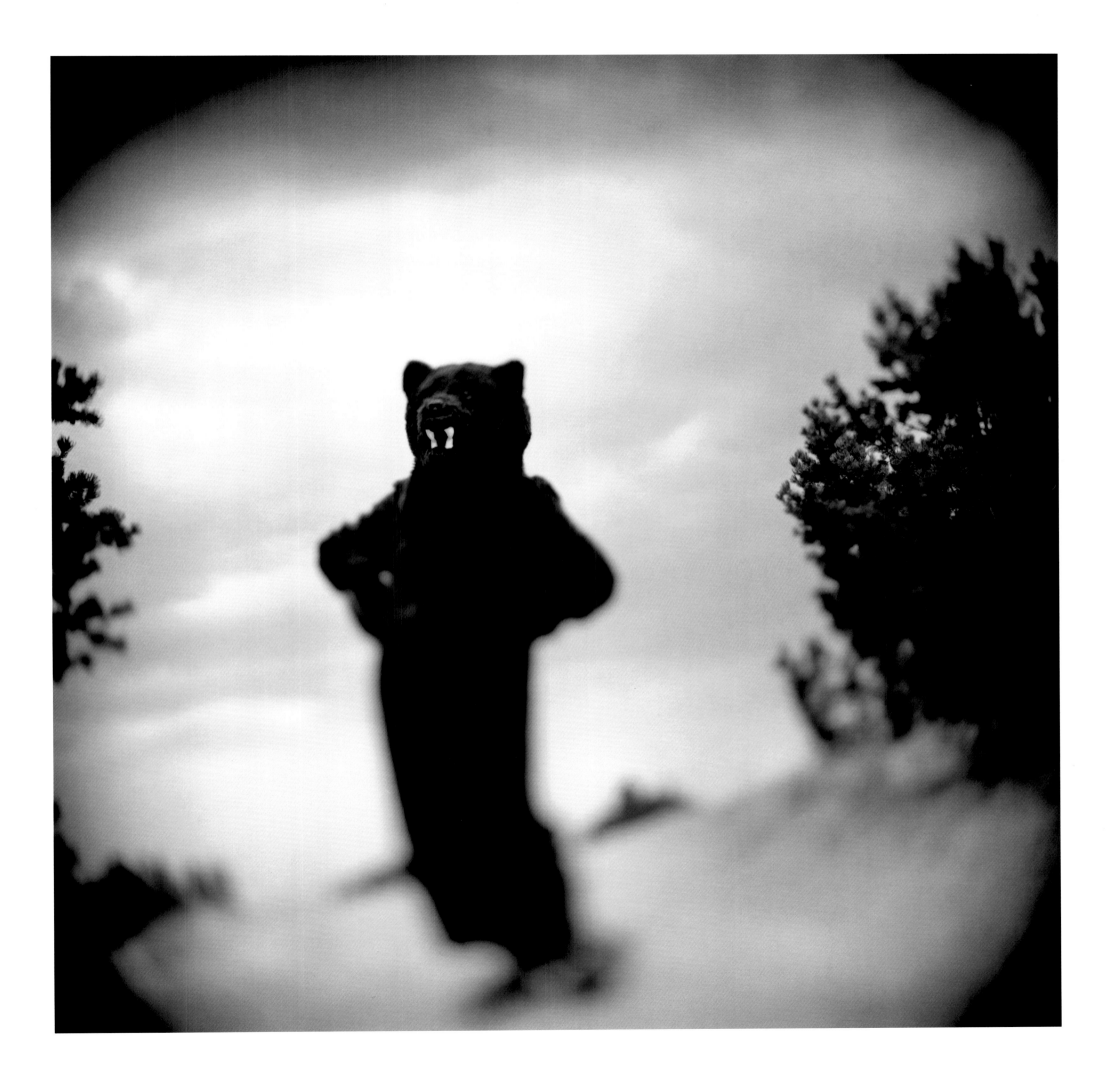

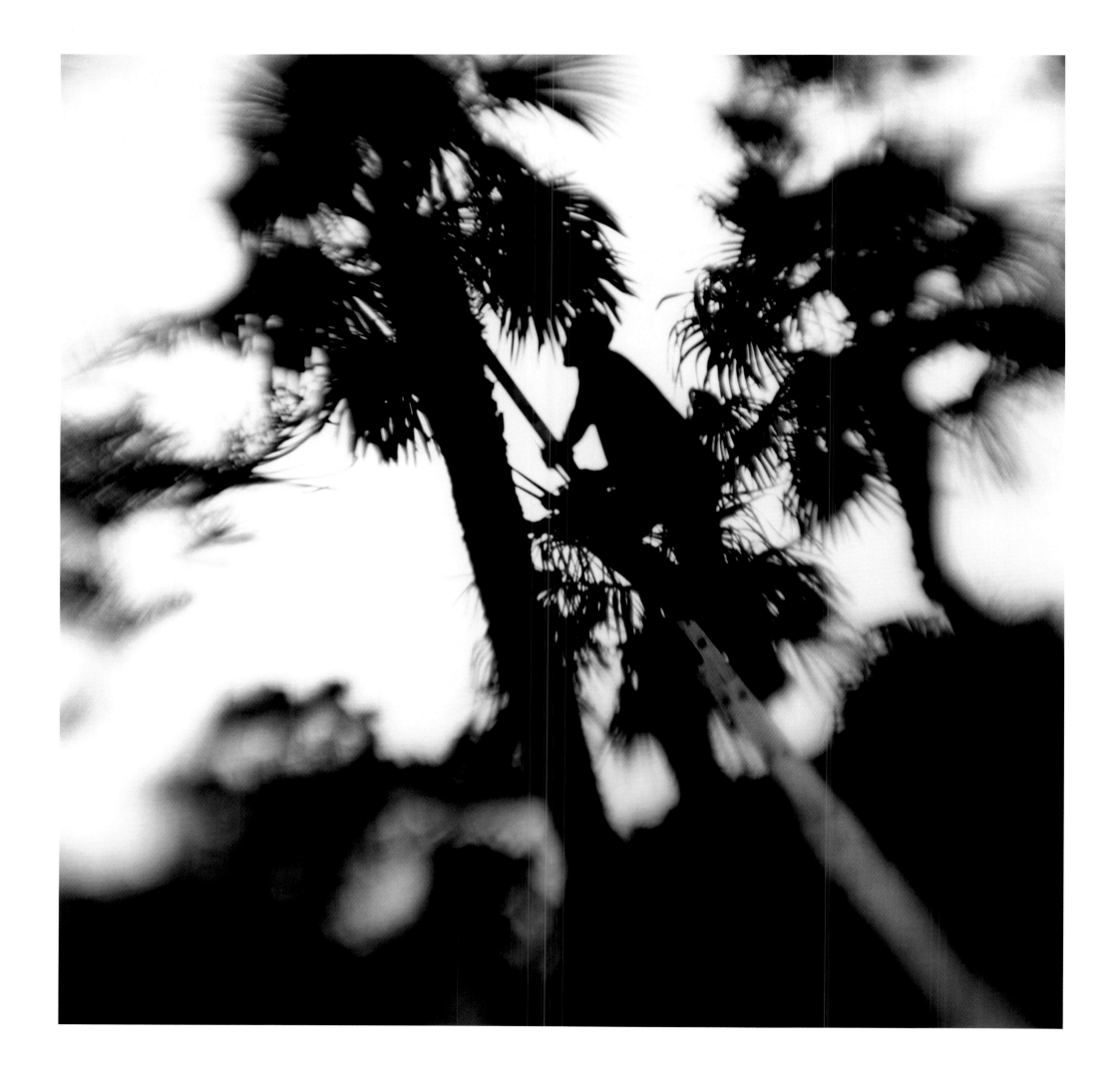

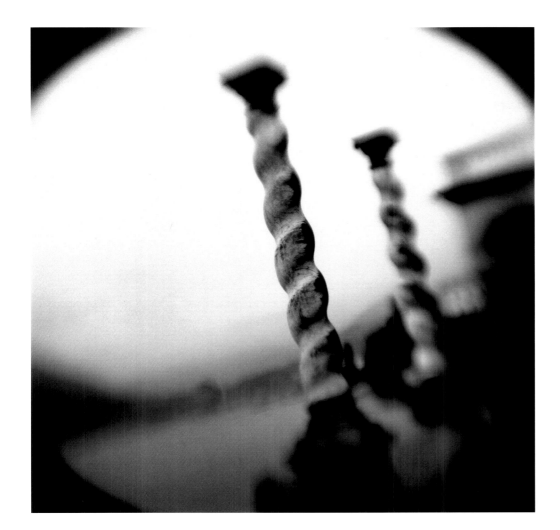

71 **PALM TREE** 2006 | 72 **TWO COLUMNS** 2005

73 **SEMINOLE CANYON** 2006

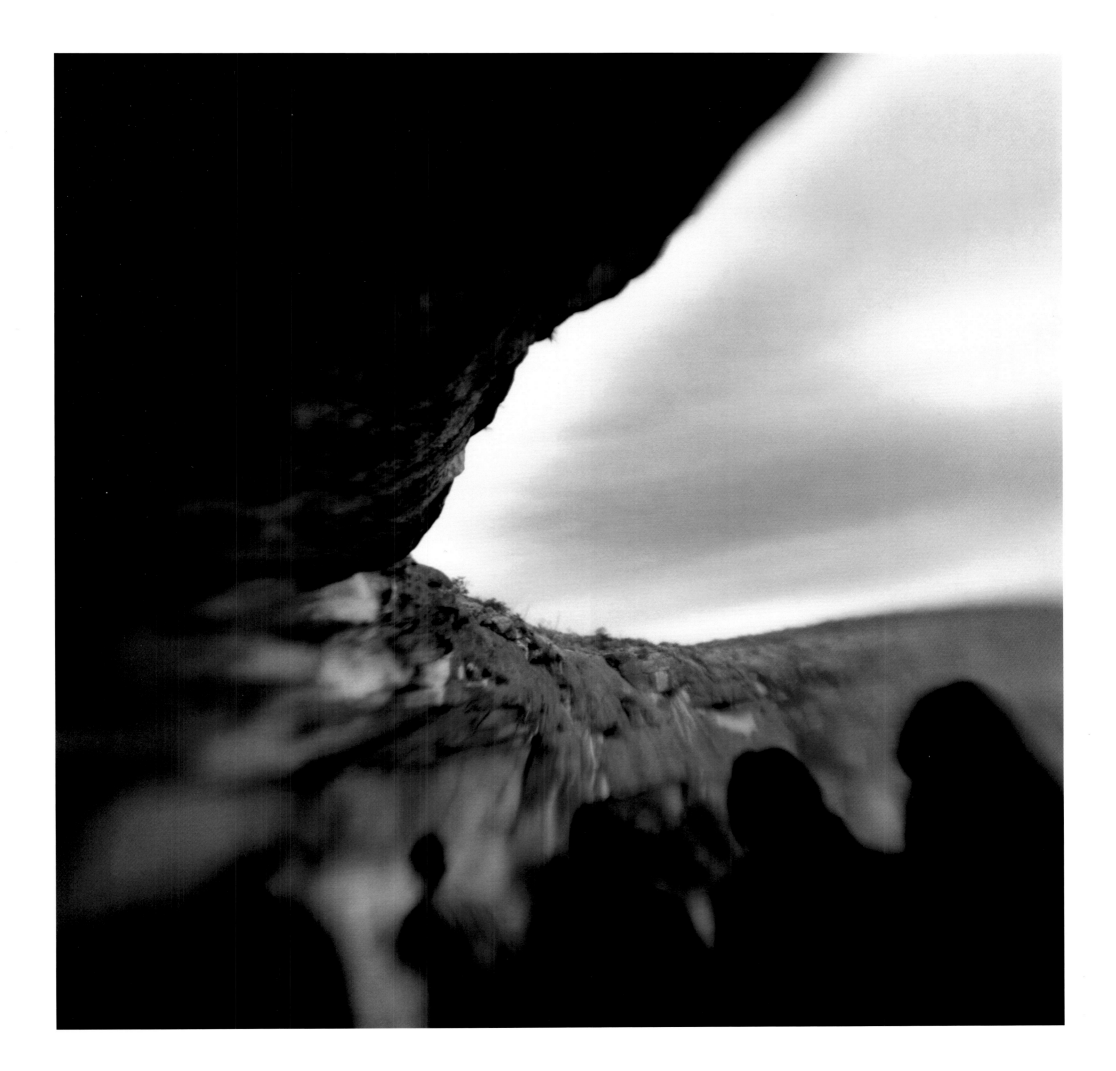

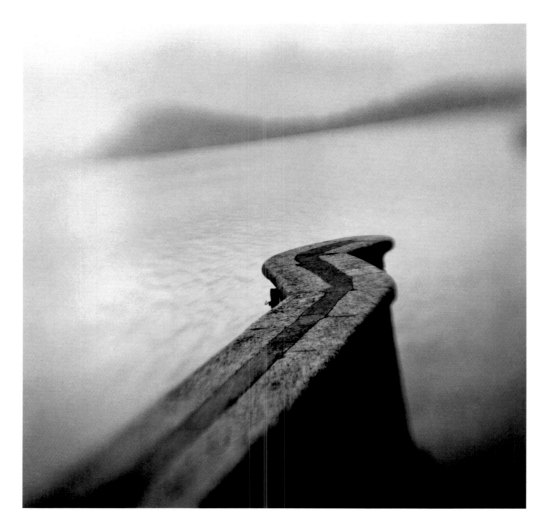

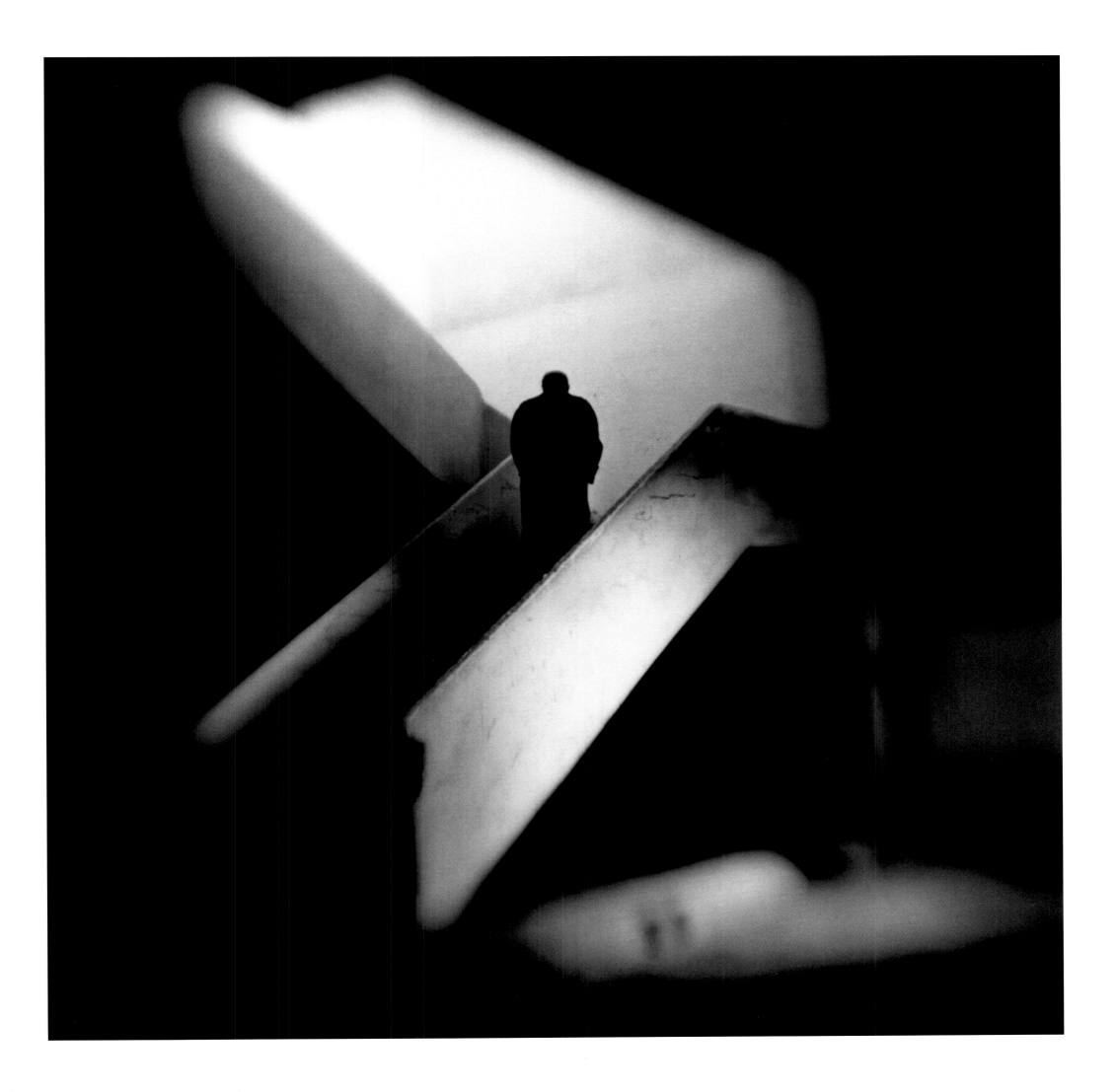

The photographs that work

grounded in grace

best for me are the ones

and intelligence.

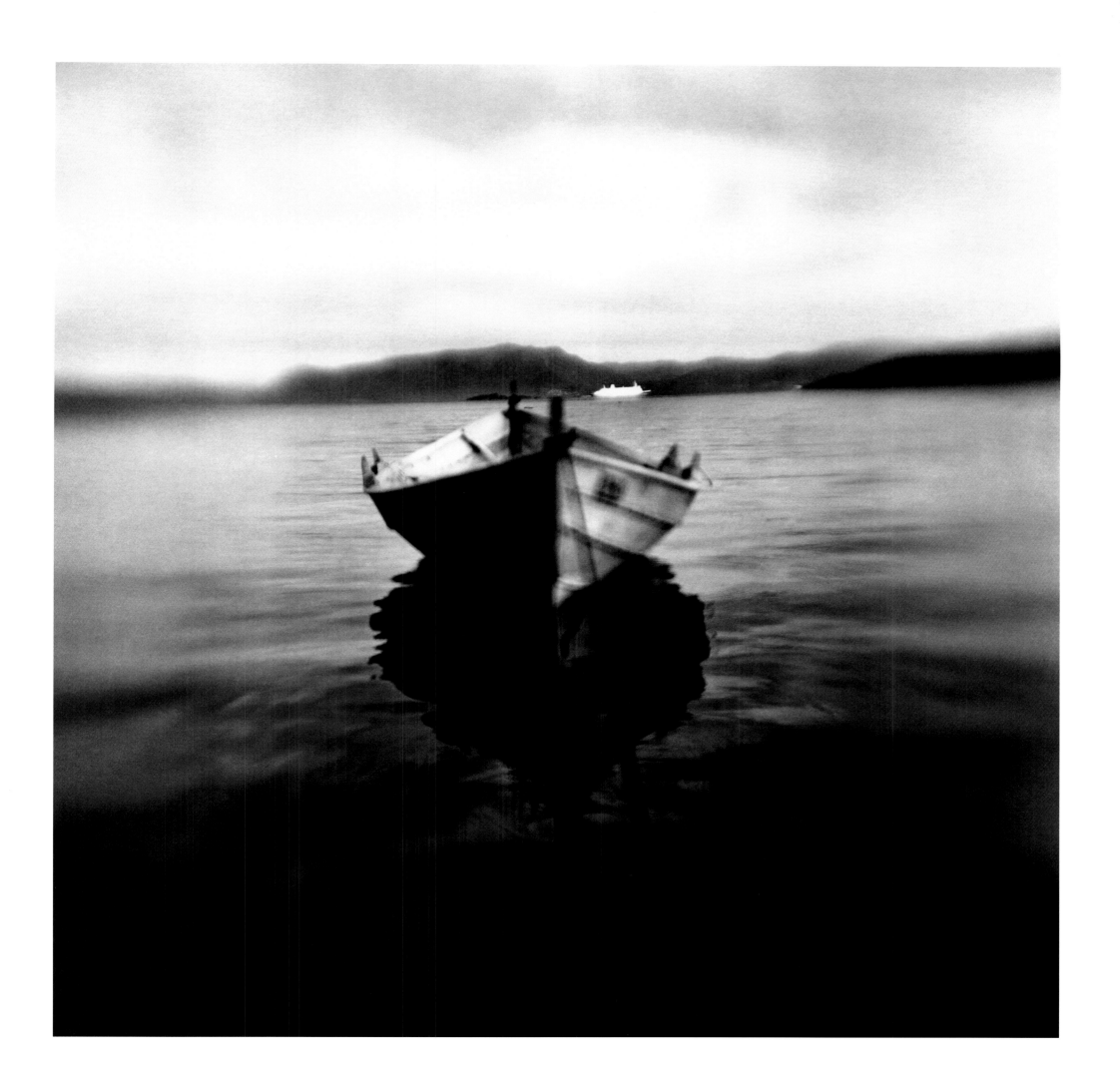

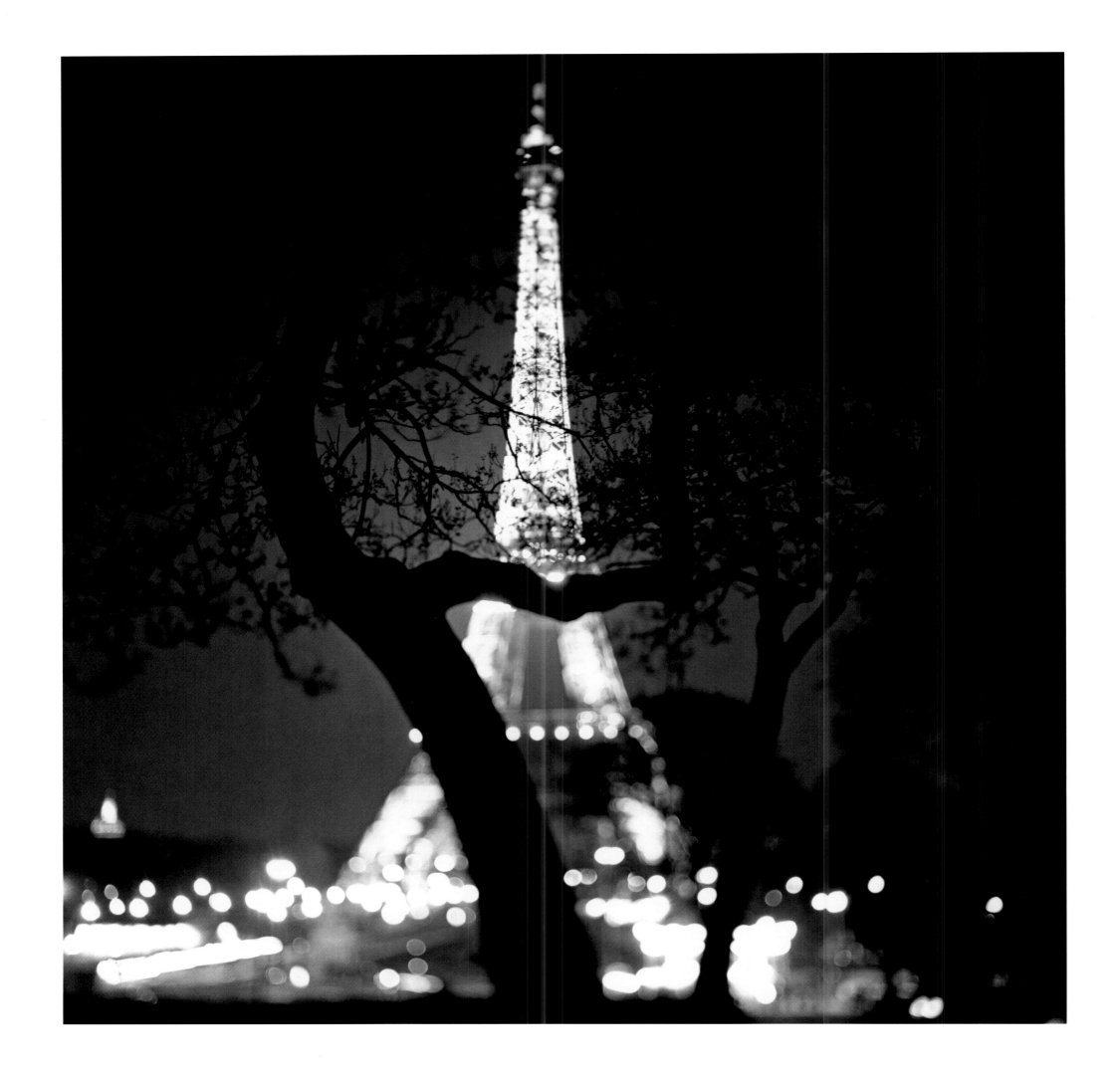

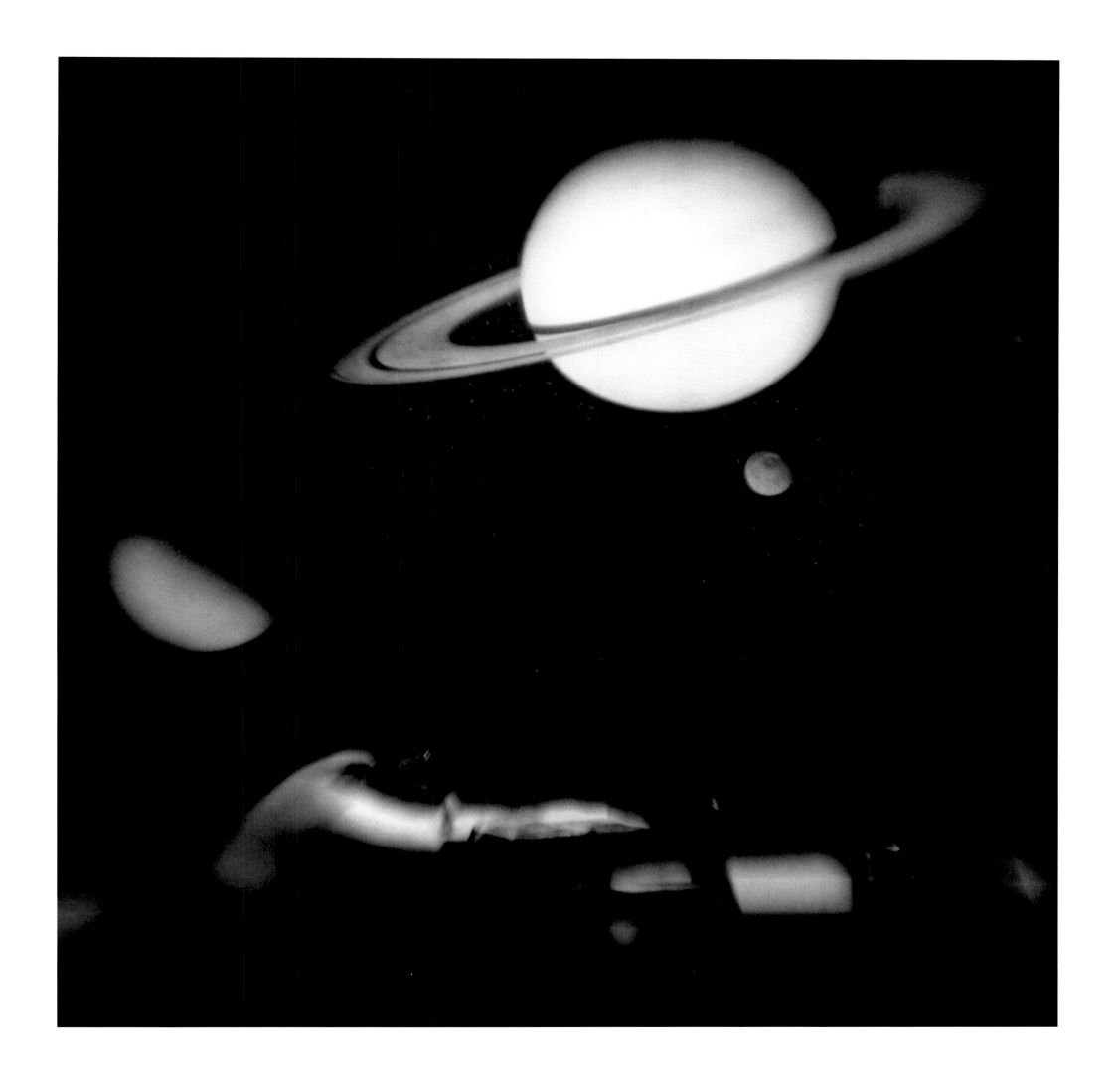

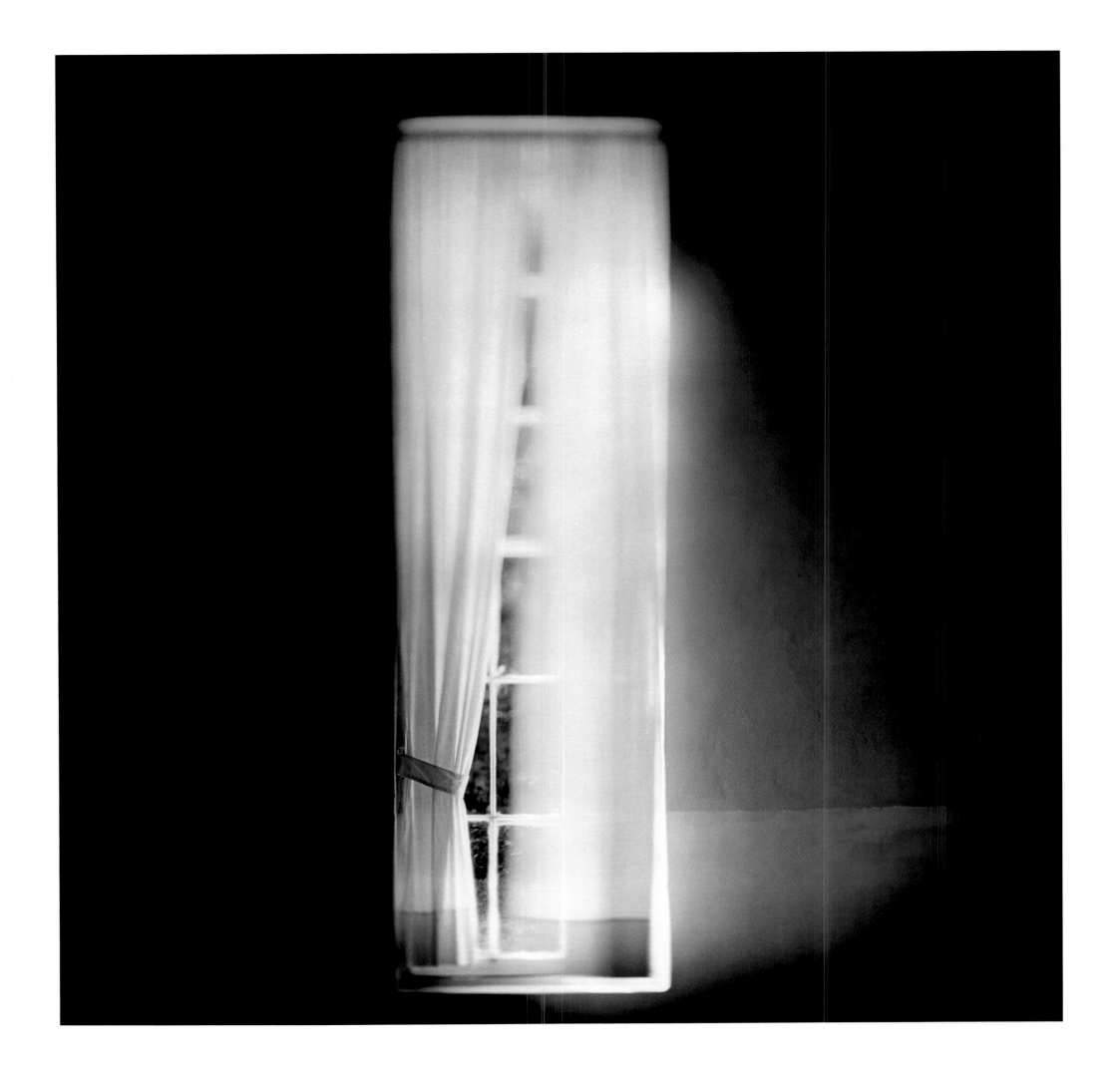

80 **WINDOW** 2002

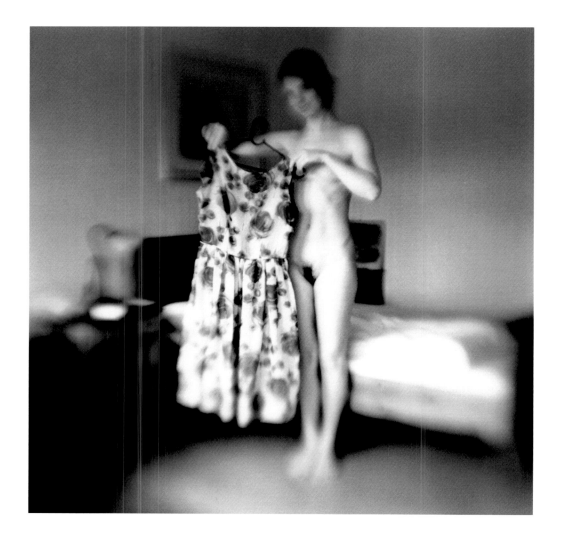

81 **GRANDMOTHER'S DRESS** 2005 | 82 **FISHBOWL** 2004

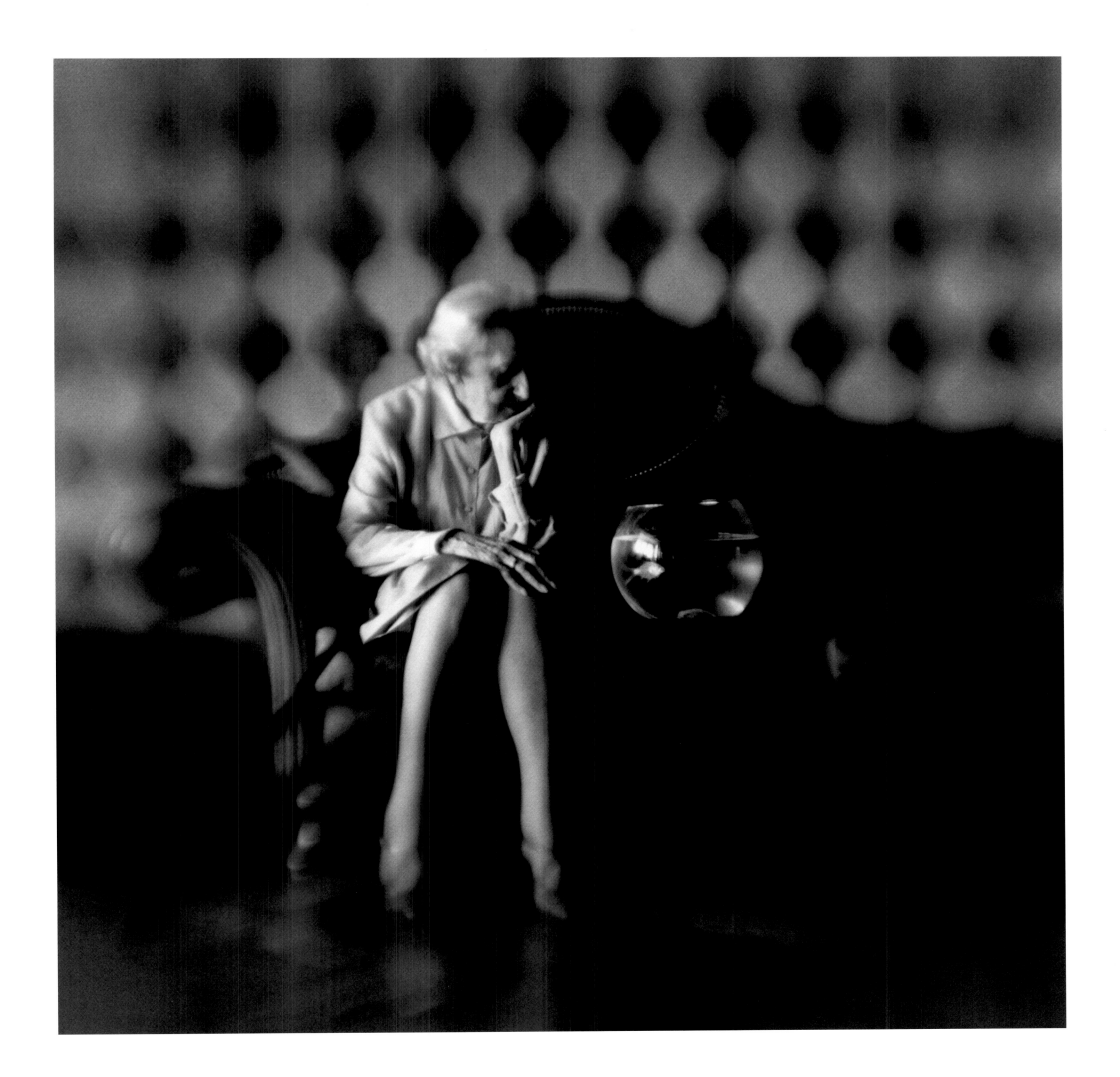

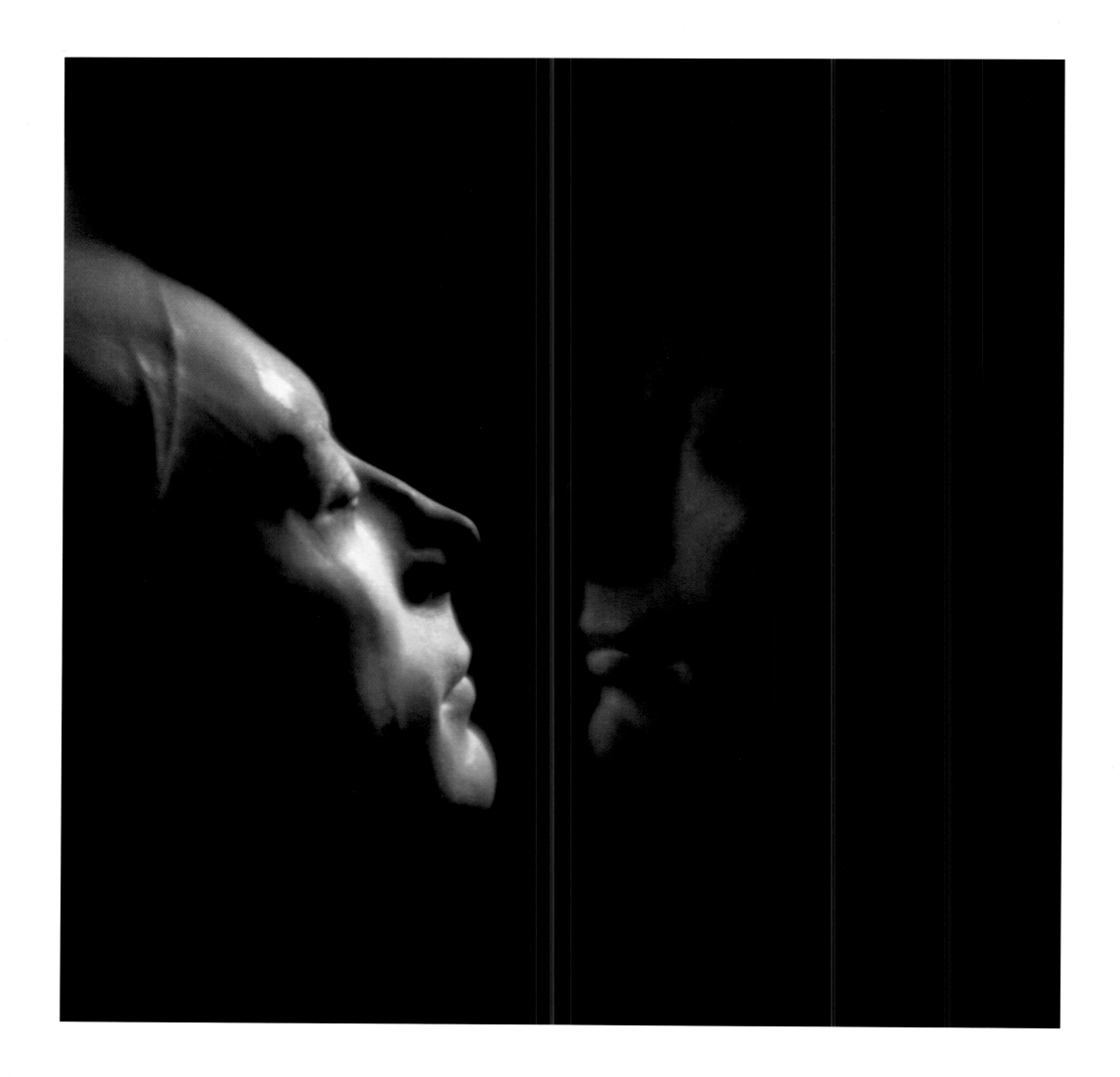

84 **FALLEN GIANT** 2005

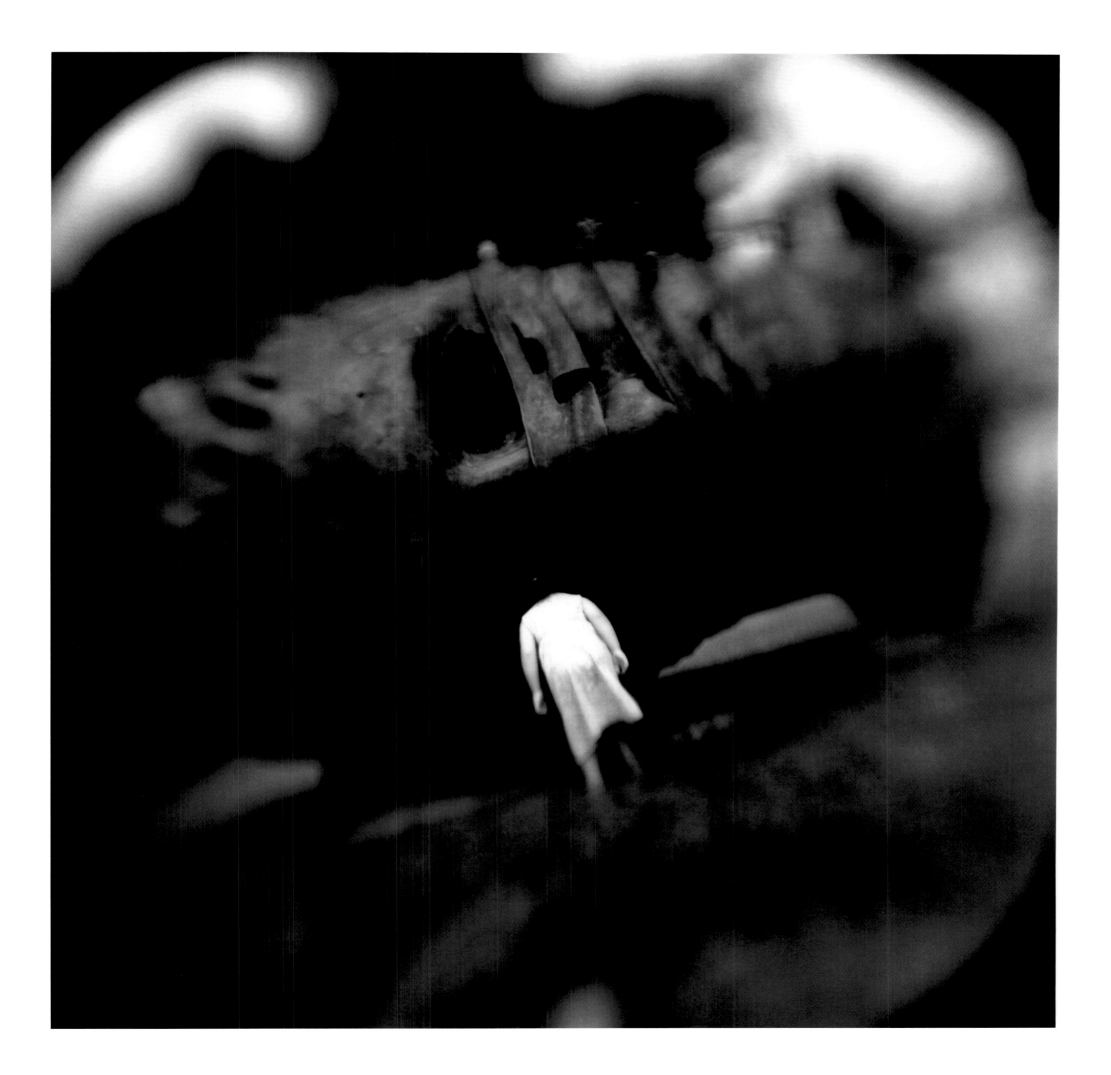

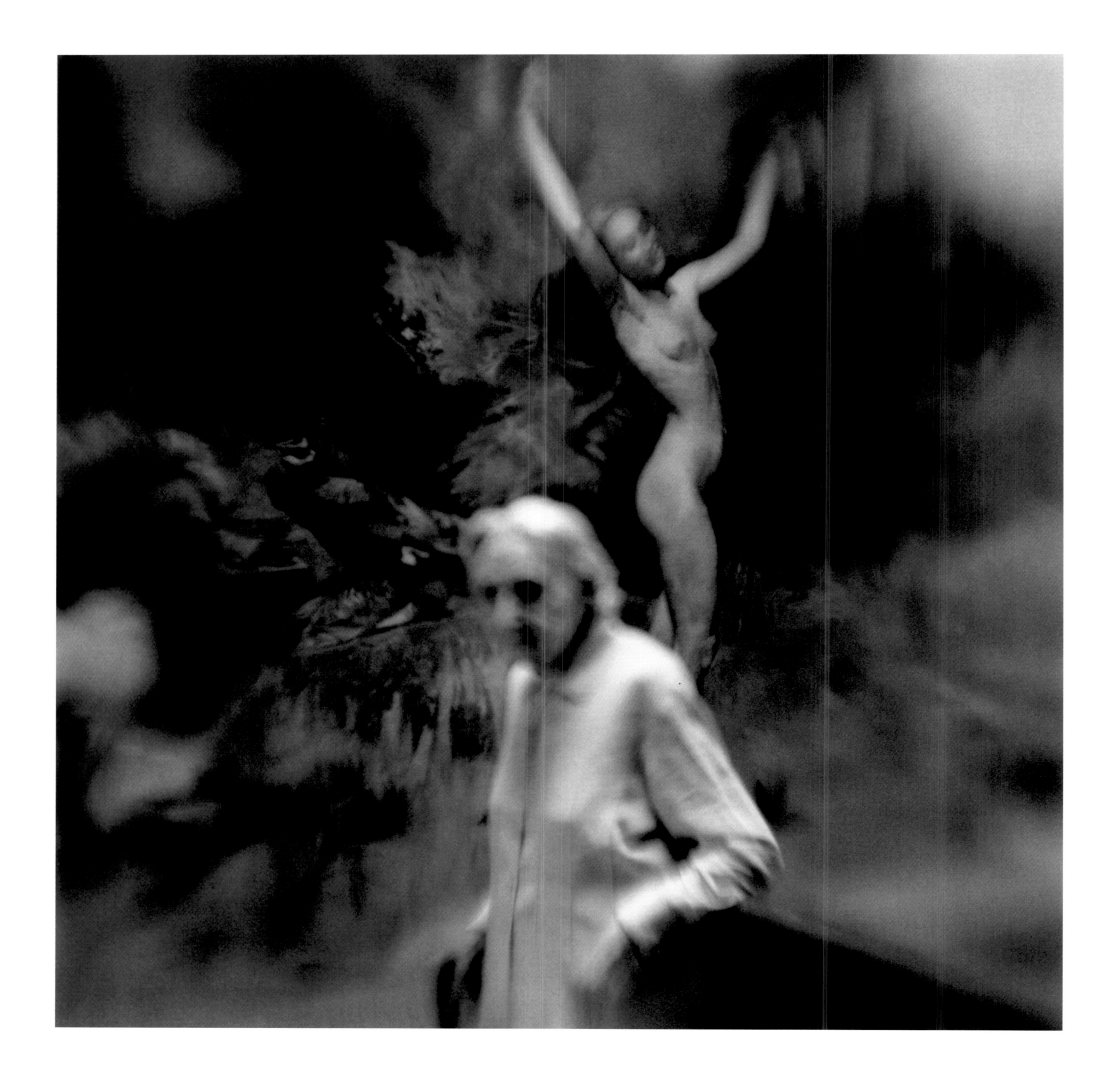

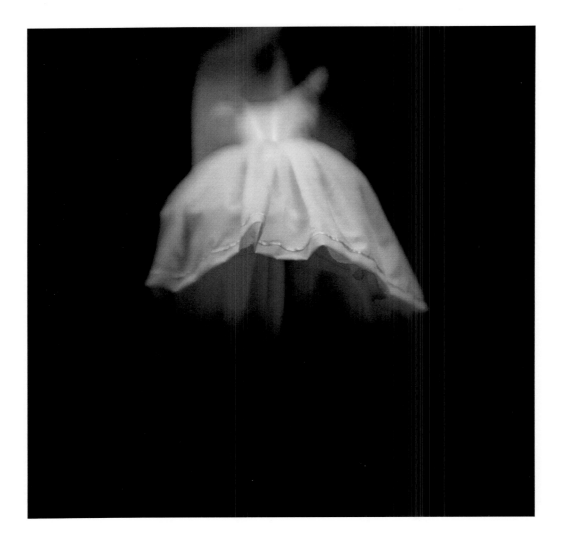

85 **MEZZANINE** 2004 | 86 **WHITE DRESS** 2003

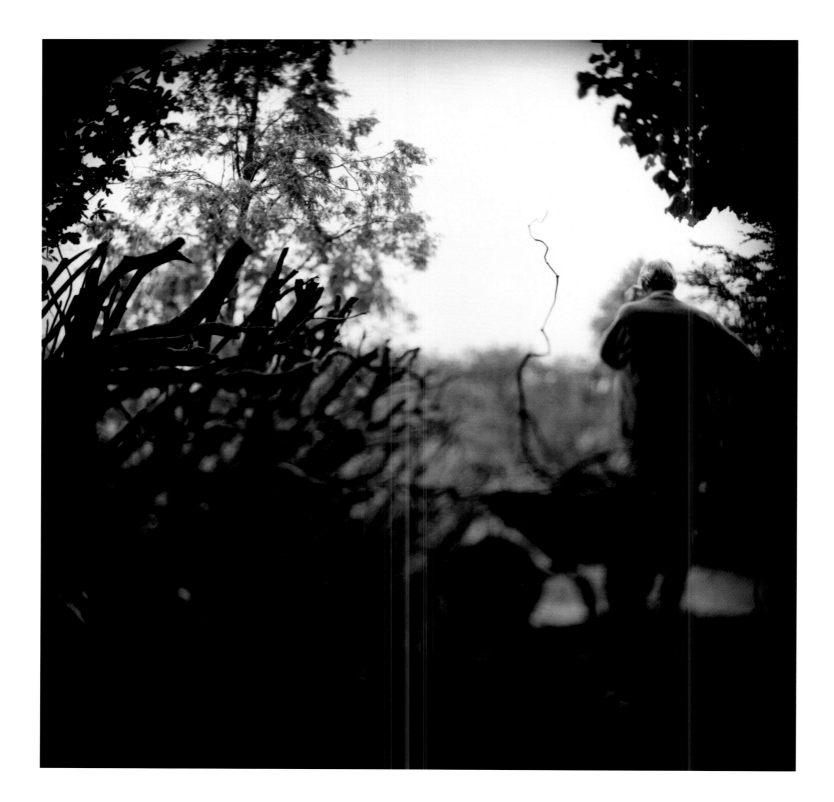

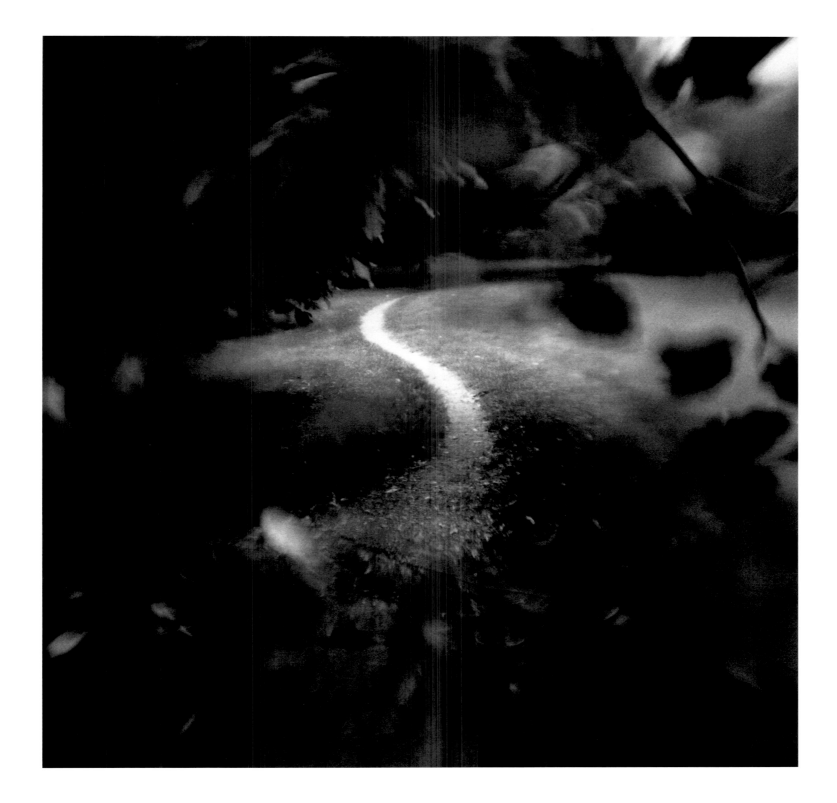

89 **MORNING WALK** 2000

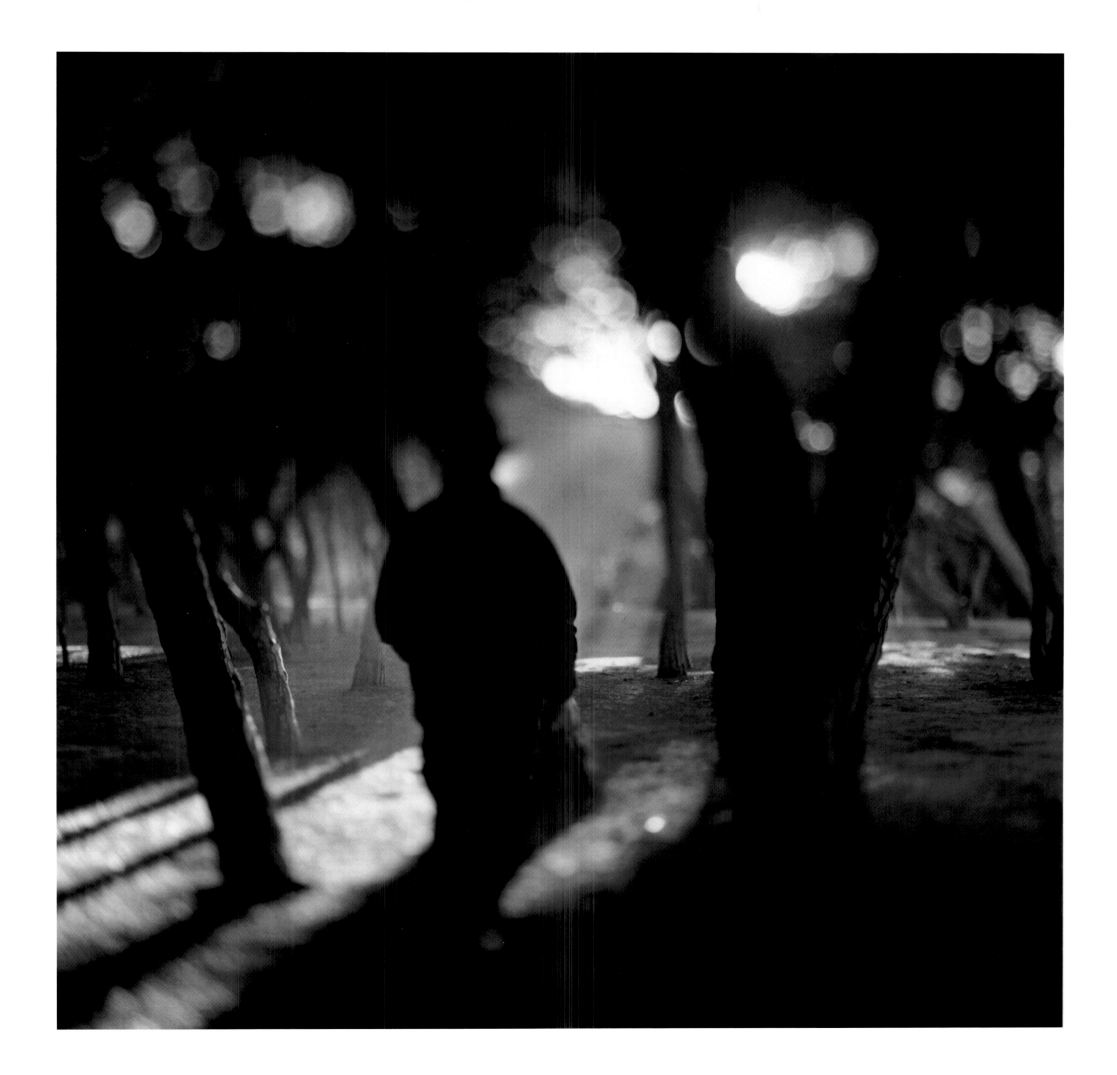

My mother, who had been a

of her life, passed away from

I took along a black piece of

I visited. Using duct tape, I

behind her and made portraits.

of us and no longer spoke.

me directly, sometimes she dozed.

through the viewfinder. When

Her hands, like small birds,

portrait photographer much

Alzheimer's. In her last year

cloth and my camera when

fastened the cloth to the wall

At the time she had no memory

Sometimes she would look at

Mostly I waited, looking

awake, she would rock herself.

were constantly in motion.

90 **JANE NO. 17** 2005

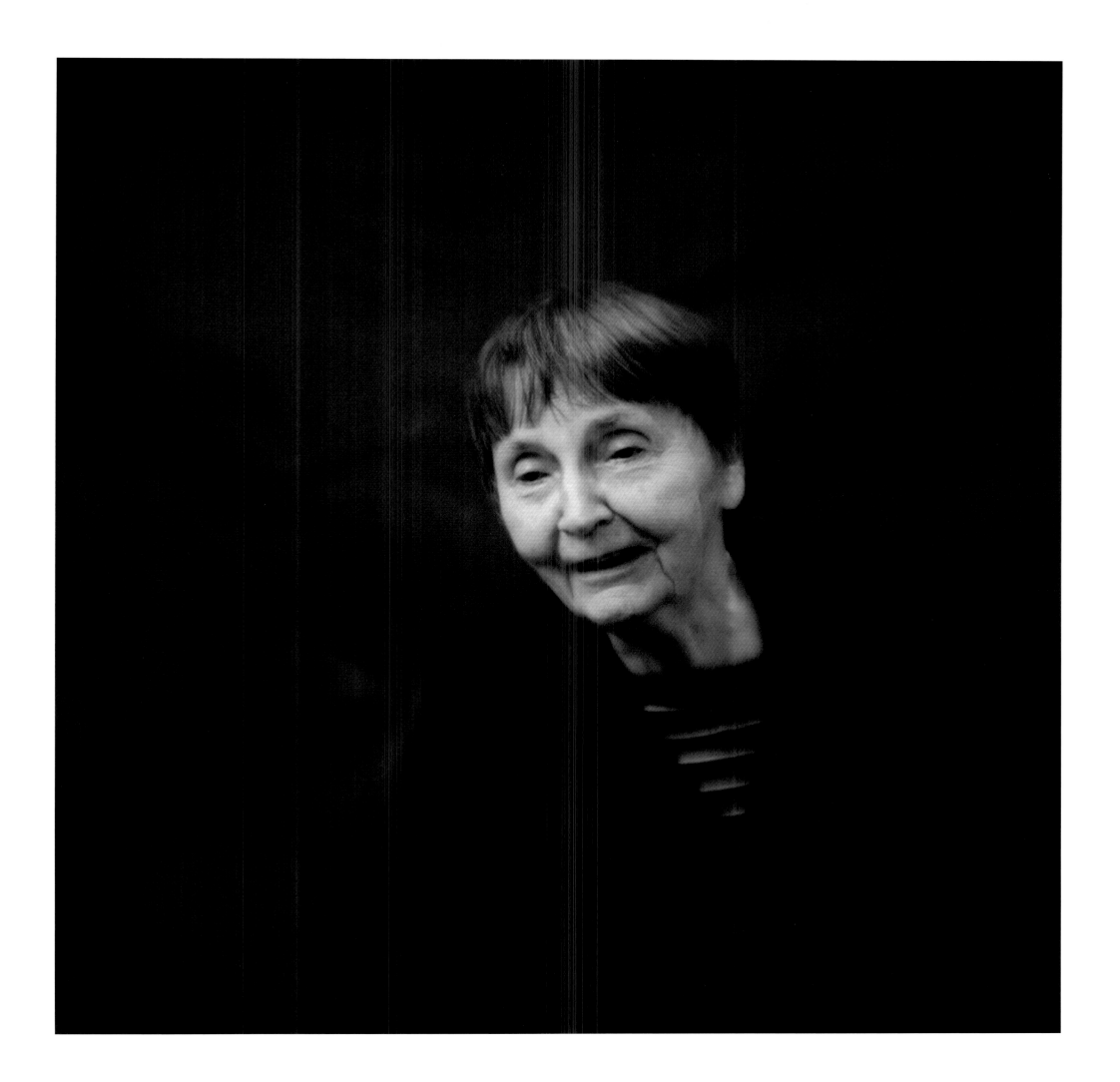

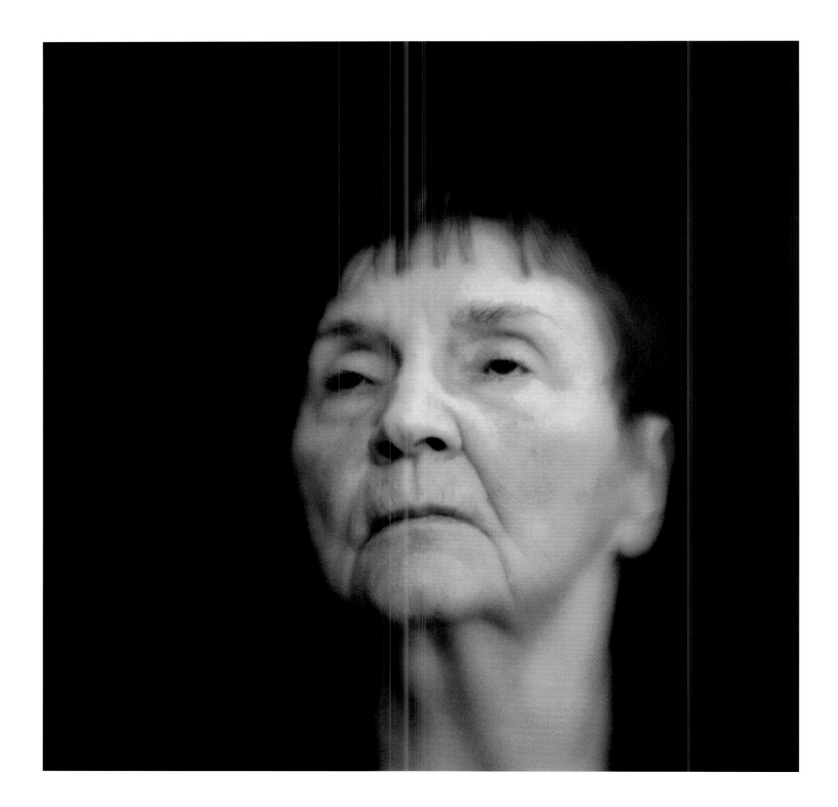

JANE NO. 42 2005

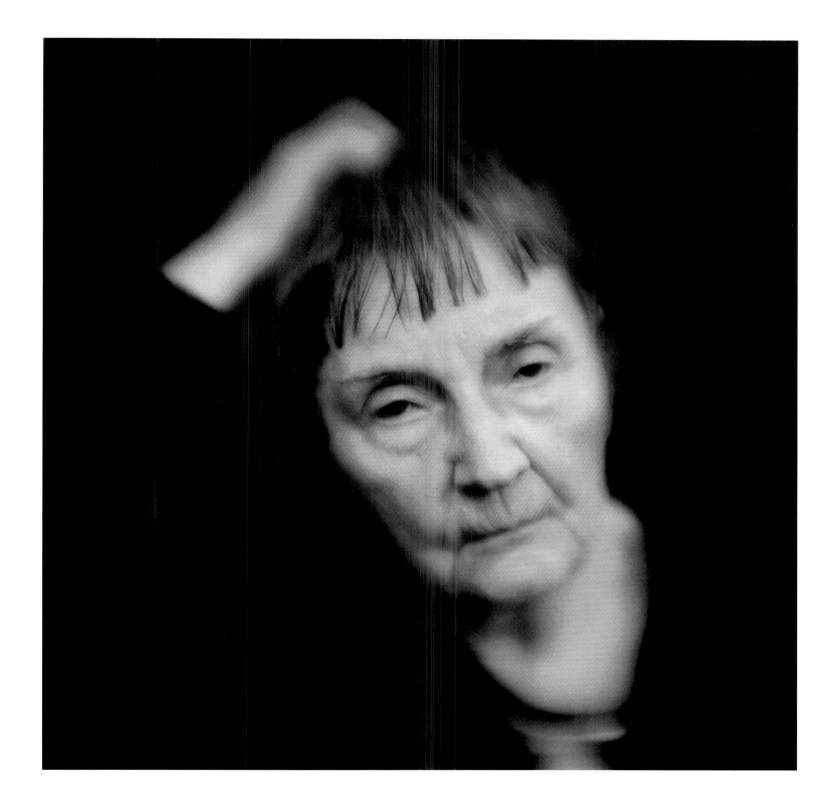

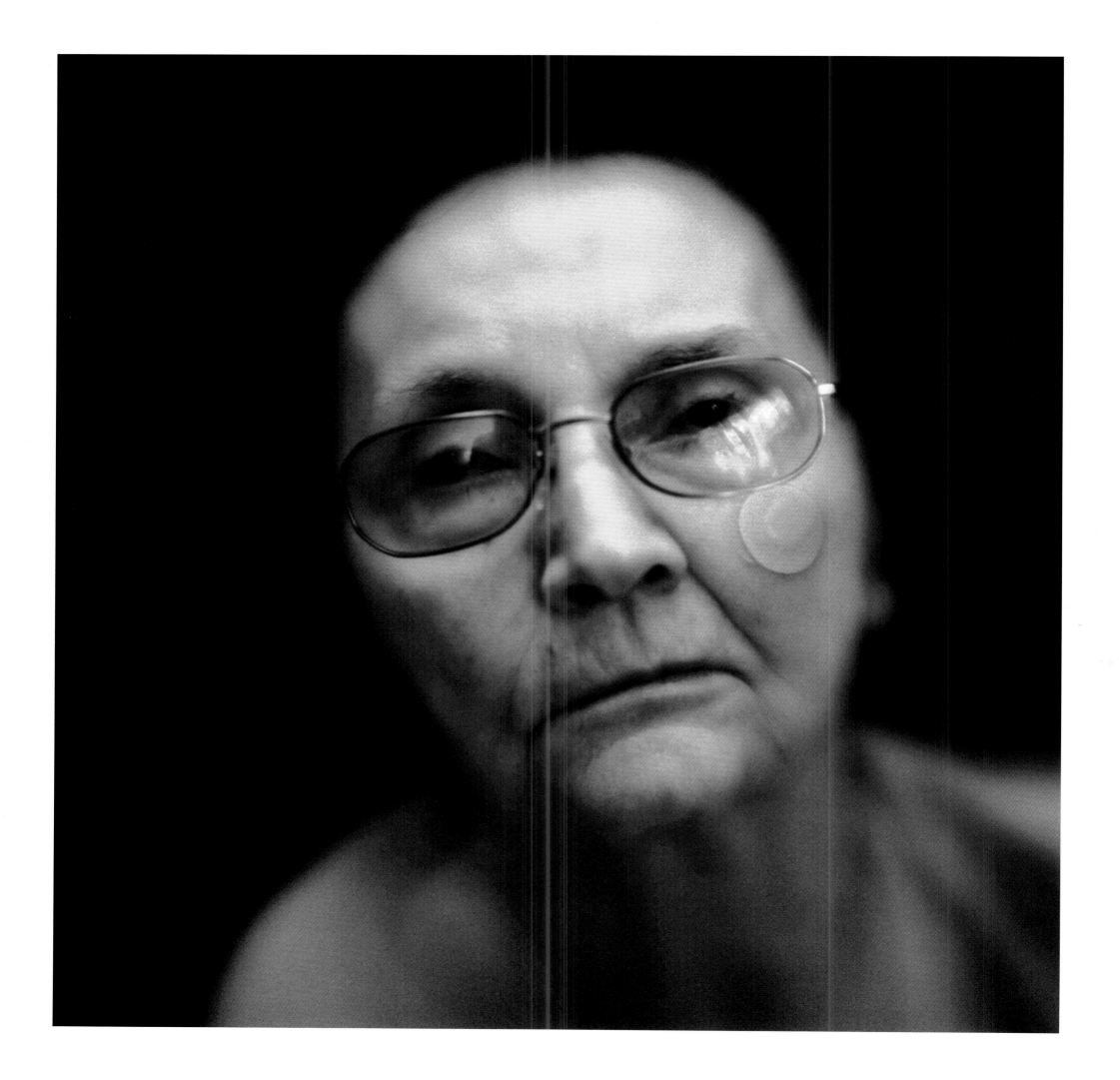

93 **JANE NO. 34** 2006

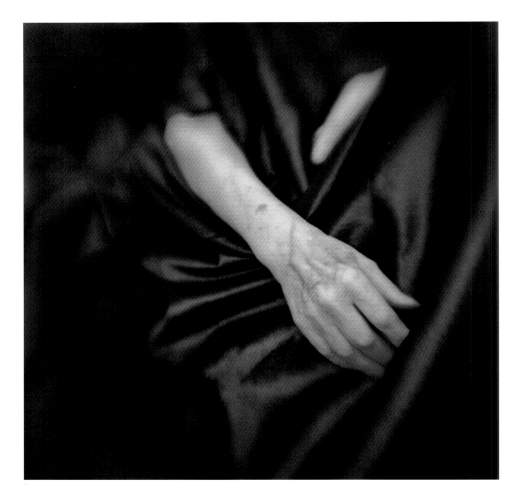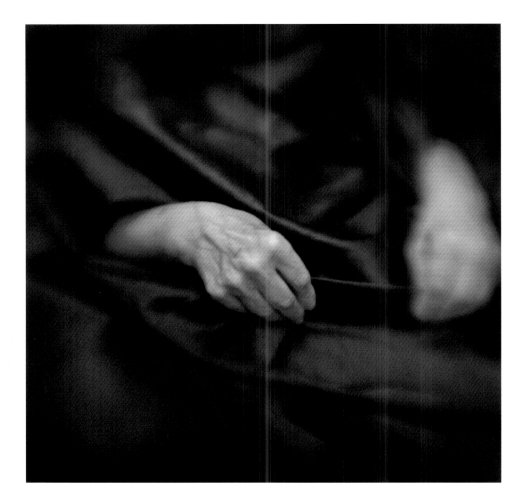

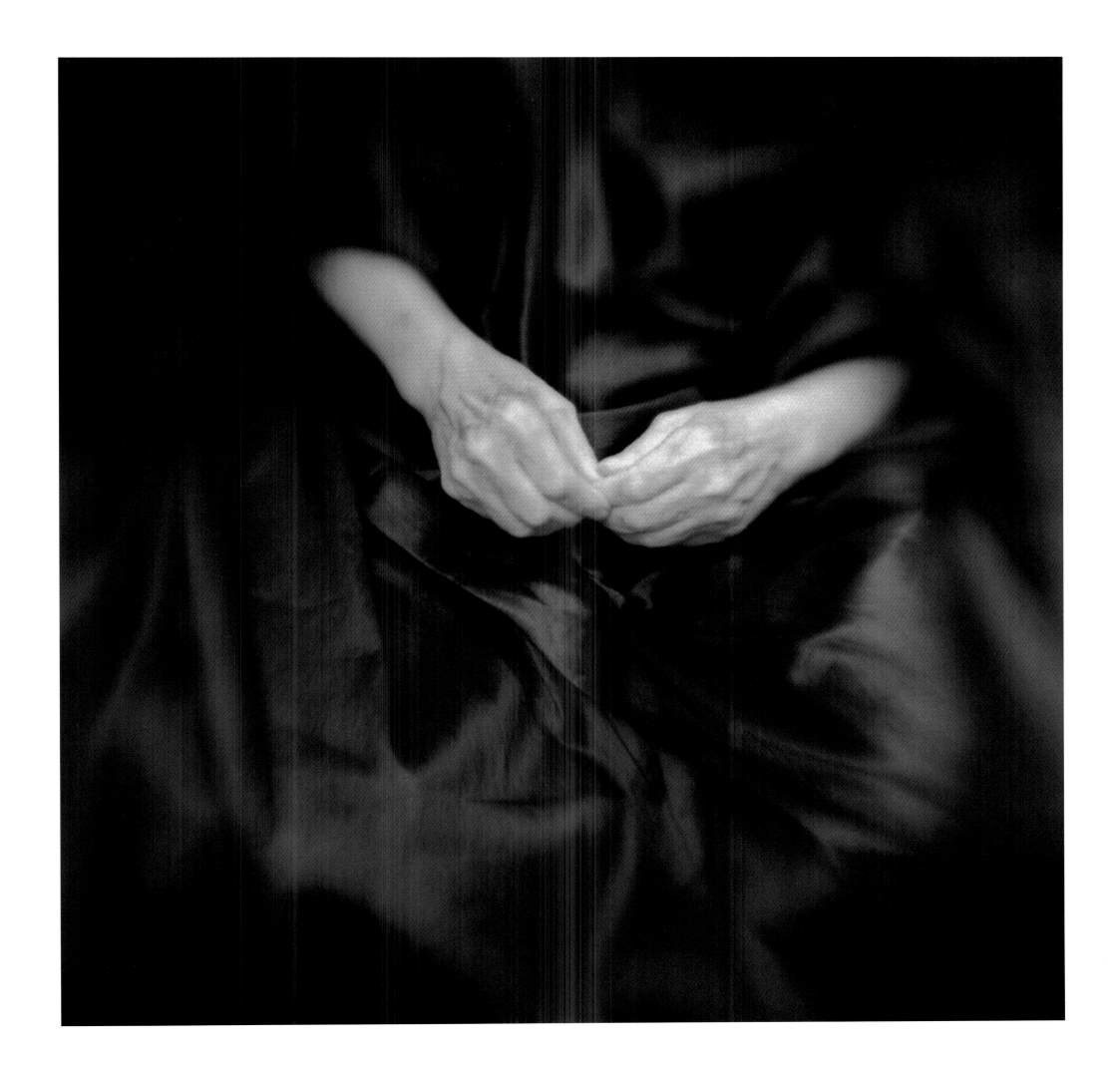

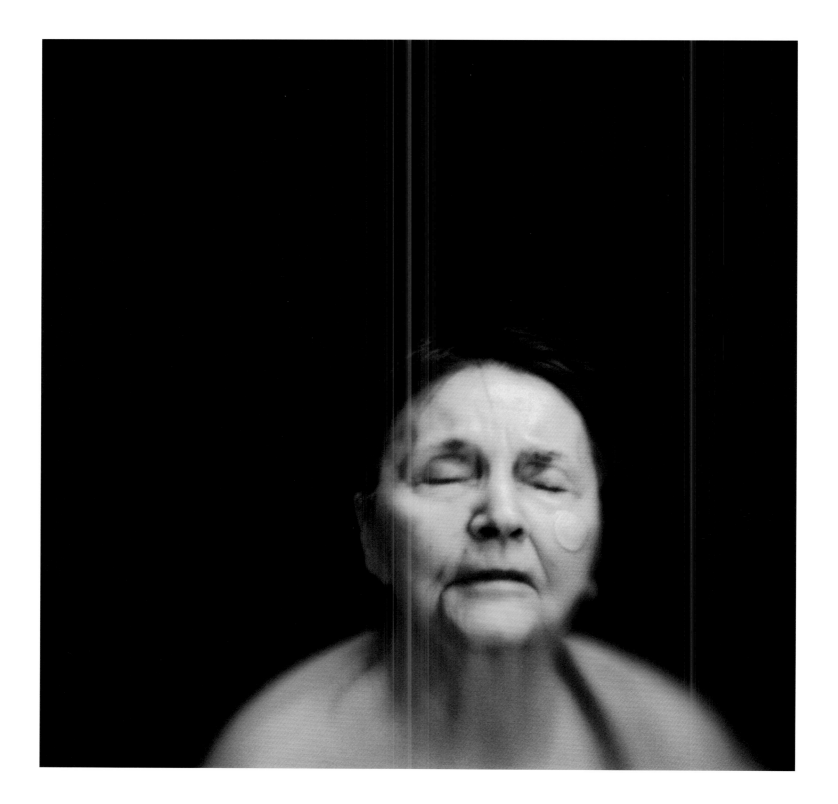

JANE NO. 31 2006

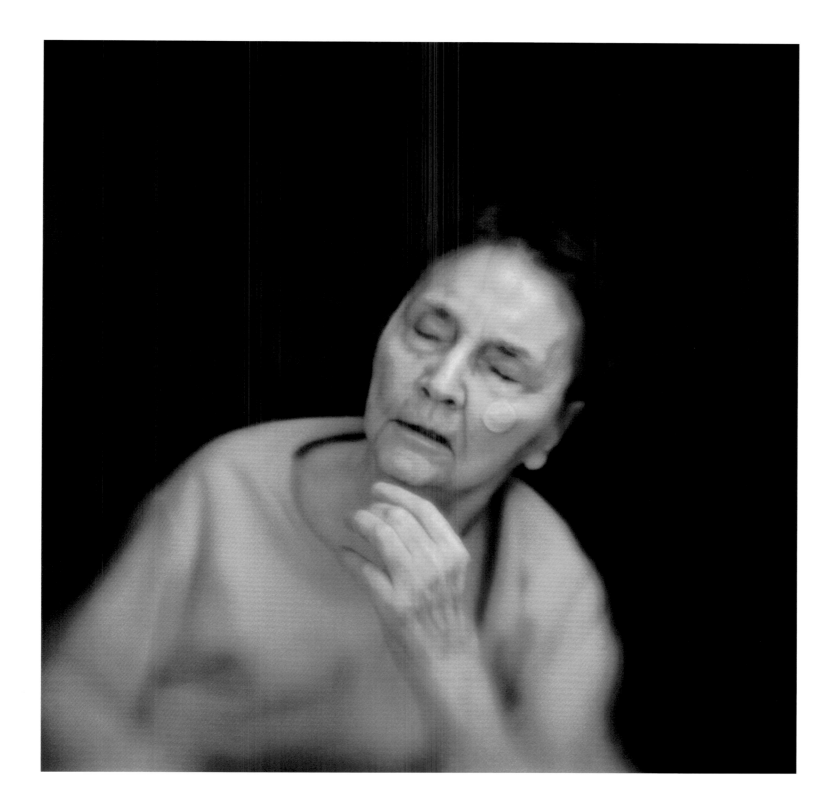

101 **JANE NO. 28** 2006

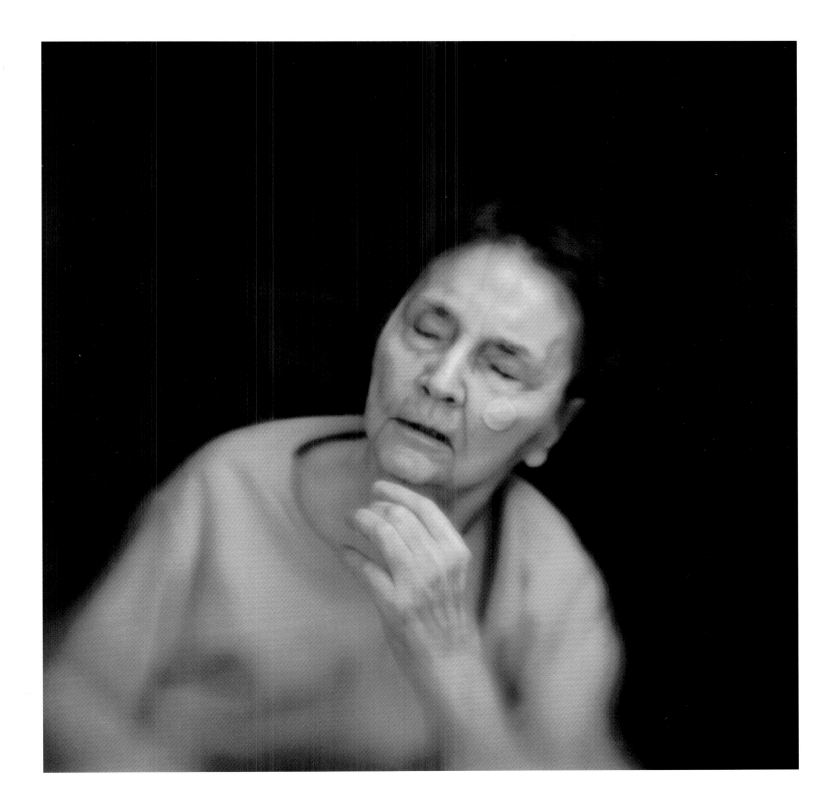

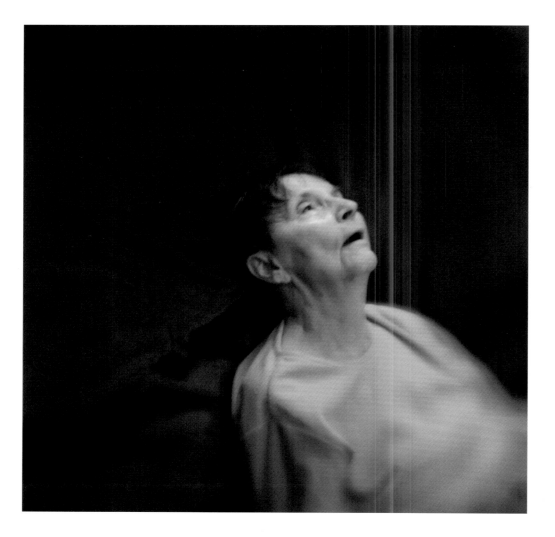

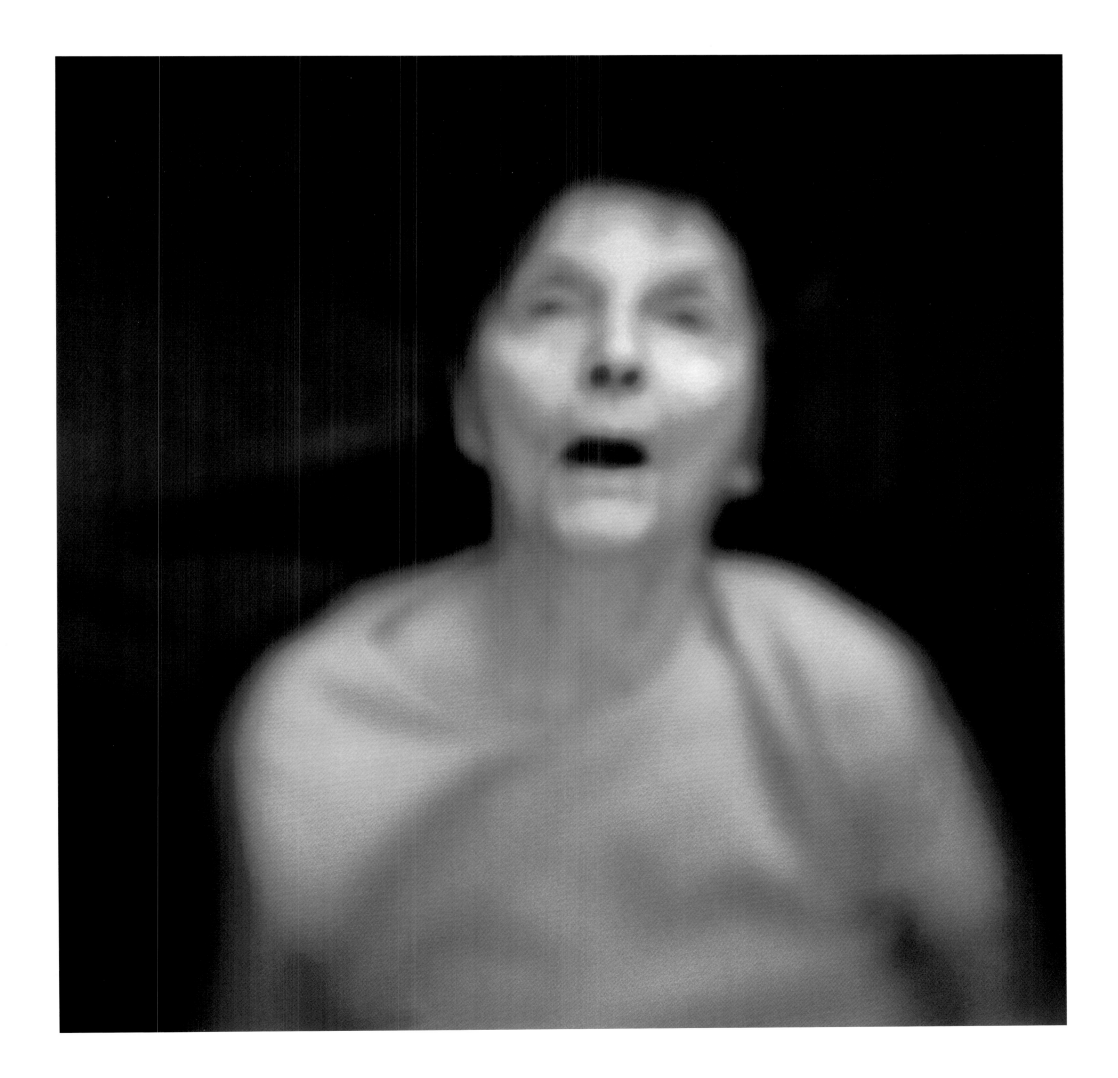

101 **JANE NO. 28** 2006

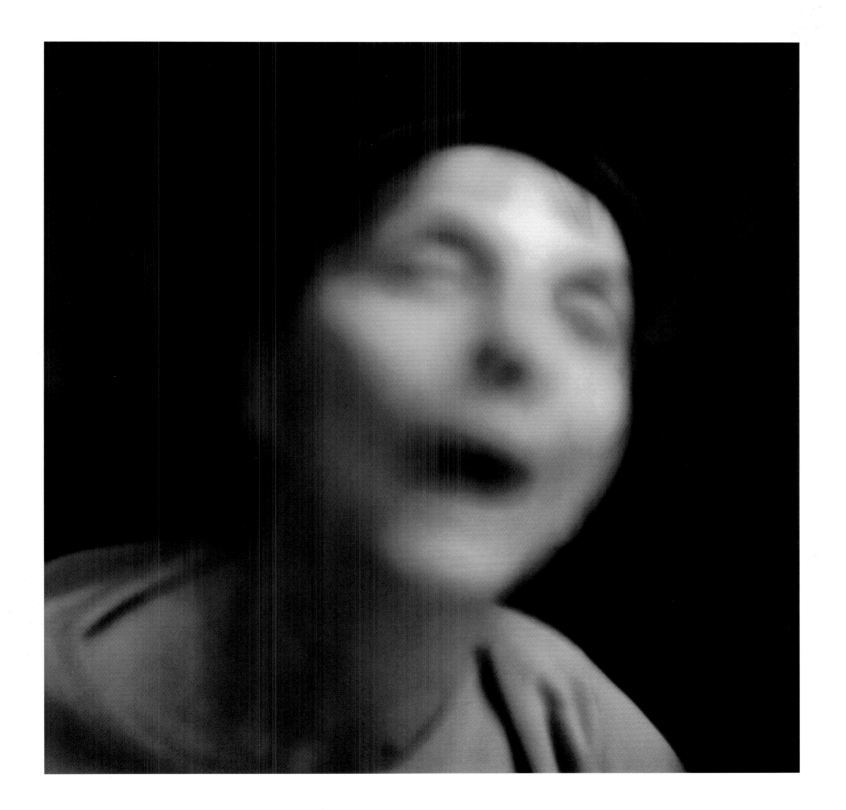

The raw materials of photography

are time, light, and memory.

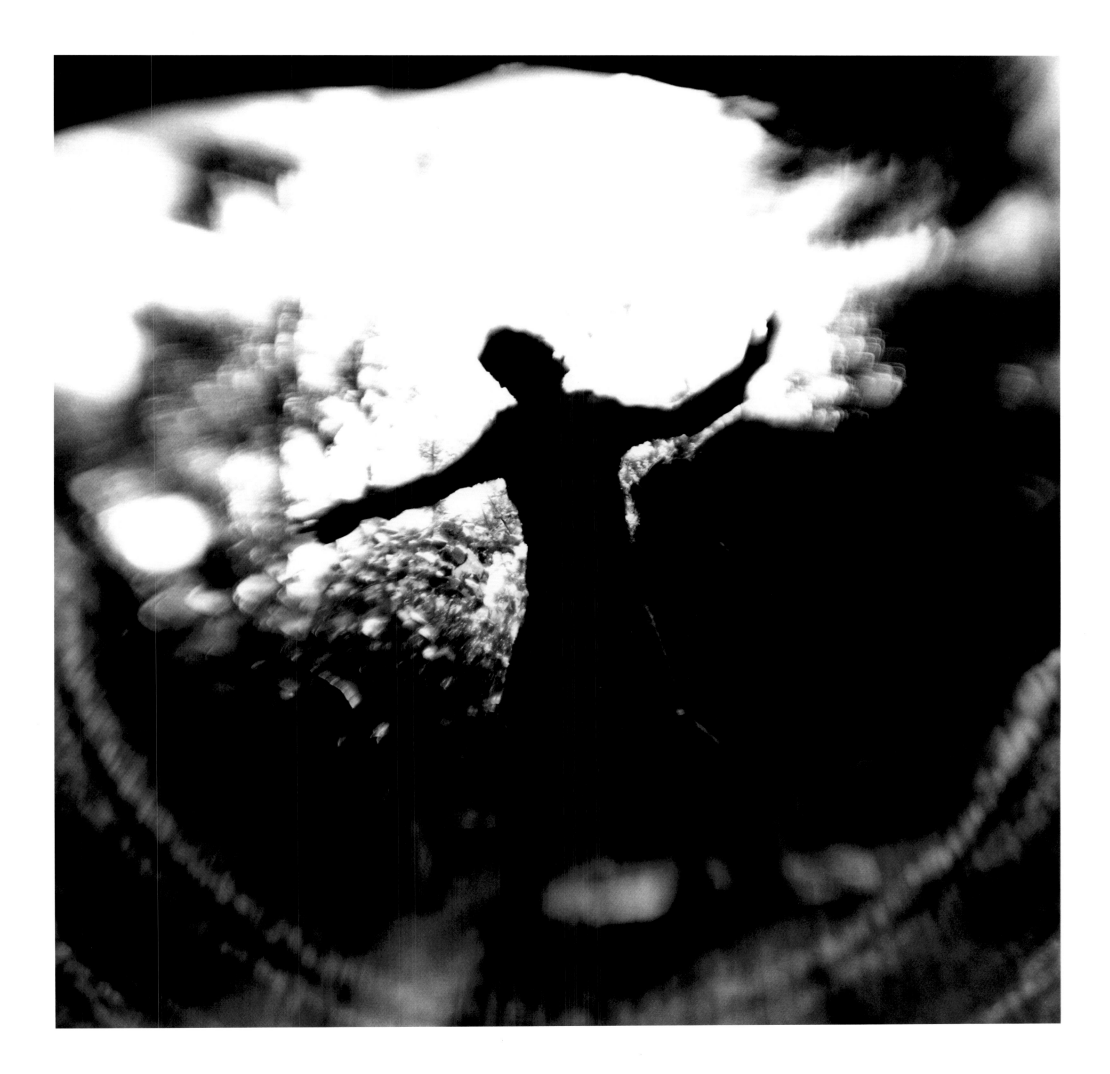

Looking out the big windows in our bedroom, I can see the studio and a corner of the workroom, the two separate structures that stand on our property behind the house. In the center of this triangle is the great live oak tree that shades the whole yard and shelters our lives. I have this same view from my office windows and from the kitchen. On any given day Keith is moving between the three points of this triangle, while I, moving from bedroom to office to kitchen, am always oriented to the same view. It is a metaphor. The studio is a life's work; the house is a marriage; and the workroom is the effort necessary to keep both going.

For Keith, work and play have very nearly come down to the same thing: making photographs. I loved photography before I loved a photographer, but I love looking at photographs, not making them. Happily my tastes and Keith's aspirations have meshed.

When we first met, Keith was a young man on fire to make photographs. But there was something else about him. He seemed to have a real appetite for the work itself. Years later, after we had married, I discovered a poem by Marge Piercy that I thought described him perfectly. It begins like this:

> *The people I love the best*
> *jump into work head first*
> *without dallying in the shallows*
> *and swim off with sure strokes almost out of sight.*
> *They seem to become natives of that element,*
> *the sleek black heads of seals*
> *bouncing like half-submerged balls.*

I don't know what constitutes a creative life for other people. One night in Mexico we were at dinner with a diverse group of friends — there was a chef, a writer, a musician, a scientist, and a couple of photographers. The talk, fueled by good food and ample wine, was about the creative process — how to catch that spark that ignites the imagination. Each person had a different take, but the musician capped the conversation when she said, "I think you just get run over by the sugar truck."

Earlier I had had a conversation with our scientist friend, who spends his days doing research which has the potential to benefit us all. He is married to a photographer, and was talking about the difference between his work and hers. He said his own work would get done, with or without him. "What I am looking for is there to be discovered, and if I don't find it, one of my colleagues will." "But an artist," he said, "if an artist doesn't do his work, then that work never gets done."

It is true that catching the spark is only half the battle. Every artist has to find a way to work and a way to keep going. I think Keith does it by faith. He has faith that it is worth doing, and it doesn't hurt that I think so too. He also has faith in what he has always called the alchemy of photography. He has thought of photographic processes as a kind of magic ever since the days when he would climb up on a stool in his mother's darkroom to watch the ghostly images appear in the developing trays.

His taste for the physical work of the process has stayed with him, and it is that quality that has saved him more than once when things have gone badly, or worse, not gone at all. To quote Piercy again:

> *Work is its own cure. You have to*
> *like it better than being loved.*

ᔆ

It took a long time for us to save enough money to build the studio. Our original idea was to find a small one-room church that was no longer in use and move it onto the property. Those austerely beautiful little churches then sat along dirt roads all over East Texas. But as a practical matter it proved impossible, and so we turned to a friend who helped us build a simple structure that we thought had a similar look and feel. The tall north wall has windows that arch high under the peaked roof. The darkroom extends across the

AFTERWORD **PATRICIA CARTER**

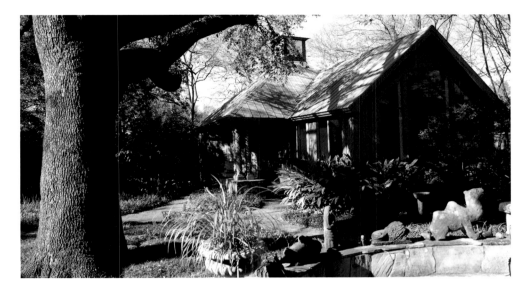

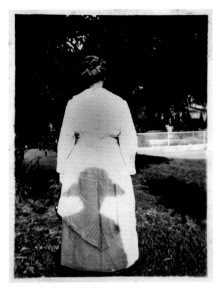

opposite south wall, and windows run along the east wall that faces the house. Today, its mossy green paint has faded, the tin roof has mottled, and it looks as if it has been there for an age, as if it has put down its own deep roots next to the oak tree.

Inside, the beautiful faded theatrical backdrop that hangs along the windowless west wall, the kilim rugs on the dark floor, and the old wooden work table are the only constants. Other things come and go — musical instruments, old medical charts, a female mannequin. It is a place that seems to have its own spirit — receptive and open — a space that allows for possibilities.

I drop everything when I am called to the darkroom for a first look at a new print, and I walk the twenty-five paces from house to studio with real anticipation. The pleasure of this experience is undiminished even though I have done it thousands of times. I want to have an authentic, unedited response to what I see. Keith, of course, wants validation. And who could blame him? It is difficult to make photographs that resonate beyond their literal content, and I hope it will not discourage young photographers to know that years of practice do not necessarily make it easier.

Some shelves in the studio hold boxes full of prints that never left home; projects that never jelled, ideas that never flew, disappointments that were felt keenly at the time. But nothing fatal or final, and nothing either of us ever called failure. Some of the boxes have been there for a very long time.

∽

Any long career is inevitably a meandering road, with ditches to fall into, wrong turns and dead ends. For Keith there is the added complication that photography is a medium that never stands still. One process always gives way to another. In recent years I have been an admiring onlooker as he has navigated between past, present, and future. His investigation of old processes, which yielded "Talbot's Shadow,"— the series of photograms included in this book (Plates 3 through 14) — coincided with his efforts to learn the language and techniques of the evolving digital era.

Keith seldom thinks in terms of single images. Rather, he thinks of any image as part of a larger body of work, as though he were writing a novel. This is not surprising since his strongest influences are literary. When starting a new body of work, he ritualizes this approach by setting aside a new portfolio box — burgundy being the preferred color — and settling on a name for the project. He believes any project goes better if you name it, so the title goes on the box before the first print goes inside. I suppose it all amounts to a declaration of intent; a formal way to begin the process of trying to give shape and substance to things that have been on his mind for a long time.

As Keith has aged, his eyesight has changed and he has become interested in photographing the way the human eye actually sees — with only one point of focus. He

Top Left: *The studio, seen from the house. Keith Carter, 2008.* Top Right: *Anonymous turn-of-the-century snapshot from Keith's darkroom wall.*

Bottom: *The live oak. Published title: Oak Tree 1991*

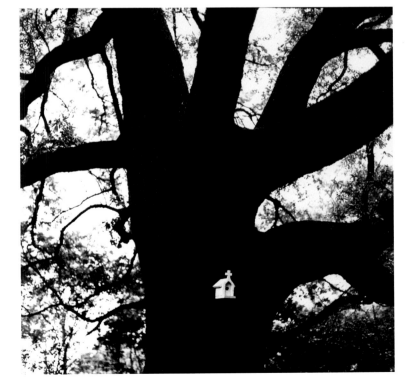

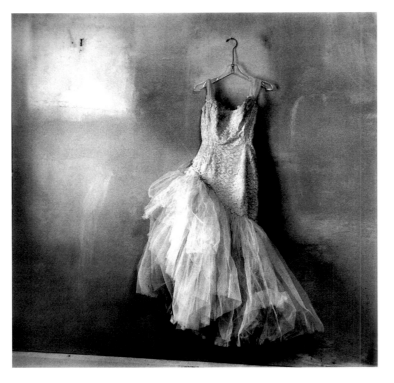

Top: *Jessamine's Gown 1994*

Bottom: *Detail of Keith's darkroom wall.*

likes leaving a little room for the viewer to finish the image, a little room for an implied narrative. His interest in this way of working may also, in some part, have grown out of his study of the history of the medium. Looking at the work of nineteenth-century itinerant photographers, he found again and again that he would look first at the subject, but then look past the subject to try to see, or imagine, what else might be there. That response was not one intended by those early practitioners who were encumbered by unwieldy equipment, slow films, and short depth of field. But Keith liked the psychological dimension it added to the images, and it reinforced his belief that the raw materials of photography are light and time and memory.

Lately he seems to feel a subtle loosening of some internal restraints. It is the kind of change that creeps in imperceptibly and is felt only after the fact. It brings the ease and confidence that all humans may feel when they have come far enough to have some faith in their own ability to get through. He has even returned to those dusty print boxes on the studio shelves and has begun making brand new work out of some old disappointments.

Recently I heard him talking to a group of adult workshop participants, offering encouragement and urging them on. "Absolutely anything you can think of is worth trying." "Make friends with uncertainty because she will always be sitting on your shoulder and whispering in your ear." "The full weight and mystery of your art rests on your relationship with your subject matter." Listening to him, I realized that he was speaking aloud the mantras he has repeated silently to himself for years, and which he has need of still.

∽

When Keith's mother was diagnosed with Alzheimer's we began making more frequent trips to the small East Texas town where she lived. In the last year or two of her life he took his camera along. He would pin up a backdrop where she was sitting and set the camera on a tripod in front of her. Photography was the thing they had shared, and it was a way to animate her. Later, when she fell silent, he grew silent too, but they would still sit together, the camera between them, for long periods. After each trip he would come home and print the portraits he had made. Her beauty was never lost to him. But in the end, the process he had loved to watch from atop a stool in her old darkroom reversed itself and her image began to dissolve before his eyes until, finally, she herself was lost to memory.

∽

People often ask why we still live in this corner of East Texas. We are a little surprised ourselves, but this place, with its soggy winters and sweltering summers, continues to nourish us both. There is a rich diversity, and there are still pockets of the storytelling culture that once defined this region. A major hurricane in 2005 brought devastation to many of our neighbors, and made us think seriously about the possibility of being uprooted. We realized that wherever we went, we would only try to re-create what we have here. And besides, to observe change and understand it, you have to stay in one place. It is certainly true that Keith's work has been shaped by his sense of place, which has gradually expanded outward from this center. As he continued to work and travel more widely he discovered that he could take that sense of place with him anywhere in the world.

When we had been married ten years he proposed a trip to Morocco to mark our anniversary. I had never traveled much and when he said Morocco he might as well have said the moon. A couple of days later he offered another suggestion: "Why don't we travel all around Texas on the back roads and I'll make photographs along the way?" I was ready to start immediately.

We ordered a big book of county maps that showed every tiny town and every road, paved or unpaved, and then we started planning. Our method for deciding the itinerary was not scientific — if we liked the name of the town and if it was not on a major road, it made our list. We circled on the map towns named Poetry, Fairy, Dime Box, Ding Dong, and many more. But Keith set himself a very strict photographic task. He

would make one photograph, and only one, in each town. Even if there didn't seem to be anything to photograph, even if the light was all wrong, no matter what. One town, one photograph.

Those trips eventually spread out over a year and a half and the result was Keith's first book, *From Uncertain to Blue.* I started the trips with notebook and pencil, intending only to keep a record of where we went and what was photographed. But I quickly began to expand the writing simply because I wanted to fix our experiences in my own memory, and, in the end, some of those notes were included in the book. Although Keith quickly moved past the documentary style of those images, it is fair to say that it was this Texas work that gave him his subject matter.

He had also found an organic way of working which fit the subject matter and suited his own nature. It suited me too. Since those days I have traveled with Keith to other parts of the world, but still, nothing is more exciting than to load the car with camera gear, maps, igloo cooler, books and music, and strike out with him in any direction.

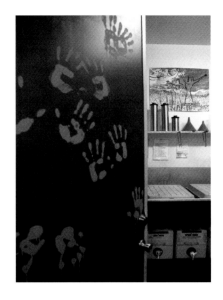

There is a special quality in our connection with the people we meet along the way that goes far beyond the natural hospitality extended by those who live in out-of-the-way places. As strangers, Keith and I have these advantages: We are not selling anything; We are not lost; We have come specifically with an interest in seeing that place. And Keith has come to make photographs. People recognize instinctively that he sees significance in the things that make up their lives. Their hearts open to us and they are eloquent.

And so, our purposeful wanderings have yielded not only photographic images, but indelible memories and experiences that have shaped and enriched our lives. There are many stories. Here is one of them.

When Keith was working on his book *Mojo,* we made a number of trips to Mississippi, spending time mostly in the Upper Delta Region. We had gotten to know that landscape and some of the people in it, and had come to know especially well some members of a small church called Pillow Chapel.

Pillow Chapel Church in that day was a typical one-room frame building that sat pristinely white in a green ocean of cotton fields. The gravel road in front ran straight as an arrow to the horizon. The only other structure in sight was a small house that stood about fifty yards to one side of the church. That house, forlorn and unpainted, seemed to sit back on its heels and looked near collapse. Its occupant was a man named Raymond. On previous trips Keith had photographed Raymond on his porch and inside his house. Church members had told us about Raymond's alcoholism and his brushes with the law. He had resisted all their attempts to bring him into the fold and had never darkened the door of Pillow Chapel Church.

Top: *Keith's darkroom door and partial view of interior.*

Bottom: *Raymond 1991*

But one bright June morning when we arrived for Sunday service, church members told us excitedly, and with some trepidation, that Raymond was planning to attend also. And it was because of us. Sure enough, as we entered he fell in right behind us. I found myself sitting with Keith on my left and Raymond, reeking of stale sweat, alcohol, tobacco, and general unwashedness, on my right.

The service got under way and soon the collection plate was passed. Keith put in a twenty dollar bill and, thinking that would surely do for both of us, I let the plate pass directly to Raymond. He dropped some coins in, but immediately began to fidget and squirm and fumble in his clothes for something. I was sure he was about to bolt. But he settled, picked up my hand, turned it over, and placed in my palm a dime and a nickel. Then he half rose from his seat, turned, and called for the plate to be sent back around. Raymond, thinking I had nothing to give, wanted to save me from shame. He held the plate in front of me and I dropped in his last fifteen cents.

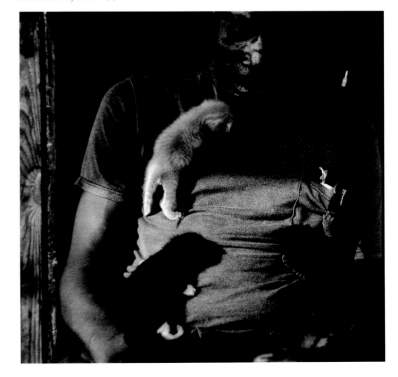

We sat quietly through the rest of the service and the three of us walked out into the sunlight together. I don't think I have ever had a clearer understanding of what it means to be a human being.

The full weight and mystery

relationship to

of your art rests upon your

your subject matter.

THE PLATES

A Certain Alchemy was designed by
Bill Wittliff, DJ Stout, and Julie Savasky.

Text was set in Stempel Schneidler Roman and Bold.

This book was printed using four-color process
on 157 gsm Chinese Gold East matte paper.

Prepress and color management
by iocolor, llp in Seattle.

Printed and bound by Everbest Printing in China,
through Four Colour Imports in Louisville.

All photographs in this book are from the
permanent collection of The Wittliff Gallery
of Southwestern & Mexican Photography
at Texas State University in San Marcos.